VIDEO STORYTELLING PROJECTS

A DIY GUIDE TO SHOOTING, EDITING, AND PRODUCING AMAZING VIDEO STORIES ON THE GO

RAFAEL "RC" CONCEPCION

Video Storytelling Projects:
A DIY Guide to Shooting, Editing, and Producing Amazing Video Stories on the Go
Rafael "RC" Concepcion

New Riders Voices that Matter
www.peachpit.com

New Riders is an imprint of Pearson Education, Inc.

To report errors, please send a note to errata@peachpit.com

Executive Editor: Laura Norman
Development Editors: Victor Gavenda and Cindy Snyder
Senior Production Editor: Tracey Croom
Copy Editor: Linda Laflamme
Compositor: Bumpy Design
Proofreader: Scout Festa
Indexer: Valerie Haynes Perry
Cover Design: Chuti Prasertsith
Interior Design: Kim Scott/Bumpy Design

ISBN-13: 978-0-13-769071-8
ISBN-10: 0-13-769071-1

$PrintCode

This book is dedicated to Daisy Concepcion and Norman Wechsler.

From Horatio Alger to Paul Simon, dim sum to Israeli politics, *Children of a Lesser God* to Ernest Hemingway, I became the teacher I am under your watchful eyes and caring hearts.

I *get* to do all of this because of you.

Table of Contents

Acknowledgments

I never want to forget that I get to do what I do because of the support of so many. Having a tribe was even more special and necessary for me with this book, as it was written through one of the biggest personal challenges I've had: dealing with Long COVID. A year and a half of my life was reduced to a blur of confusion, exhaustion, and fatigue. I can honestly say that none of this would have been possible without the people mentioned here.

To my wife, Jennifer, and daughter, Sabine: Thank you so much for your inexhaustible patience, care, and support. You have been my rock and inspiration, and I'm grateful for everything you do.

For my mother, Cristela Concepcion: Everything I've ever achieved has come from your blessing and support. I am ever proud to be your son.

Para mi madre, Cristela Concepcion: Todos mis éxitos son por su bendición y apollo. Es un orgullo ser hijo suyo.

Thank you to my gang of six: Victor, Everardo, Leobardo, Jesus, Carlos, and Tito. I love how much foolishness goes on in our brothers-only text thread, helping me feel connected, if only for a text at a time. A special thank you to our permanent oasis guests Carlos and Vicky who make summers in Syracuse even more special.

To Danielle and Jim Bontempi (a.k.a. Nana and Choo-Choo): Your care and support for me as your son-in-law gives me great strength and comfort. I'm grateful to have you in our lives. With Merri, Tim, Maddy, and Ellie, I feel like I have a second family. Thank you.

To Curt and Mitzi Hedges: Your love and support of my crazy ideas makes me feel like a blessed man. Thank you for opening your home in San Juan to me. I can't wait to see you again.

To Latanya Henry: More than a friend, you are my confidante, cheerleader, whisperer, and spiritual sister. If you only knew how much of what I do is because of you and my need to make you proud. The bond our family has with you, Linwood, and Tatiana is something that is very precious to me, and I am very thankful for it.

To Al Fudger: Whether days or weeks go by, you are still my "best" man. Thank you. Boop!

To Bonnie Scharf and Matt Davis: I'm grateful for our ability to pick up the phone and pick up our friendship no matter what. Thank you for looking out for me, for offering comfort, and for never wavering, showing true friendship.

To Kirsten Recore: I can honestly say that being able to reconnect with you has been one of the biggest joys of my adult life. Thank you for always understanding me, even when I wasn't the easiest person to understand.

My deepest thanks to my extended tribe: Gabriel Paizy, Harold Navarro, David Sutherland, Ken Falk, Kim and Denise Patti, Jay and Susan Abramson, Rebecca and Nate Peña, Dan and Stephanie DeVries, Bruce and Tina McQuiston, my hot sauce fam (Shana, Nate, Sydney, and Zach Boyer), Vincent Laforet, Edna Senderoff (RIP), Alexis and Tito Trujillo, and the amazing DJ Bella J, who is featured in this book. You are an inspiration.

To my National Public Radio bestie Nicole Werbeck and Keith Jenkins: Thanks for the friendship. One day, Tiny Desk. One day.

To my colleagues at the Newhouse School at Syracuse University: Mark Lodato, Regina Luttrell, Hua Jiang, Susan Nash, Olivia Stomski, Liz Curinga, Donna Till, and Stanley Bondy. Also to Gregory Heisler, Amy Toensing, Hal Silverman, Milton Santiago, and the rest of the VIS department: Thank you!

To my friends at Adobe: Katrin Eismann, John Nack, Mala Sharma, Jeff and Rachel Tranberry, and Meredith Stotzner. Thank you for putting up with the random questions at odd hours of the night, your guidance, and your friendship. I'm ever proud to fly the Adobe flag.

This book would literally not be possible without the help of my team at Pearson: Laura Norman, Jarle Leirpoll, Linda Laflamme, Tracey Croom, and Scout Festa. A double extra thanks to Victor Gavenda, who had to decipher my incoherence at its darkest points yet still found a way to bring a smile through his comments on the work. I shall forever be in your debt.

I've saved the best for last. To Cindy Snyder: Part manager, part wrangler, part editor, but most of all, friend. Thank you for putting up with 16 years of my ADD and still making me look like I know what I'm doing. My love and thanks will never be enough.

Biography

RC is an award-winning photographer, podcast host, educator, and the author of 15 best-selling books on photography, video, Photoshop, Lightroom, and HDR. He is an assistant teaching professor of visual communications at the Newhouse School for Visual Communications at Syracuse University

As an Adobe Certified Instructor in Photoshop, Illustrator, and Lightroom, RC has over 27 years of experience creating content in creative, information technology, and e-commerce industries and spends his days developing creative content for corporate clients, educational institutions, and students looking to take their creative vision further.

As a Photoshop and Lightroom expert, RC also worked with Adobe to write the Adobe Certified Expert exam for Photoshop CS6, Lightroom 4, and Lightroom 5. He has written the Lightroom and Photoshop books for the Adobe Press Classroom in a Book series.

RC is a highly sought-after public speaker, presenting to corporations and creative students at seminars and workshops around the world. He has created educational content and video productions for clients such as Intel, Dell, Epson, Nikon, Canon, Samsung, Nokia, SanDisk, Western Digital, G-Technology, Google, CreativeLive, and PricewaterhouseCoopers, among others.

Introduction

Did you know that as of 2023, 65% of all internet traffic is video-based?[1] Over the last few years, we have been quickly moving from visiting a specific webpage to research something to "going on YouTube" to find the answer. For many, YouTube is the new Google, making video more and more pervasive in our daily lives.

When students come to the Newhouse School on tours—wide-eyed at the sheer awesomeness of the place—I remind them of this statistic. To me, video is becoming the new printed word. (No, the irony is not lost on me that you have to read this statement on a printed page, although you could be reading it on a Kindle. But that's another story for another time.)

Whether we use a printed page or a video, however, the idea that we are trying to convey doesn't really change. The only thing that's changing here is the language we use to share that idea. But the idea needs to take form. That form comes when we learn the words we need to speak it into reality.

I want this book to feel like a handbook for the common things that are important to understand when you're starting out with video. To do this, I make the following assumptions:

- Books sometimes overexplain things and make what you need to learn difficult.

- Many believe bigger cameras make better video, while not paying attention to the power of the camera that's in your pocket.

- You need to be clear about what you want to say and how you're going to say it.

- Once you have everything organized, you need to understand how to use the tools to make it happen.

- Learning how to do video is hard with just a book.

1. "Sandvine's 2023 Global Internet Phenomena Report Shows 24% Jump in Video Traffic, with Netflix Volume Overtaking YouTube," Sandvine, January 20, 2023, accessed June 22, 2023, www.sandvine.com/press-releases/sandvines-2023-global-internet-phenomena-report-shows-24-jump-in-video-traffic-with-netflix-volume-overtaking-youtube.

The first part of this book is dedicated to getting the thoughts in your head organized so that they follow a specific progression. You'll learn about story formulas as jumping-off points to getting your ideas in order.

If you subscribe to my analogy of video being the new printed word, then video editing software like Adobe Premiere Pro is the new Microsoft Word or Google Docs. The video editing software is the tool that lets you organize your ideas and make them real. Premiere Pro is not a *creative* tool per se, but more of an *assembly* tool. For you to be as effective as you can at video storytelling, you're going to need to learn how to use this software in a very specific manner.

The second part of this book addresses the hardware that you'll need to make your video stand out. While the phone in your pocket is perfectly capable of recording video, you can add some things to it and change a few settings to make your video and audio that much better. I also provide some suggestions for additional gear that you can use as a foundation to build a storytelling rig.

The third part of this book focuses on moving your organized idea through a specific workflow in Adobe Premiere Pro. Rather than cramming 400 pages with step-by-step instructions for you to follow, this book covers the general concepts in the workflow and offers companion videos that you can use to follow along.

Now you might not be ready to execute an idea just yet, but might want to dive into learning how to put an idea together. To help with that, I included a project that's based on an exercise I use with students in the classroom. This project is completely organized and shot. I assigned myself the task of making a several-minute video of two people playing cards. I created the concept for the video, organized my thoughts into a series of sequences, shot all of the individual video clips, and organized them in a shot list.

This means that you can pick up the book from this section, download the project, and use the book as a reference while the accompanying videos walk you through how to build the project step by step. It's like being presented with a recipe and ingredients for a dish that you just have to cook.

Once the video is complete, I cover how to put the final product online so that you can share it with the world and track how well it performs.

The last part of this book offers another project you can cut your teeth on. It involves creating a video in a news format. Because I teach students to be journalists, it's important for me to share a workflow that I think can help you tell a story quickly and save you time from concept to creation.

At the end of this introduction, I share a couple of stories about the creative process that I think you should find helpful. In addition, the accompanying materials for this book include sample project folders that you can use for your own projects, resources for creating the videos, and templates that you can apply in Adobe Premiere Pro.

I hope that you will use this book in tandem with its video files, using it as a reference to key ideas while the videos give you the step-by-step instructions to dive in.

Each of the sections could be a book unto itself. I could write hundreds of pages about microphone patterns, best practices for capturing audio, encryption, formats, and all sorts of techno speak. I could write volumes about story arcs, characters, and the creative process. But I don't think all of that is necessary right now.

The goal is to get you started with story development and making a video quickly. If you would like to learn more about the journalism process and telling a story, you can take a class. If you find yourself more interested in cinematography, you can dive into other books. This book is part classroom and part theory, but short enough to make it easily digestible and fast.

Now, if there's anything that I can help you with, please feel free to reach out online. You can find me on Twitter, Facebook, or Instagram under the username @aboutRC. If you're in the area, you're more than welcome to stop by and visit at the Newhouse School of Public Communications at Syracuse University in New York.

The Words (Dear Mrs. Senderoff)

I grew up as one child of seven in the Bronx (that's me pretending to be superman). My mom is from Mexico. Dad was from Puerto Rico. Neither of them ever set foot in a school. My brothers and I grew up in the time when crack was really beginning to take off, ravaging families and communities block by block. Through it all, my mother plowed on, belt in hand, making sure that each and every one of us got our chance at school.

My mom looks back at these times and feels bad, often wondering what she could have provided us that would have been better than what we had. I always look at her in disbelief. Access to a school and the drive to want to get the hell out—that's pretty much all we needed.

Right from the get-go I was labeled the smart kid of the unit. School came relatively easy to me, and I found myself taking on more work and reading more, even at an early age. My brothers teased me, but I think they were all really happy to see how much I was learning, and how much I wanted to learn.

There was one problem, however. Hanging out on the street didn't really go well with wanting to learn, and I often found myself very schizophrenic about the things that I *wanted* to do versus the things I *needed* to do. I was supposed to apply for all of these smarty-smart specialized high schools in New York City (Bronx Science, LaGuardia, etc.). What I wanted to do was play handball with my friends. I invariably blew off every deadline and every test for applying to those schools. The problem was that after I played a couple of games outside, I felt like I wanted to do something else.

An Angry Kid

In junior high, I was placed in an advanced English class taught by Mrs. Edna Senderoff. I remember being so angry at being there. While everyone did their work during the first day of the term, I just sat there, arms folded. I was determined to get kicked out of this class to go back to my friends' class. Mrs. Senderoff didn't make any sort of scene about this, but instead let the class run as it should. When the bell rang, she asked me to stay behind to chat with her.

"Do you want to go back to the other English class, Rafael?" Mrs. Senderoff asked.

"Yes. Yes I do," I quickly replied.

She turned away and started walking back to her desk. "That shouldn't be a problem. I can make that happen immediately."

Mrs. Senderoff then turned and spoke to me in a way that cut through everything I had inside. What she said would be the fuel for most of my careers and one of the driving principles for why I do what I do.

"Rafael, I see such incredible promise in you, but you appear to be a very, very angry boy. I believe that I know *why* you are angry, and I know how to fix it. You are angry because you have all of these different emotions running inside of you and you have absolutely no way to tell them to anyone. Do you know what an epiphany is? This is a word that can explain a feeling. You are in need of learning all of the words you can to describe all of the things that you feel. Once you do that, you're going to be surprised how much better you will feel. I want you to think about that tonight. If you don't agree, I will put you back in the other class. If you do agree, I want you to come back tomorrow and work, just like everyone else."

She was right. Absolutely right. It was one of those defining moments of clarity that I desperately searched for. And there it was, in a little old lady with a piece of chalk in her hand. I came back the next day, committed to learning every single word I could to express what I felt.

I became editor of the JHS newspaper—much to the surprise of everyone around me. I decided I wanted to take English Literature in college. I graduated when I was 15 and was in college by age 16. I also decided that I wanted to be a teacher. All of this because of Mrs. Senderoff.

Saying Thanks

After a couple of different career paths (that went very well, I might add) I did send her a note. A few weeks later, she wrote back, congratulating me. She wrote a series of vignettes of what she remembered about our time together. Her memory was spot on. I am so happy that I was able to email her and thank her for setting me on the path to success.

Some time ago, I decided to write her a letter to tell her that I—out of all people, *that kid*—actually became an author. I searched for her online, only to find out that Mrs. Senderoff had passed away several years before. Talk about a punch in the gut. Somehow, I think she still got to see all of the cool things I have done. At least, I know that if she didn't, I'm going to dedicate my time trying to learn more words and to help others in the same manner that she helped me.

This is why I am a teacher. This is also why I love it.

What Does This Have to Do with Video and Storytelling?

In photography and videography, we spend a lot of time talking about megapixels, f-stops, ISO, power ratios, cameras, and the like. Sometimes we don't spend enough time talking about what all of these things do to help us express how we feel. It sounds cliché, and I'm often made fun of for saying it, but what we do in this field *does* come from the heart, enabled by the brain.

When you go out there to learn, don't get too sucked into things that don't feed the heart or the brain. Don't get sucked into the lifestyles. Don't get sucked into the marketing. Sit down and look at shot sizes, camera framing, movements, and all of the technical things as "words" you need to learn to make a sentence. See compositional framing as a noun. See camera movement as a verb. See light as an adjective. Once you learn all of the words of this language, sit and focus on exactly what you want to say.

I'm writing this book—and this is *still* the hardest part for me—saying what I want to say. How we express ourselves is the journey we each go through. Some of us are farther along the road than others, and the destination doesn't really matter. It's just fun being on that road.

Like when you learn a new language, you will find yourself sometimes criticizing the way you "speak" in front of others. It happens to me all the time. Part of me always criticizes myself, wondering whether I'm good enough to be at the table and have the conversation in the first place.

But that doesn't matter. I've learned the words. I've learned this language. I'm talking now. And I want to spend all of my days sharing how to do that.

For that, Edna Senderoff, I owe you more than I can ever say.

Vincent Laforet on Permission to Create

During the fall of 2011, I sat in a small bar just down the road from the B&H Photo superstore in New York City. Across from me was Vincent Laforet, a Pulitzer Prize–winning photographer for the *New York Times*. We were in New York for a trade show, and we stole away for a couple of moments of quiet when he decided to show me a quick preview of a short film he had just made, *Mobius*.

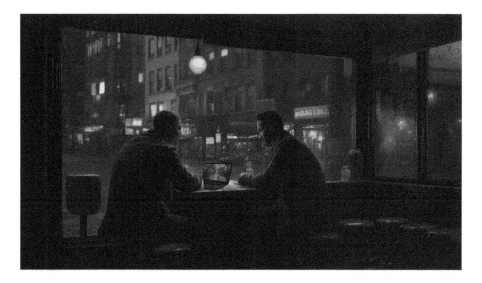

To say that Vincent is an amazing artist is an understatement. While he has made some incredible images for the *New York Times*, he is also known for his incredible aerial work over New York City. Highly accomplished in the world of photography as a journalist, Vincent seemed determined to take his visions to even bigger heights. After a chance encounter with the new Canon 5D Mark II, Vincent said he wanted to find a way to showcase its video capabilities. Armed with only one light, he produced *Reverie*, a three-minute showcase of the future of video.

Effortlessly moving through a fantastical boy-meets-girl story, you follow the protagonist from his home, into a car, and up in the air, the sound of Moby's "Extreme Ways" pulsating through the story to its dramatic conclusion. When *Reverie* was released on Vimeo, the impact was seismic. In no time at all, the 5D Mark II was being used by folks at *Saturday Night Live*, and several episodes of the TV show *ER* included use of the DSLR camera for video. I am of the opinion that the ushering in of digital video as we know it is owed to Vincent Laforet, its *original* godfather.

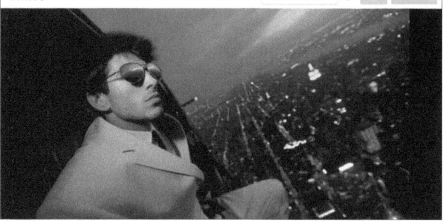

So I was sitting in this bar, taking a look at a master's new work, in awe of the opportunity. After watching it, I intimated to Vincent that while I loved photography and had won awards and recognition, I always felt like I saw a lot of my world through a series of these weird short scenes—images that played out in my head for different emotions. While I tried to record them here and there, I couldn't find a way to jog myself free from the still image and venture into the world of the moving picture. It always felt too fantastical.

Vincent turned to me and said, "I know exactly what your problem is. Your problem is permission. You are intent on waiting for someone to come over and tell you that you're a [capital D] Director. No one is going to do that. Only you can do that. You have to wake up one morning and say 'Okay, I am just going to do it' and just go and do it." He also shared that while photography was something that I could do on my own, filmmaking was more of a "team sport," requiring me to put down the idea that I needed to know everything on every component. The goal for me should be to focus on the images in my head and to make sure that I can get them out as clearly as possible. Those images will then be "solved" through my technical skill.

We finished our drinks and left for the evening. While I can't say what was in his head after this conversation (or if he even remembers it), that encounter was a pivotal moment for me and one that I will forever share with my students.

You see, the clarity of your idea depends on the honesty of your intention. If you wake up in the morning half-wondering if you are going to make a good piece of work, you too are waiting for someone to bop you over the head and say, "You are the Director now." You are Estragon waiting for Godot.

I tell my students that before coming to class, they should stare at themselves in the mirror and say, "For the next 90 minutes, I am a Director. For the next 90 minutes—no matter what my major is—I am a Director." While this may seem like fanciful role-play, it will surprise you to see how much clearer you are with your ideas when you give yourself the permission to make them reality. You will transform your attempts to describe your scene from "Well, I don't know…I was thinking that maybe…I mean, I guess we could" to something far more definitive and useful.

Giving yourself permission will give clarity to your intentions. You will see the story that you want to make in all of its detail. Once you write all of that down, you can then use all of the other tools and techniques that you are learning in this book and really swing for the fences.

Give yourself permission. And if you run into Vincent Laforet at a film festival, make sure you give him my thanks.

To see more of Vincent Laforet's work, please visit www.vincentlaforet.com.

Vincent Laforet's Reverie
Use the QR code to go to the video. If you're reading a print book, scan the code with your mobile device. If you're reading an ebook, tap or click the QR code. To watch *Reverie*, go to https://rcweb.co/laforet-reverie.

The Making of *Reverie*
Use the QR code to go to the video. If you're reading a print book, scan the code with your mobile device. If you're reading an ebook, tap or click the QR code. For a behind-the-scenes look at the making of *Reverie*, visit https://rcweb.co/reverie-bts.

The Elements of Story

An effective story, at its core, has three distinct components: a beginning, a middle, and an end. This allows you to be able to set the time and the place for the story, introduce the level of drama that you need in the story, and bring the story to a natural conclusion.

One of the most important things to keep in mind is that your story needs to have a point. It needs to have an overall message that you bring to the viewer, and you can't do that without having a foundation for how the story is going to begin, how the drama is going to unfold, and what the story's key takeaway is.

Not designing a story in this manner makes the viewer think to themselves, "What is the point? Why am I listening to (or watching) this story? What is this person trying to tell me?" You have only a limited amount of time to get your point across, so the clearer that you are in the development of the story, the better it is for you and for your viewer.

Attention Capital: Spend It Wisely

I have this (far-fetched) belief that every human has a specific amount of attention capital that they share with another person when they first meet. It's as if we subconsciously say, "Nice to meet you. I am going to dedicate X amount of time to you. Let's see what you do with it." As the relationship with this person evolves, we continuously review the amount of attention capital we have with them to see if they have enough to "spend" in our interactions. I painfully learned this lesson with my friend Al.

You see, I used to call Al and just talk. I'd go on and on about what I was doing, not giving any consideration to what I was actually saying. I was happy to just be talking. One day, he frustratingly said into the phone, "Wow. You are a like a whole bunch of middles. No beginning. No end. Just a whole bunch of middles." This made me mindful of how I told stories to him in the future.

FIGURE 1.1 The mobile device demands your attention.

He was joking (I hope), but I think he had a good point there. As you interact, you ask for the precious commodity of time. In return, you should bring something to the conversation so you can show that you are a good steward of that time. When you do, you are rewarded with even more attention capital. The more you value that transaction, the more capital you generate. If you squander that capital early with no real goal, it can be impossible to get it back.

I believe video storytelling operates under these same rules but with even more on the line. In a story, you have mere seconds to show a viewer that you are a good steward of their time and that the message you bring will be a good one. You need to be intensely aware of this attention capital and make sure you do not needlessly spend it.

The best way to do this is to know exactly *what* you want to say—and know exactly *how* you intend to say it. Two venerable story structures can help: Freytag's Pyramid and The Hero's Journey.

Freytag's Pyramid

Gustav Freytag was a 19th-century playwright who illustrated the elements of story in a pyramid. Used to this day, his pyramid outlines seven elements that are important in the development of the story: exposition, inciting incident, rising action, climax, falling action, resolution, and dénouement.

FIGURE 1.2 Gustav Freytag, German novelist and playwright

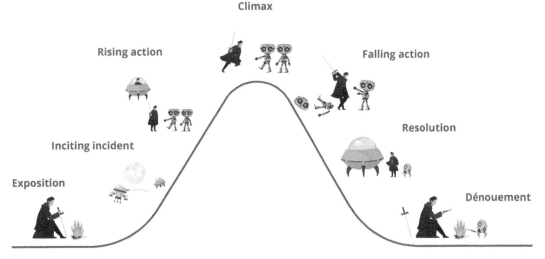

Climax

Rising action

Falling action

Inciting incident

Resolution

Exposition

Dénouement

FIGURE 1.3 An overview of Freytag's Pyramid

Exposition

In the exposition, you set the scene for the story. While this part of the pyramid is short, you need to do some key things here. You need to introduce the characters and where your story is taking place. If needed, this also would be a good time for you to introduce a backstory: elements of the character or the environment that your reader or listener needs to be familiar with before the story begins. This has been a common device from Shakespeare's *Romeo and Juliet* to Ryan Coogler's *Black Panther*.

The goal of the exposition is to set the overall tone for your story and set the ground rules for what the viewer is going to experience. Taking the time to be clear about this at the start of the story will help you avoid having to unnecessarily push the information along later.

In the *Harry Potter* series by J. K. Rowling, for example, we are first introduced to Harry at the home of his aunt and uncle on Privet Drive. We see Harry as a child who lives under the stairs and is treated badly by his adoptive family. That is the *exposition*: it sets the time and the place. You know that you're in England. And you know that Harry is a person who is not appreciated by his adopted family. The protagonist, in this instance Harry, is defined as a person who you immediately feel bad for and who is a bit of an underdog. In this exposition, you're introduced to the time and the place (Privet Lane, in a town in England), and you begin to understand the main character (Harry).

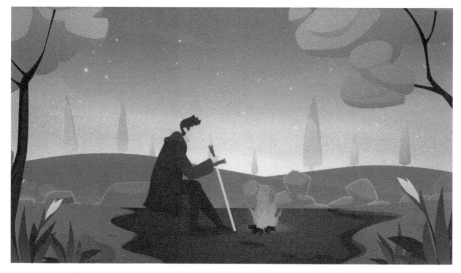

FIGURE 1.4 Exposition: Setting the scene

Inciting Incident

In the *inciting incident*, your character is affected by an event that will set the story in motion. This is the moment where the incredible journey begins. The inciting incident is also a great place to introduce not only the protagonist(s) and antagonist(s) of the story, but also to introduce the change in the status quo of the world you just introduced.

In *Harry Potter*, the inciting incident occurs when magical things start to happen around Harry. The introduction of these magical elements doesn't necessarily introduce the villain, but they trigger the chain of events that drives the rest of the story. This incident gives you "Hey... What's going on here?" moments—and introduces suspense.

FIGURE 1.5 Inciting incident: Something happens to trigger the story.

Rising Action

Once you've set your story in motion, it's time to introduce my most favorite part: the drama. In every story we want to feel like there is a set of odds that the character is trying to beat. It's that sense of a struggle against a stacked hand that makes people want to stick around for the ending.

FIGURE 1.6 Rising action: Things start to get intense.

Imagine I'm telling a story about a person arm-wrestling a really large, muscular opponent. If that person started arm-wrestling the opponent and the opponent easily beat him, there would be no drama. If the person went back and tried to arm-wrestle the person again, and that person handily beat him again, there would be no movement in the drama. If the person tried to arm-wrestle him a third time and the opponent beat him with not so much as a hint of effort, the viewer would wonder, "Why am I watching this? The outcome is exactly the same every single time." I've lost the attention capital of the viewer—and the viewer leaves the story and clicks into the next YouTube video.

A good story has a sense of action or drama that *increases* (*rises*) as the story progresses. The challenges and the conflicts increase so that the viewer becomes invested in the struggle. In the case of Harry Potter, as his classes at Hogwarts become more difficult, new characters are introduced that block his success. The true identity of the villain is teased, and all of this tension slowly ratchets up, keeping the viewer hooked.

When the intensity of the action stays the same, the attention capital that you get from the viewer is immediately spent. When the intensity of the action increases, you earn attention capital from the viewer. The viewer is invested in the story and excited to see what the outcome will be.

Climax

The height of the emotion in the story is known as the *climax*. That's the peak point of drama, the eventual showdown between the protagonist, the subject of the story, and the antagonist. In different story structures, this climax could be represented differently. Perhaps it could be the protagonist facing the antagonist. It could also be the protagonist facing their most deep-seated internal conflict. This is where all the work you've done previously as a creator leads to a final battle. Will you succeed or will you fail?

▶ A NOTE ON PROTAGONISTS AND ANTAGONISTS

In every story structure, there is a *protagonist*, the main subject that moves the story forward, and an *antagonist*, the challenge that opposes the protagonist. These characters do not have to be real people in every story. In fact, they don't have to be people at all.

In *Moby-Dick*, Melville gave us Captain Ahab as the protagonist and a whale as the antagonist. In the movie *The Matrix*, the protagonist is Neo, a person stuck in a pseudo-reality generated by the antagonist, which is a computer.

Dracula is not a real person but, certainly, one of the most notorious antagonists in story. In the movie *The Perfect Storm*, the captain of the *Andrea Gail* is the protagonist and his antagonist is nature—the storm.

While trying to find their protagonist and antagonist, beginning storytellers often fall into the trap of believing that they must be people. They can be elements, supernatural elements, or environments. Protagonists can be individuals, movements, or events. Consider this when you are developing your story and make sure that you highlight who, or what, is the main driver of your story (the protagonist) and who, or what, is the main challenger to the protagonist: the antagonist.

FIGURE 1.7 Good vs. Bad

FIGURE 1.8 Climax: Hitting the high point

Falling Action

Past the climax, the next stage is the *falling action*. The falling action can be relatively short in stories, as it's usually the action that is the result of what happened at the climax. This series of events brings you closer to the next phase of the story, where all loose ends are tied up. Harry Potter emerges victorious against his antagonist (I'm trying not to give away any spoilers here), and he lives to fight another day.

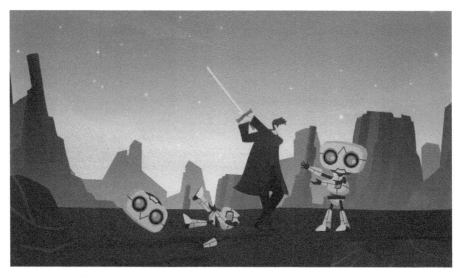

FIGURE 1.9 Falling action: Wrapping up

Dénouement

At the bottom of Freytag's Pyramid is a phase called *dénouement*, which comes from the French for "the ending" (literally, "the untying" or "the unknotting"). This is also known as the *Resolution* stage in the pyramid. This is usually where the story shares its overall meaning, the *moral,* if you will. If we look at stories as examples of what to do or what not to do, what to care about or what not to care about, the dénouement offers an opportunity for you to connect with the viewer and say *why*. Why has this been important? Why did I take you through this entire story? And what is the key purpose of this? In creating any kind of story, it's very important for you to be able to illustrate the reason you took someone on that particular journey. The dénouement section of the story allows you to explain it one more time to make sure that the viewer understands and tie up the story to its final conclusion.

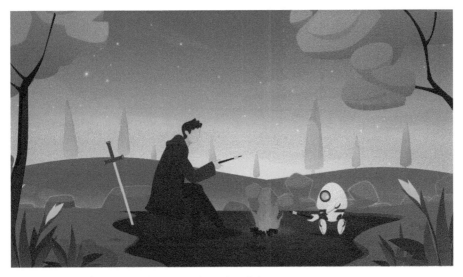

FIGURE 1.10 Dénouement: Revealing the point of the story

The Hero's Journey

Joseph Campbell was an American professor who developed a more detailed formula for storytelling that he used to describe common elements that he found in many stories told the world over. Campbell summed up all of those common elements as The Hero's Journey in his book *The Hero with a Thousand Faces* in 1949.

The Hero's Journey is designed as a circle with discrete phases at specific points, much like the numbers on a clock. The circle is bisected, separating the top part into a *known world* and the bottom part into an *unknown world*. Further, the known world is bisected into two quarters symbolizing the Departure and the Return. Key moments in the story proceed in a clockwise fashion around the circle, touching upon specific milestones along the way.

If I needed to give you a two-sentence definition of The Hero's Journey I would sum it up like this:

> A character leaves what he knows and goes into the unknown to fight or challenge something he fears. When he wins, he comes back with the wisdom of the experience to begin his life renewed.

In total, there are 17 steps within The Hero's Journey, and not all stories will employ each of these steps. Think of these as a large-scale roadmap of this story type should you need it.

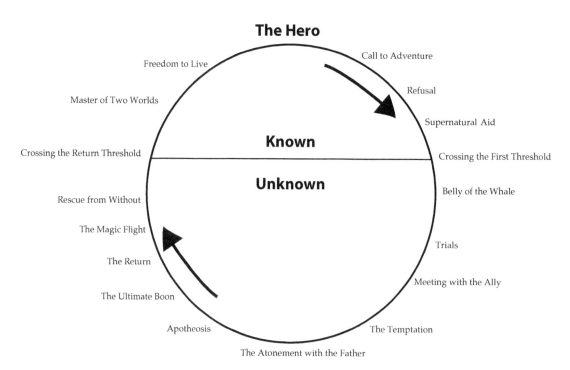

FIGURE 1.11 The Hero's Journey

Key Things to Remember About The Hero's Journey

We could take this entire book to discuss the merits (and faults) of The Hero's Journey; this is meant merely as an *amuse-bouche* to get you interested. If you are familiar with the pattern at a basic level, you will be able to see how so many well-known stories—big and small—use elements of it for their success. So what are the most important things you should keep in mind?

The protagonist travels from the known world into the unknown world and back with the help of guides. While in the unknown world, the character learns the things needed to overcome the problems that world poses. Usually, that journey to become a hero deals with issues that are internal to the person—and the trials they face bring out the characteristics in that person that allow them to become heroic. Once they have achieved this status, they return to the known world to find the next challenge that will test what they learned—or make them do it again.

Consider *The Lion King* as an example. This story introduces the protagonist, Simba, and navigates him into the unknown world of the forest with the help of his guides, Timon and Pumbaa. Simba *literally* leaves his known world and enters the unknown world of the forest (Hakuna Matata) and later has to come home and face his fears back in the known world using what he has learned—a classic Hero's Journey.

Harry Potter leaves the familiarity of Privet Drive (the Departure) to enter an unknown world of magic and mystery through the use of his guide Hagrid. While he is at Hogwarts, he undergoes a series of trials with two more allies at his side: Ron and Hermione. In each of the seven books in the series, he experiences personal growth and development until he faces Voldemort (or one of his followers), and returns to the known world (Privet Drive) to do it all again the following school year.

In fact, George Lucas relied heavily on The Hero's Journey in the development of *Star Wars*, with the protagonist, Luke Skywalker, brought into the mystical science fiction world by his guide, Obi-Wan Kenobi. The formula is tried and true, and knowing how to use it effectively will create an engaging story.

Suit the Structure to Your Idea

The Hero's Journey and Freytag's Pyramid are but two of a multitude of formulas that you can use in the development of story. But it's important to understand that neither one necessarily serves a specific story type. You can have Hero's Journey stories that last two minutes, and you can have Freytag Pyramids that last an hour.

As you start developing your own stories, you may even find variations of these story structures out in the wild that fit the specific idea you have in mind—and that's good!

The most important takeaways here are to understand that formulas for building a story exist and that it's important for you to find a formula that will best tell the story that you are trying to tell.

The Three Pillars

When creating a video, think of it as built on three main components:

- What you see
- What you hear
- What you say

Each of these components helps in moving the story along—and each one of them has to be used purposefully.

Here's an example: Imagine that you've set a scene that includes papers strewn about a desk. This conveys a specific idea of the environment and mood that you are working with in the story: hurried, frantic, disorganized.

But—what if in the same shot, you position an hourglass at one side of the scene. The additional element distracts viewers from the whole scene and makes them say, "Wait, why is that here? Does that have anything to do with anything?"

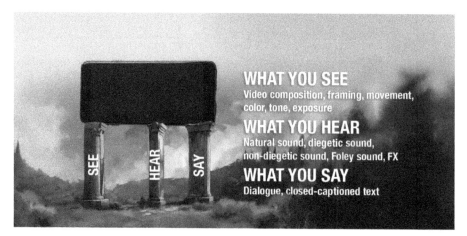

FIGURE 1.12 A good story needs strong support.

If the hourglass is there simply to serve as a paperweight, you have squandered your attention capital with the viewer, and they are less likely to stay. If you bring back the element of the hourglass through subsequent shots, you tie the element into the story, and the attention capital you create with your audience increases—and hopefully brings you to a bigger payoff.

Here's a good thing to keep in mind while you plan what your audience will see in your video: if something is clearly visible in a video—and that something does not add to the story—there is a good chance that the element is taking *away* from the story.

When I talk about "what you hear," I mean the sounds and music that you choose to include in your video. Each sound must have a purpose, and that purpose should be to move the story forward. If in the previous scene with the messy papers, the viewer heard a tea kettle whistling but you never addressed that they heard it, your viewer will be left with a "why was that there?" moment. Your attention capital has now decreased.

The same goes with what you say in the video: the words in the script or the sound bites in the interview. If your subject relays information that does not pertain to the matter at hand, you will quickly lose the attention capital you have earned with your audience, and they will move on to the next story.

No matter how big or small this video is, you have to keep all three of these guidelines in mind. Lose one of them, and you've lost your viewer.

Story Helps Us Change How We Feel

While it is true that a story contains a series of events that may merely occur or that may develop dramatically to a conclusion, it's important to remember that the purpose of the story is to spark a change in the viewer who is watching it. Story coach and author Lisa Cron sums it up perfectly in her book *Wired For Story*, writing "stories are about how we change."

Every story that you want to tell has a hidden message for someone to discover. People can watch TikTok videos to marvel at the absurdity of life or check out an Instagram reel that inspires them to have confidence in their next career jump. Others can view a news package that motivates them to go out to vote or follow an instructional video on YouTube that motivates them to tackle that skill they've always wanted to acquire. Each story has a message, and your job is to take the viewer to that message through your plot.

FIGURE 1.13 Use your
video story to convey
feeling.

One of the best ways that you can achieve this is to focus on conveying feeling. Your story—no matter how short or long—should make sure that it elicits a feeling in an individual. If you can make a person happy, sad, angry, indignant, confident, or inspired, you can make them remember the message you are trying to share.

No matter if I'm making a video, a photograph, or an audio, I always write down on a sheet of paper the feelings that I want to inspire in the viewer. Once I do that, I outline what I want to change or highlight. Having those two compass points in place, I start looking at what I am going to show, what am I going to hear, and what I am going to say to serve that message.

Now the next step is to come up with the plan.

How to Structure Your Story

If there is one piece of advice that you should keep in mind on your video journey it's this: You are working in the service of telling a story that will motivate and change the minds of viewers. As you dive into this process, you'll undoubtedly start exploring the technical aspects of producing these stories and encounter unfamiliar terminology and tools. You may then become lost in the technicality of it all—either frustrated and overwhelmed by the volume of details or so full of excitement you drive headlong into bleeding edge territory without a map. Both these paths can quickly lead you away from your original purpose: to tell the story. Remember, you work in the service of the story, and the techniques that you choose to use should serve you and not the other way around.

Learning a New Language

Technology, with its specialized vocabulary, is *knowable*. You just need a clear motivation for using it and a solid process for learning it. If you were to embark on learning a new language—German, for example—you would have a reason to want to do it. Perhaps you're traveling to Berlin. You would start with simple phrases that you felt you would need like "Where is the bathroom?" or "How much is that jelly doughnut?" You would learn the appropriate nouns and verbs and learn how to put together simple sentences to achieve what you want. If later you wanted to talk to someone about financial markets, you would have to learn new nouns and verbs—like maturation, accrual, dividends—and then new sentences would be a part of your vocabulary.

Video storytelling is very similar to this—but easier. The rules you need to know to speak the language of storytelling are simpler, and the vocabulary is smaller. Although you can more quickly put together a statement to say what you want to say, you still need to have an idea of *what* you want to say first.

What you choose to show in the video frame—the scene you present to the viewer— can be seen as a noun. *Where* you choose to position those elements in the frame could be considered the adjectives. *How* you choose to move the camera could be considered a verb. Lighting and sound can be seen as additional adjectives, with transitions serving as adverbs to color the sentence even more. When you put all of these components together, you'll form a visual sentence, called a *sequence*. A series of sequences will tell your story as you intended it. But none of this can happen if you do not know what you are trying to say.

The most memorable stories are deeper than just a series of events that happen in succession. They spark a change in the viewer. As storytellers, we use the vehicle of

a series of events that navigate our subject through a process to elicit an emotion from the viewer. Whether it's awareness, outrage, inspiration, hope, or motivation for action, the overall effect of the story should move the viewer emotionally.

If you want to be successful at arranging all the elements so that you can receive this emotional result, you need to have a plan. An outline is a good place to start.

Outline Your Idea: The Arc

Your plan doesn't have to involve a great deal of notes. A rough outline will do just fine. A good simple story will tend to have an arc to it: a beginning, a middle, and an end. I find it helpful to see this arc as a series of acts. In each act, a series of scenes moves the story along to the next major act.

A basic story could follow this format:

Act 1—Beginning	Act 2—Middle	Act 3—End
• Scene 1	• Scene 1	• Scene 1
• Scene 2	• Scene 2	• Scene 2
• Scene 3	• Scene 3	• Scene 3

Plenty of stories may need more acts or more scenes, and the acts themselves do not literally have to be the beginning, middle, and end either. Organizing in this manner, however, enables you to take a 35,000-foot view of your story and focus on the most important components.

FIGURE 2.1 Freytag's Pyramid

Jasmine's Arc: An Outlining Example

Let's walk through an example of how to use an arc outline with a story that I'm currently working on about Jasmine and On The One, a DJ center in Syracuse, New York.

Jasmine is a musician who was born in Coney Island, NY, and presently lives in Syracuse, NY. A lover of hip-hop, she traveled down to New York City to learn how to become a DJ at the famed Scratch Academy. She became the official DJ for the Syracuse women's basketball team and juggled her love of DJ'ing with her other work. Jasmine thought that residents of central New York could learn a lot about technology and music through learning how to become a DJ, so she opened On The One at the Destiny Mall. On The One is a center dedicated to giving lessons on DJ'ing, sharing historical perspectives, and providing a place for youth to experience something new.

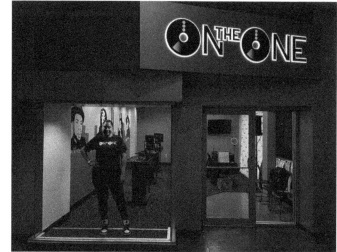

FIGURE 2.2 Jasmine at the entrance to On The One

Writing a story about a new store in a mall would be very superficial—no matter how interesting turntablism may be. Writing about a person on the path from lover of music to DJ teacher would be a literal description of events from start to finish. But, I thought, what would that story lead viewers to discover about themselves? How would they change after hearing that story?

Looking back at what I knew, several elements popped out:

- Jasmine loves music.
- Jasmine is driven—enough to travel to New York City to learn how to be a DJ.

- She juggles multiple things to make DJ'ing a part of her life.

- She is teaching her daughter to DJ.

- She thinks technology, music, and history can work together in an interesting way.

- She thinks the youth of her community would benefit from experiencing something new.

- She took a chance on making something.

In looking at these elements, I further distilled the idea into the emotions I wanted viewers to feel through the story:

- Dedication

- Grit

- Love of music

- Pride of offering music as a legacy

- Gut-wrenching fear that goes along with taking risks

These elements were the North Star I used as a guide while developing the story. In any story, the events are just a vehicle to evoke and convey emotions, so knowing what you want the viewer to feel from the start will inform the acts you create, the scenes you shoot, and the visual compositions you use.

Having the emotional elements in mind also helped me—and will help you—to organize a narrative. For Jasmine's story, it enabled me to focus interview questions on the important things I needed to include and let me make sure my SOTs matched my story line.

> **TIP** SOT (Sound On Tape) is a term used in broadcast news for an interview with a person that has been recorded to add to the video.

An early outline of Jasmine's story looked like this:

Act 1 : Love of music and determination to be a DJ
- Scene 1
- Scene 2
- Scene 3

Act 2: Determination to start On The One
- Scene 1
- Scene 2
- Scene 3

Act 3: Passing love, determination, and grit on to a new generation
- Scene 1
- Scene 2
- Scene 3

One of the benefits of outlining your idea in this manner is that you will begin to see your story overlaid on a story structure. As that story structure takes form, you may take key events from one part of the story and move them to another part for greater emotional impact. When I am outlining a story for myself, I often wonder what kinds of emotions I want to elicit from each of the segments and whether the story is emotionally moving in the way I want it to. Having each of these sections defined will let you do that and will keep you focused.

Remember, too, that you do not have to have each of the elements in Freytag's Pyramid match a set of acts that might make up your story. Use it as a general guide or jumping-off point, not a strict and rigid rule. As you start creating more complex stories, you'll learn new ways to say what you want to say.

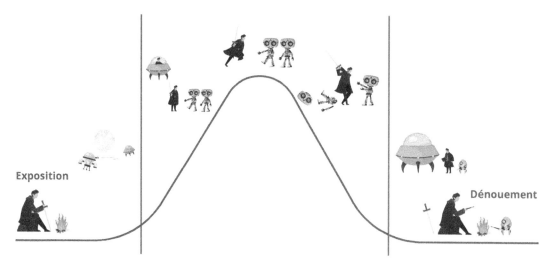

Exposition

Dénouement

FIGURE 2.3 You can think of the stages of Freytag's Pyramid as a three-act structure.

Build Your Idea: Shot Sizes

I'm sure that by now, you have an idea for a story and are itching to hit the Record button. It's not enough to start the camera and point it at a subject without considering *what you are trying to say* when you do so. Learning how to speak this language requires that you learn the common techniques that are used in telling a story.

Let's spend some time going over the different shot types you can use in a video story, as well as *why* you would use one over another and what each type of shot may convey in your story.

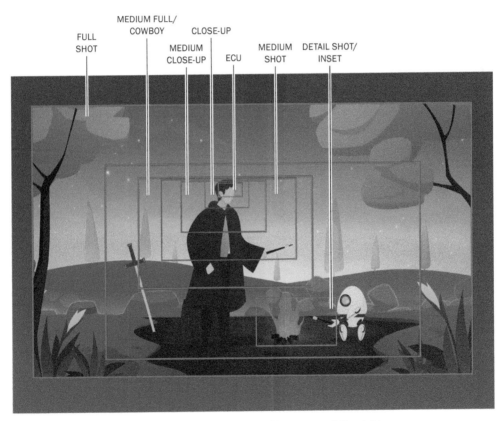

FIGURE 2.4 Each standard video "shot" captures a different part of the visible scene.

Establishing Shot: This is usually the widest shot that you will use in your story. The frame allows you to "establish" where the viewer is and introduce the environment of the story. You can also use it to set the tone of the story. In an establishing shot, any audio will usually be off-camera, such as narrator dialogue, music, or natural sound elements.

Master Shot: Push the camera a little closer for the master shot. Used to identify characters and the scene, this shot lays down the foundation of the elements of a sequence.

Full Shot: This camera angle shows the subject from head to toe. Most often, you'll use a full shot when you want to show the physicality of the character, as well as show any whole body movement for a character.

Cowboy Shot (Medium Full Shot): This shot evolved from a need to show western characters in a heroic pose. This camera angle usually covers the top of the head down to the middle part of the thigh, where you would see the entire gun holster. This type of shot is usually shown with a low camera angle, one under the eyeline to connote a more heroic pose (more on that in a bit).

Medium Shot: You'll find yourself using this shot the most. A medium shot starts at the top of the head and covers the area just above the belt line. This shot tends to mimic what you would see if you were standing a couple of feet from another person while talking. Because of this, it is a good shot to use for general dialogue. It also allows you to use wider and tighter shots to show more emphasis on a scene, leaving this one right in the middle.

Medium Close-up Shot (MCU): This shot moves the camera so that it captures from the top of the head to the middle of the chest. Because the camera pushes in a little closer, the shot enables you to see more of the expressions on a face while still including a little bit of the body and background to add to the emotion of the shot.

Close-up Shot (CU): This shot focuses on the eyes of a person and ends just under the chin. This shot is mainly used to convey the emotions of a character. Think of it as an exclamation point and use it when you want to put some emotional emphasis on something at key moments in your story.

Extreme Close-up Shot (ECU): This shot usually focuses on a body part that provides a piece of information critical to the story. It is extremely powerful when focused on the eyes.

Over the Shoulder Shot (OTS): This shot is not so much a tighter or wider shot, but more a shot that is shown over the shoulder of another person.

Detail Shot: This is an extreme close-up shot of something that is not the body part of a person in the story. Also known as an *inset shot* or a *cutaway*, a detail shot breaks the tension of a series of shots of individuals and enables you to highlight the importance of an element in a story.

Frame Your Idea: Look Right Here!

Now that I have your attention, let me tell you: just as this section head made you focus on what I was going to say, each shot type you use does the exact same thing. When you choose a specific shot type, you are asking the viewer to pay attention to one of the Three Pillars that underlie your story (see Chapter 1, "The Elements of Story"): what you see, what you hear, or what you say. If you switch to a shot without a specific reason to use it, the viewer will be left subconsciously wondering if there was something important in that scene that they missed. If you do this repeatedly, you will teach your viewer that there is no real reason for your choice of shots, and you will have squandered some of your precious *attention capital*.

One of the most common situations where I see this is in a scene that involves opening a door. Imagine a medium shot of a person walking to a door and opening it. Beginning storytellers often pair this shot with a close-up of a hand holding onto the door handle, commonly known as a *match action shot*.

The problem with this is that we are all familiar with what happens when a person goes to a door to open it. We know that a hand will turn the doorknob and the door will open. Pushing into a close-up of the door handle then seems superfluous and unmotivated. You could easily film another part of the scene without showing the door handle, and the viewer would automatically assume that the door had been opened and closed. If you add the superfluous angle, it highlights that you are not aware of the emotional value of the shot.

Imagine another scene: You have a medium shot of a person who is slowly getting nervous in a room, then goes to the door. When the person reaches for the door handle, you cut to a close-up of the hand nearing the handle. This time, however, the hand is shaking and tentative. Yes, you're still showing a hand at the door, but what you are communicating here is *emotional*, not literal. The shaking of the reaching hand adds tension to the story and a reason for the shot: The viewer now wonders why the person is nervous or what they will see on the other side of the door.

Make sure that you keep the Three Pillars in mind when you are choosing the type of shot you want to use. If you are trying to paint "look right here" on your scene with a particular type of shot, make sure that there is a purpose for doing so.

Composition and Framing

Once you decide on a specific shot to use, you can add emphasis and heighten emotion by the placement of your camera relative to the subjects.

The arrangement of elements in a frame, the *composition*, determines how the human eye travels through the scene. If you stare at a compelling picture, you'll notice that there is a path that your eye follows through the shot. The more engaging that visual journey is for your eye, the more you want to explore. This principle also holds true for video.

The following methods of shot composition are among the most powerful tools in a photographer's toolbox. Having a basic understanding of these guidelines will increase the quality and effectiveness of your story.

RULE OF THIRDS

To picture the Rule of Thirds, draw pairs of vertical and horizontal lines (like a tic-tac-toe grid) on a frame of your video. This common composition principle states that objects placed at the intersecting points of those lines will be more visually interesting.

FIGURE 2.5 Imagine a 3 x 3 grid superimposed on your view of a scene.

LEADING LINES

A well-composed frame will often include elements that create natural paths or lines that lead the viewer's eye through the scene. Compose your frame in such a way that its elements suggest lines that draw the viewer's attention to what you want them to see. If you notice natural leading lines in your frame, take advantage of the opportunity.

FIGURE 2.6 Use the geometry inherent in your scene to lead the viewer's eye.

HEADROOM

When framing your video, make sure to have a little bit of space above the speaker's head. All too often, though, people leave too much space over the head. How do you gauge how much is too much? If the top of the frame looks like you can run a magazine masthead (the big title on the cover) over the speaker's head, you probably should zoom in a little tighter.

FIGURE 2.7 This newsreader was first shot with too much headroom, but after reframing the shot her headroom was just right.

NOSE ROOM

Similar to headroom, nose room is the amount of space in front of the subject's nose. A frame is more visually interesting when the subject is facing into the picture (the majority of space is in front of the nose) than when the subject is facing out of it (the nose is close to a frame edge). Think of your subject's nose as an arrow, pulling the viewer in the direction it points. If the nose is pointing to the nearest frame edge, it's leading the viewer out of the picture: Turn the subject around to pull the viewer in.

FIGURE 2.8 The man's nose is pointing *out* of the frame, but the woman's nose is pointing *into* it.

NEGATIVE SPACE

Like the empty white space surrounding the text on this page, negative space surrounds the protagonist in a shot. There's something very powerful about a scene in which your subject is the smallest thing in a frame and the rest of the frame contains as little as possible. Using negative space is a powerful technique for showing vastness or expressing loneliness. It is a technique best used sparingly, however, as it could, at best, seem like a cliché, and at worst, seem poorly composed.

FIGURE 2.9 The protagonist and a companion are surrounded by negative space.

FRAME DEPTH

For many, one slice of cheese between two pieces of bread would barely constitute a decent sandwich. Add ham, bacon, lettuce, tomatoes, mayonnaise, relish, and peppers, and the sandwich would certainly be more interesting (if not heartburn-inducing). Your visual frame works the same way. The more "layers" you include in a frame, the more interesting it will be.

Placing a subject in front of a simple wall yields one result—a relatively flat one. To give the same frame more depth, move the subject away from the wall and add some visual elements between the subject and the wall. Now you have a frame with a sense of a foreground, a middle ground, and a background, making it feel more textured and visually interesting. You can accent these varied levels of depth even further with lighting, too (more on this in Chapter 5, "Working with Video").

FIGURE 2.10 The layered elements between the subject and the wall behind contribute to an interesting composition.

BEWARE OF INTERSECTIONS

When framing a subject, be aware of unintended optical illusions. Ensure you place the subject in an area where no objects intersect or protrude from their head. Anything that appears to come out of a person's head will immediately break the attention of the viewer and look unprofessional.

FIGURE 2.11 No, this subject does not actually have a tree growing out of his head.

EYELINE POWER

When you shoot video, be conscious of where the camera is placed in relation to the subject's eyeline. Changing the eyeline of a shot can change the power dynamic of the scene. When the camera is at the same eyeline as the subject (usually the best choice), the viewer feels they're on the same level as in a face-to-face conversation. When the camera shoots from an angle high above the eyeline, however, the subject appears to be looking up to you like a child to an adult, putting the person looking down in a superior position. Change the camera angle so that it views the eyeline from below, and now the viewer feels they're looking up at the subject from an inferior position.

FIGURE 2.12 The camera looks up at this subject from below the eyeline, putting her in a position of power.

🎬 **Panning the Camera**
Use the QR code to see an example of a pan shot. If you're reading a print book, scan the code with your mobile device. If you're reading an ebook, tap or click the QR code.

Shot Movements

Many of the stories that you tell will rely on a "locked" tripod with the camera set to a fixed position. Occasionally, you can distinguish your story by adding motion to your shots. This raises the production values of your piece. Let's take a look at some of the common camera motions.

PAN/WHIP PAN

For a pan, the camera is in a fixed position and slowly pivots left or right. This is similar to your motion when you use your mobile phone to make a panoramic image. One of the most common movements, pans can be used for following a subject, as well as revealing characters, additional scenery, or key details about your story. Used slowly, a pan can generate anticipation. A quick pan, called a *whip pan*, can create tension or unease.

FIGURE 2.13 The camera rotates horizontally to pan.

TILT

In a tilt movement, the camera rotates up and down from a fixed position. You can use this motion to introduce or follow a character, but oftentimes it is used to emphasize the scale of an object.

FIGURE 2.14 In a tilt shot, the camera rotates vertically up or down.

PUSH OR PULL

A push shot moves the camera closer to your subject, while a pull shot moves it away from the subject. As the camera pushes closer, the viewer feels drawn in emotionally. By pulling the camera away, you can reveal elements in the surroundings or emotionally disconnect the viewer from the scene.

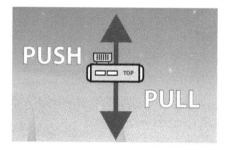

FIGURE 2.15 Push and pull shots change the distance of the camera from the subject.

TRACK/FOLLOW

In a track shot, the camera follows a subject around in any direction. You can capture track shots from in front of the subject or behind. This shot is a good shot to help your viewer feel like they are following along in a story.

TRUCK/CRAB

A truck shot follows a subject but reveals elements as it moves side to side in a frame. This will sometimes be called a *crab shot* because the camera moves sideways—like a crab.

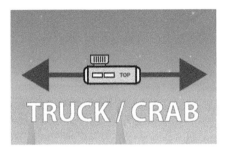

FIGURE 2.16 In a truck shot, the camera moves sideways.

FOCUS PULL

In the focus pull technique, a subject or object starts as the focal point, then another subject or object that is at a different distance from the camera is pulled into focus, leaving the first subject or object blurry.

FIGURE 2.17 This scene begins with the foreground character in focus, then the background character (the subject) is pulled into focus.

POV

A POV shot is used to show a scene from the character's point of view. With a point-of-view shot, the camera should match the eyeline of the subject as much as possible. If your subject is a bloodhound on a scent trail, be sure to keep the camera at the eyeline of the dog rather than of a human as you navigate the scene.

▶ CAMERA STABILIZERS REVOLUTIONIZE PRODUCTION QUALITY

One of the biggest things to keep in mind when recording video is the need to eliminate camera shake. Wobble that's practically imperceptible while you're recording can result in unusable video when you try to edit it. Shooting with the camera mounted on a tripod is often the best way to eliminate wobble. More elaborate cinema productions rely on electric motors called *gimbals* to stabilize cameras as well as complete stabilization systems, such as the Steadicam. The cost of such technology, however, has been out of reach for most smaller productions—until recently.

FIGURE 2.18 The DJI Osmo

Starting about ten years ago, this technology took three big leaps in the direction of consumer-friendliness:

- Companies like DJI started developing gimbal technology that fit in prosumer aerial drones. This advancement meant that shoots that required expensive and elaborate mechanical systems or helicopters could be performed by more people.

- Around 2016, DJI adapted the gimbal technology used in their aerial products to create hand-held products to stabilize mobile devices, like smartphones, for smooth video capture. Other companies quickly followed suit, creating their own mobile-friendly stabilization products.

- The most recent advances now use stabilization in the phone itself, reducing the amount of shake at the point of creation. GoPro, Insta369, and similar companies are also introducing AI systems to reduce shake as well.

These advances have opened the doors for creators to experiment with more elaborate camera techniques without breaking the bank. While it is still important to make sure to record as many shots as possible with a tripod, you can now add more production value into your stories by experimenting with this new technology.

Put Your Idea Together: The Sequence

Now that you have thought about what you want to say and have learned a little bit of the visual language you need to use, you're ready to start forming the simple sentences of your ideas.

A small video segment that expresses an idea through an arrangement of shot types, composition, and motion is known as a *sequence*. I like to think of a sequence as a simple sentence that explains an idea. When you put them together in the right order, a collection of sequences builds your complete story—just like combining sentences to produce a book.

> **NOTE** *Of course, your video project will most likely include material other than video shots, including audio recordings, text, and motion graphics, to name a few. All of these bit of media are called clips, and you will be hearing a lot about clips throughout this book.*

Just as you broke down your story into acts, and your acts into multiple scenes, a best practice is to map out your scenes into individual sequences.

This ensures that the overall story has a good visual variety. This variety, coupled with the choices that you make in the audio, will pull together your package in a compelling way.

Ordering Your Shot Types

Let's take a look at how you might compose a sequence. Suppose you are making a video about someone named John who works at his computer while consuming endless amounts of coffee until one day he receives a message. This is what you want to say, but *how* do you want to say it?

Suppose you use an establishing shot of John entering the office getting ready to sit down.

As he sits down, you cut to a medium shot of him showing the computer and a cup of coffee.

As he reaches for the cup of coffee, you cut to a close-up of the coffee to show his hand grabbing a coffee cup handle, then panning to the left to reveal the keyboard and a note that has been left behind.

Dum, dum, *duuuuum*—you just started the inciting incident!

The selected shot types in the sequence show the viewer what you want them to pay attention to and serve as your nouns. The composition of those shots directs interest to specific things—your adjectives. The shot movements that you add to the video are your verbs, carrying the video to the next idea in your story.

The Benefits of Sequencing

By outlining your story in easily digestible sequences, you also give yourself the time to think about the overall story arc and to make sure that you include all of the necessary components to tell your story most effectively.

When you are filming on location, for example, you will have a solid plan that you can follow as you shoot and a verifiable blueprint that you can refer to in order to confirm that you got all of the components you need to tell the story. Obviously, you could make changes in the field to expand or contract the series of sequences, but by having a rudimentary plan before you start shooting, you do not have to think of all of the components at once.

A plan will also help you avoid a common problem for journalists: the placement of two very similar shots next to one another. Two adjacent shots that are very similar in nature create a *jump cut*, which is not desirable in storytelling. When shooting on the fly, you may find yourself stringing together similar clips one after another. The lack of transitional material can create jarring effects for the viewer. Having a plan to shoot different shot types in a sequence can help eliminate this.

Another benefit of planning your shoot is that you can plan for the human element in your story. In a fast-paced scenario, it's easy to fall victim to quickly capturing a series of shots that illustrate what happened. It's better journalism to step back a moment and think about the *why* in the story. Having a space to come up with this idea will allow you to approach subjects with clearer questions and an honest intention to tell the best story possible.

At the end of the day, we all are trying our best to tell stories that move the viewer. Having a plan frees us from logistical concerns, so we can focus on conveying emotion.

CHAPTER 3

Previsualizing Your Idea

Once you create a general outline for your story, it's time to start rendering the story into better focus. A good way to do this is by constructing a *shot list*, a list of every type of video shot that you think you will need to tell your story. The shot list allows you to look at each point of the story and think about that moment in specific detail. For each moment, you can decide what kind of shot you want to use, what the overall angle should be, and if there is going to be any kind of movement. In short, the shot list enables you to previsualize what you would like to happen in the story and make purposeful choices that reinforce the emotional goal you are going for.

Working with Intention

In my classroom, I often tell students to print out examples of the different types of shots (like those in Figure 2.4 of the previous chapter), and cut them into small cards. When they work on their shot lists, I have them place all of these cards in front of them. As they contemplate the individual events in the story, I ask them to think, "What would be a move I could pull here that would totally impress Professor Concepcion?"

I'll be honest: This is not entirely meant for me; it's to motivate them to work with intention. If you've ever seen a movie and thought "oh, wow... that was pretty cool," you can be certain that the filmmaker sat down during their previsualization and said to themselves: "How can I get my viewer—at this specific moment—to say 'this is pretty cool.'" That is working with *intention*.

When we set out to create a story, we set out to evoke a feeling from a person for a specific person. From a commercial to a political ad to a news story, our job is to make someone feel something and inspire them to do something with that feeling. We use our available tools—our pillars of what we hear, what we see, and what we say—but each of those tools is used with an extremely specific intention in mind.

As you get better in this craft, this process becomes so automatic it's invisible. Your reward will be a smile when you see someone react at the precise moment you wanted in the story. You'll tell yourself "I *meant* to do that"—and that will be the best feeling.

The Shot List: Plan to Build. Build to Plan.

Many storytellers forgo the previsualization process because it can seem time consuming and confusing. I mean, who wants to be working on a list when you could be out pushing the red button! Reality is that these same impatient storytellers often find

themselves in binds later on when they realize they didn't get the specific thing that they needed, the shots look visually uninteresting, or the talent appeared frustrated throughout the process because of how long it took. A shot list will solve all of these problems by helping you to focus your idea and to set it up as efficiently as possible.

Use Google Sheets or Microsoft Excel

You can find tons of shot list examples out in the interwebs, all varying in their levels of color coding, complexity, and detail. While these are all well-intentioned, I think that level of complexity can turn away a lot of filmmakers that are just starting out. Instead, I recommend that you start as simply as possible in an app like Microsoft Excel or Google Sheets, and then expand from there. Download either program onto your phone, and you're on your way.

Are you ready to create your first shot list? Fire up your app! I'll use Google Sheets for the example list, but the Excel steps are similar. First, bypass the templates. Yes, they can be a great way to set up a document quickly, but we are looking for a bare

FIGURE 3.1 A file list in Google Sheets on a smartphone

FIGURE 3.2 Tapping the plus button displays two commands.

FIGURE 3.3 Give your new sheet a name.

minimum of stuff. Instead, tap the plus button in the lower-right corner and tap New Spreadsheet to create a basic sheet. Give it a more descriptive name than the default; I called mine On the One - Shot List.

Work Horizontal

While it may seem unnatural compared to how you normally hold your phone, working with it horizontally will make writing a little easier in your spreadsheet. To give yourself more room to describe your shots, you can also drag the line between the A and B columns to the right to stretch the width of column A a little bit.

At the bottom of the screen, notice the field with the pencil? This is the area you will use to enter information into the cells. To start, I would keep your file to three columns: Shot Description, Shot Type, and Shot Movement. Tap the pencil icon, and type the first column heading in cell A1. Tap the B1 cell, type its heading, and do the same for C1. Now you're ready to start filling in all of your ideas in the second row and continue down the list.

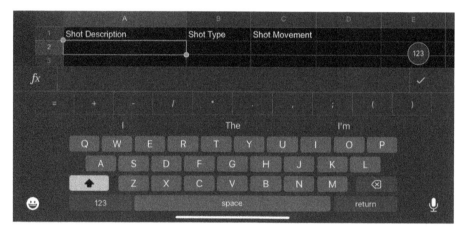

FIGURE 3.4 Use Sheets with your phone in a horizontal orientation.

Freeze Rows

When you have long or complex lists, it helps to always be able to see the column headings. You can easily "freeze" this first row in place at the top of your screen. Tap the number 1 on the left side of the sheet to select the entire first row of column

headings. With the row selected, tap the number 1 again and tap the Freeze Row command in the menu that appears. Now you can swipe down through as many entries as you have and never lose the heading row from view.

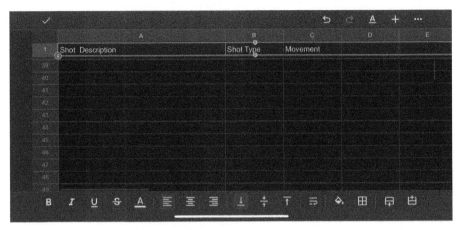

FIGURE 3.5 Freeze the row with the column headings in place.

Use Dictation

Keep in mind here that you do not have to use the keyboard to type all of your ideas. Both iOS and Android phones have really good dictation built into them and this can help speed up the process of working up your shot list. On iOS, you can enable dictation in the Settings app under General > Keyboards > Dictation.

Work in Different Languages

I am a native Spanish speaker (my Mom came from Mexico, and my Dad from Puerto Rico). However, many native speakers like me are not very confident with writing Spanish or the spelling of more complex Spanish words. We simply "spoke" Spanish and knew what sounded right. While great when communicating informally, this can give an impression you'd rather not give in a professional environment.

On iOS devices you can enable dictation for multiple languages. I have mine set to take dictation in both English and Spanish. When I need to communicate my ideas in Spanish, I switch to that keyboard and start dictating. The software is amazingly good at recognizing what I am trying to say and adding all of the accents and spelling as I need it—and it is fast!

FIGURE 3.6 Keyboard settings in iOS

FIGURE 3.7 Selecting languages for dictation

Move to the Computer to Finish

Another common barrier to making a list that I see among creatives is the whole "Ugh, I have to sit down and work on it on my computer." Truth is, having your list on the phone means you can work on it wherever you want. Instead of brewing coffee while waiting for your desktop app to load, you can load your shot list with ideas while waiting at your favorite coffee shop. In fact, I find myself often walking around outside with my phone, using dictation to generally fill out the shot types as I think things through.

Because all of your information is stored in the cloud (remember, you're using Google Sheets), you can also bring your coffee to your computer later and add any additional details you may need.

FIGURE 3.8 Your shot list begins to take shape.

From Outline to Shot to Scene

After working out all of the ideas that you want to use for your story, you can flesh out your shot list with additional information. This will make capturing the content on the day of the shoot a lot easier, as well as assembling the pieces later in the edit.

Organizing into Scenes and Shots

A *scene* in your story is a collection of shots at a particular time, in a particular place. Think back to the story of John at the keyboard with his coffee. The time is that moment when he is in front of his machine. The place is inside of his office. The cameras are not really moving here into another moment of time or place; they are just covering different angles of John that add to the emotional value of what you (as the creator) are trying to say. In this case, a scene is similar to a sequence.

FIGURE 3.9 Organizing the shot list into scenes makes the list more useful.

Each of your scenes should have a distinct number, and each shot that makes up the scene should have a number as well. Because of this, it would be beneficial for you to create two additional columns in your shot list: one to keep track of the scene that you are working on and the other to identify the individual shots in that scene.

You can identify scenes by numbers, and create shots with a combination of numbers and letters. For example, the fifth shot of Scene 1 would be 1E. If the number of shots in a specific scene exceeds the letters of the alphabet, start with AA and move on.

TIP The letters I, O, and Z are generally omitted for shot identification, because when they are handwritten they can be confused with numbers.

Shooting Out of Sequence

Most videos are not shot in the same linear fashion that you see them. Doing so would mean that you would have to move the camera, lighting, and talent for every shot, making the process take a lot longer than it needs to. It is more advantageous to group all of the shots of a specific type together so that you make the best use of the time when you have a camera set up in a particular way in a specific location. Once those shots are complete, you can make changes to the camera-lens-lighting setup and record the next set of shots. The result, however, is a series of clips that are completely out of order from the story. How will you know how to put all of it back together?

This is where the shot list is worth its weight in gold. Because each shot has an individual file name, you immediately have a roadmap for what shots go where and can put the story together in a snap.

Scene 1, Take 5

As much as we would like to think that production is going to go flawlessly, mistakes happen. Your talent doesn't look in the direction you want. The camera's batteries run out. Someone walks into the scene as you are recording. Every scene and shot will have a series of takes—attempts at delivering what you want correctly.

When you hear on TV shows "Scene 1, Take 5," what they are saying is that it is the fifth time that this specific shot has been done, with four other times not being up to scratch. Can you have a take 37? You can. That's usually a start to a very long day of shooting. But if you add a column to your shot list to track the good takes, you can more easily make sense of it all later.

Expanding Your Lists for the Printout

To account for the unexpected, add a column for Notes to your shot list. You can use this area to keep track of any thoughts that may come to mind before, during, or after the shoot.

Next, fill in your scene and shot numbers, but leave the Take and Notes fields empty (unless, of course, a thought has come to mind). Your list is ready—almost.

FIGURE 3.10 Expanding the spreadsheet for your story

On the day of the production, I recommend that you print your shot list and put it on a clipboard. I'll give you four reasons why this will be incredibly helpful:

- During the shoot, you can take a look at the list of the shots that you are working on for a quick read of what you've covered and what is left to do. Be sure to check off each of the shots as they are completed, guaranteeing that you don't miss something essential.

- You can fill in the Take field during the shoot. When you start recording and something goes wrong, you can pause the recording and start again—the next take. Once you get the take you want to keep, record its number in the Take field.

- You can access your shot list while your phone is doing the recording. How are you going to call up Excel while the line is busy, so to speak?

- You can access your list if your phone battery runs out. You know this will happen eventually, and you don't want it to stop the production.

The biggest reason I like to use a clipboard, however, is a certain level of professionalism. Phones are so pervasive these days that a person or client could perceive you as being distracted from the project because you're engaged with who knows what on your phone. Clipboards, however, still convey a feeling of "we are working here" and can make people stand a little straighter during the shoot day.

Working with Storyboards

As you start working through your idea in shot list form, you may want to dive into a little more specificity.

I know I want John to come in and sit down in front of his camera, and I know that I want it to be a medium shot... but I want to see him like **this***!"*

I believe many of us have a pretty good idea of what we want our stories to *look* like. We just need to figure out a better way to articulate this to others so that we can get on the same page. This is where a storyboard comes in really handy.

What to Include in a Storyboard

A *storyboard* is a graphic layout of the shots in your story. Its overall goal is to give you (and others) an idea of character, scene, location, and movement—that's it!

A storyboard is *not* meant to show off how awesome you are at drawing things. In fact, I think a lot of people hesitate to use storyboards because of a general fear of being asked to draw—and many of us (me included) think we're terrible at drawing. Stop worrying: The pictures you add to storyboards can be extremely rudimentary as long as you follow these guidelines:

- Use perspective and scale to show the position of the camera.

- Draw characters in the direction you want them to face.

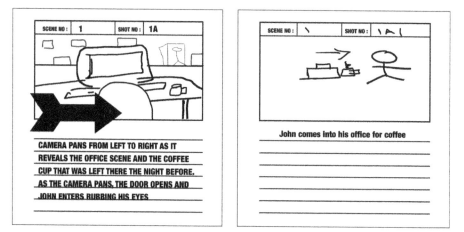

FIGURE 3.11 Even primitive drawings can make a storyboard come to life.

- Draw an arrow in the direction you want a character to move.

- Make a rough shape and label it to stand in for something you can't draw.

- Indicate specific camera motions you need with arrows.

The more information you can give to someone in terms of location, angle, character, and mood, the better it is. If you are an artist and can really add details here, that's awesome! Just know that you are adding the details in the storyboard to render the idea into better focus. If what you draw cannot be reproduced due to time, manpower, or budget, you may not want to be as detailed.

Video Storyboarding à la Robert Rodriguez

An amazing creative talent, Robert Rodriguez has shot, directed, scored, written, and produced *El Mariachi*, *One Upon a Time in Mexico*, *Desperado*, and many, many other films. Having his hand in every part of the creative process of his movies has led to his distinctive type of moviemaking to being known as "Mariachi style." Robert has also developed a previsualizing process for streamlining the production of a scene. As he discusses in his video "Anatomy of a Shootout" (YouTube: https://rcweb.co/anatomy-shootout), Robert used a small camcorder and stand-in actors to record what a scene would look like while making *El Mariachi*. He then used the video to previsualize the angles and frames in the scene so that when it came time to shoot the scene on cinema cameras, he would already know what would work and what would not.

FIGURE 3.12 The artist himself

Using your smartphone, you can adapt the same technique to help keep your own productions on time and budget. If you have access to the location where you want to shoot, bring a couple of stand-ins along to previsualize your planned scene. You can record from all the angles you think you like—and even take still images from the video right on the fly. To take a still photo while recording your video, tap the small white button (iPhone) or the shutter icon (Android phone) in the lower part of the screen. The still photo will have the same aspect ratio as your video.

📽 Anatomy of a Shootout
Use the QR code to view Robert Rodriguez's video about previsualizing on the cheap. If you're reading a print book, scan the code with your mobile device. If you're reading an ebook, tap or click the QR code.

When you are back at your computer, you can import those pictures into a storyboard document, and you'll have a template for where you need to place your camera and talent. When it's time to go shoot the video, you won't be guessing at what you *think* will be successful— you'll know. You will be building to your preset plan.

FIGURE 3.13 You can make a video story-board using a mobile phone.

Anatomy of a Storyboard

A Google search will yield a ton of options for storyboard templates. Make sure whichever one you use has four key components:

- A set of cells to hold your drawing (or photo) ideas

- An area to mark the scene number

- An area to mark a shot number

- An area to write out more information about the cell

FIGURE 3.14 A storyboard template

When the entire storyboard is put together, you'll have a clear progression of your idea that looks like a comic book (graphic novel) version of each scene in your story.

The drawings may not be perfect, but your overall plan will be clear.

Working with Scripts

When you need to provide even more detailed instructions for the video that you are creating, you can control what is said and heard using a *script*. While the subject of scriptwriting could fill a separate book, the following sections highlight a couple of things you can immediately put to practical use when starting out on your video journey.

Hollywood Script vs. A/V Script

Your first choice is which kind of script to use for your project. When you are producing something that is similar to a television show or a movie, you should choose a *Hollywood script*. This type of script has preset formatting rules, and the text is usually set on the page in a single column from top to bottom.

Commercials, promotions, news stories, and other types of videos often follow the *A/V script* format. This script uses a two-column, table-like format. One column holds all of the elements that the viewer hears (the A or audio) and the other column holds the description of what the viewer sees (the V or video). Each row in the table is designated for an individual shot.

FIGURE 3.15 An example of a Hollywood script

FIGURE 3.16 An example of an A/V script

Common Script Elements

While Hollywood scripts and A/V scripts are used for different purposes, they do share a bit of formatting in common. Let's look at these common elements more closely.

Master slug line: Appearing at the start of a scene, the slug line specifies whether the scene is interior or exterior (INT or EXT), the location of the shoot, and time of day.

Action line: The action line section describes the action of the scene and introduces the characters that the viewer will see. Usually introduced in all caps, characters can have a name (JOHN) or a general description (OFFICE MANAGER 1). The action is written in the present tense. Sometimes, the word *we* is used to reference the viewer.

Dialogue: Dialogue is written out whether you see the characters speaking it or it's spoken by an unseen narrator. If it is spoken off-camera or has a note describing special circumstances, it appears in parentheses.

Parenthetical: Instructions are written in parentheses and are usually verbal cues or direction given to the actor in the scene.

Shot: If a shot changes in the scene, you can use this heading to let the camera operator know that you require the camera to take a different angle or position within that scene. This would appear as a "CLOSE-UP ON ADAM" or "LOW POV OF FEET MOVING."

1. MASTER SLUG LINE
2. ACTION LINE
3. PARENTHETICAL
4. SHOT LINE
5. DIALOGUE LINE
6. MUSIC SLUG
7. SOUND EFFECT SLUGS

▶ **SCRIPTWRITING APPS**

While you can certainly use a standard word processor to format a document to follow
screenwriting guidelines, dedicated scriptwriting software can make the process easier.
Here are a few examples:

- Final Draft is considered the de facto standard in the market, but it's pricey
 (www.finaldraft.com).

- Trelby is one of my favorites among the many free options (www.trelby.org).

- Celtx is my preferred paid program to use for creating scripts and features three
 different plan options to choose from. Their Writer Pro plan adds other helpful tools,
 enabling you to work through storyboards, shot lists, and different types of scripts
 in one suite, which I really like (www.celtx.com).

- Highland 2 by screenwriter John August is also well regarded; it's available in both
 free and paid versions but only for macOS (www.highland2.app).

- YouMeScript works with Google Docs and is available in free and paid versions
 (youmescript.com).

The next scene will start with a slug line that displays the location and time and so
the process moves on.

MUSIC AND SOUND EFFECT SLUGS

In the A/V script, you may see additional MUSIC and SFX slugs to describe any audio
besides dialogue in a scene. Both types of slugs appear left-aligned in the AUDIO
column, but the SFX slugs are in lower case and in parentheses, while the MUSIC
slugs are in title case without parens.

The Day of Production

When you have all of your story's elements outlined, organized, and previsualized,
you are (finally) ready to get to recording. Before you work through your first produc-
tion, however, I'd like to share a couple of things for you to keep in mind.

Think Like a Duck

Even with all of the planning in the world, you will inevitably run into random problems. Expect this, and a project's curveballs won't rattle you as much. Keep calm, and handle the situation as professionally as possible. What will rattle your team or client is someone who doesn't know how to adjust to and learn from a situation. As I often tell my students, you need to think like a duck: calm on the surface while paddling your tail off underwater.

Refer to a Paper Shot List

When you are working on production day, your brain will be on executing the details of the shot you're immersed in. That level of focus tends to give you tunnel vision— perfect conditions for you to forget the specifics of *another* shot you need.

As I mentioned earlier, placing a printed shot list on a clipboard will give you a constant reminder of what you need to shoot. As you finish the individual shots, cross them off the list so you can easily and quickly see what's left to do. Even better, hand the printed list to an assistant to look after so you can focus on shooting the video.

Use a Clapper/Slate

Lights. Camera. Action! The most recognizable object in cinema has got to be the *clapper board*, but many people don't know how absolutely helpful one can be. The main piece of the board is a *slate* on which you can write scene, shot, and camera information. You can wipe the slate off and update it every time you start recording. Above that is an additional piece of wood on a hinge: the *clapper*. When this is brought down on the slate, it makes a loud clap. If you are using multiple cameras to record audio and video or syncing with a separate audio recorder, you can use that clapping sound as a synchronization point for the video and audio from all the cameras. The top part of the clapper board may also have a set of colors that you can use to correct color and exposure of the video later in post-production.

For a small investment, using one of these boards can pay big dividends. You can find physical boards as cheap as $17 on Amazon, as well as clapper board apps on your mobile device's app store.

FIGURE 3.17 A clapper/slate board

John's Memorable Coffee Shot List Rafael Concepcion

SCENE	SHOT	TAKE	Shot Description	Shot Type	Movement	Notes
1	1A	7	John entering the office getting ready to sit down.	Master	Push	Brew coffee at start of day
1	1B		John starts to sit down- as he is sitting we see the coffee cup	MS	Static	
1	1C		John starts to reach for the coffee cup	MCU	Push	
1	1D		Johns hand grabs the cup of coffee - reveals keyboard	CU	Pan	
1	1E		John looks back as he notices someone else is here	ECU	Static	
2	2A		Dark hallways shows someone appear	Wide	Push	
2	2B		Footsteps of a person coming closer	ECU	Track	
2	2C		Eyes of the Jenna looking sad	ECU	Track	

FIGURE 3.18 Jot down notes in your shot list as you complete each shot.

Stay Organized with Your Clapper and Shot List

Everything looks so simple when organized in a shot list, with its columns for scenes, shots, and takes. As you go though the shots in the field, however, your actors will need to make multiple takes of many or all of them. It just happens. You may go into a shoot with a list of 20 shots but come back with 90 video files, including all of the mistakes. How do you know which shots belong with which? If you're using two cameras, how do you know which video files belong to which cameras? Your clapper board and shot list can help!

As you start the cameras recording, make sure you place the clapper board where both cameras can see it at the same time. This way, if there is a problem with one of the audio tracks, you can use the visual cue of the clapper board closing to synchronize that track with the rest. Seeing the video information on the slate will also help you synchronize the videos with one another

When you get a successful take in the field, immediately write that take's number on your shot list (you do have it handy on a clipboard, right?). When you get back home, you will be reminded that Scene 1, Shot 001A had a successful take on Take 7.

Log Your Footage

When you record a series of videos for your story, it is a common practice to review all of the footage that you recorded to choose which of the files to use for the final video. This process is called *logging* and can be very time consuming.

Instead of watching all of the videos from beginning to end to see which takes are the best, however, you can perform a quick review of the videos without actually opening them. To do so, open the folder containing your videos in Finder (macOS) or File Explorer (Windows). Make sure the window is displayed in Icon view, and increase

 WHY REVIEW COMPLETE CLIPS DURING LOGGING?

It's pretty easy to spot the one take out of a whole series of shots of a scene as "the best," and you can edit together a decent video using only "the best" takes.

But there are usually parts of other takes that are good, maybe better than anything in the overall "best" take. For example: That look on the actor's face in Take 3, the camera movement in Take 5, the delivery of lines in Take 7, the reaction in Take 4 may all be perfect little moments that you would lose if you chose to use only a single take.

It takes more time and more care, but if you use the best parts of multiple takes (especially if you had multiple cameras running) to build the complete sequence, you can produce a richer and more nuanced work.

the size of the thumbnails. Each thumbnail shows the first frame of the corresponding video—the frame that shows all of the information written on the front of the slate. Now, record the name of each video file into a File Name field in your shot list and move to the next shot in your list. Having your notes and the thumbnails handy will speed up the process of logging your footage enormously.

The Payoff of Previsualization

Getting your ideas in order before shooting can feel overwhelming, but it is an essential part of the creative process. Understand that not all videos will require the same level of detail. Some stories will need really elaborate scripts; some will have a list of shots on a back of a napkin. This process will expand and contract as your needs require, and you'll become more in tune with how much of it you'll need in your work as you get more projects under your belt.

The biggest takeaway here is that a lot of video production deals with the realization of a well-formed idea. The clearer you can formulate this idea at the onset, the better your results will be.

Working with Sound

This will probably come as a surprise to you, but many people believe that the most important part of video isn't video at all—it's *sound*. The viewer is a lot more forgiving of potential problems in the visuals than the audio. Present something with poor sound, and you will immediately lose a viewer's attention.

Conversely, if you spend more time to fully develop the sonic component of your video, you may find it leads to higher levels of engagement. Sound has a way of transporting a person into the story, from the individual foreground and the background sounds to the soundtracks that support the emotional boost needed at key moments.

For proof of the power of sound, try turning it off and watching Indiana Jones run away from the boulder in *Raiders of the Lost Ark*. Notice how much is lost? The same is true when you cannot hear the drum sounds while entering Wakanda in *The Black Panther* or the bits of metal coming together to form Iron Man. In each of these examples, sound completes the landscape and—as one of the pillars of video creation—is a field that you should completely explore.

Capturing the Sound

One of the biggest differences between microphones is how they capture sound. The sound that accompanies a video recorded on your phone is very different from the recorded sound that you hear in a TV show. The footsteps that you hear in a scary movie sound eerily full, impossible to reproduce with smartphone microphones. Knowing a bit about how microphones work and the difference between the various types will help you tailor your choice of microphone to each situation.

FIGURE 4.1 If you were responsible for picking the music for this scene, what kind of music would YOU pick?

A microphone's directional sensitivity to sound is known as its *polar pattern*. There are several polar patterns, and each pattern is used for a specific purpose.

Polar Patterns for Sound Gathering

A microphone's polar pattern and sensitivity to sound is usually described in terms of degrees. Imagine placing a microphone directly in front of you, with the front of the mic (usually, the part with the label) facing you. The area that is directly in front of the microphone is considered to be 0°. As you travel around the microphone in a clockwise circle, you increase the rotational angle between your position and the front of the microphone until you reach 360°—the point at which you started. With that model in mind, lets look more closely at some common polar patterns:

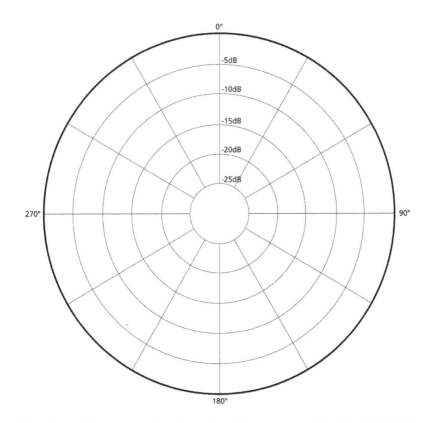

Omnidirectional: Microphones using this pattern gather sound equally from all directions. These kinds of microphones are great for capturing room sound and ambient natural sound. No matter where the sound source is positioned relative to the microphone, the sound will be picked up. These microphones are very sensitive to wind noise, however.

Cardioid: A microphone with a cardioid pattern picks up the most sound directly in front of it at 0°. The sensitivity begins to diminish as you move away from 0° to either side. Sounds that are at 180° (directly behind the microphone) will hardly be recorded. These microphones are good for picking up vocals that are directly in front.

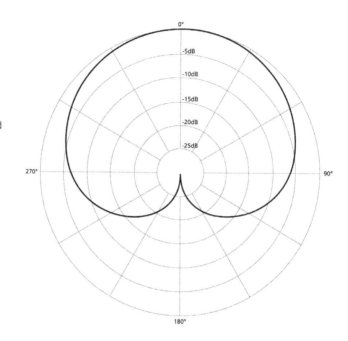

Supercardioid: The pickup field for a supercardioid pattern is tighter than for a cardioid one, emphasizing sounds coming from the very front of the micro-phone, while being less sensi-tive to the left and right sides of the microphone. There is some sensitivity to the sound coming from behind (at 180°), but it is lower than at 0°. These micro-phones are also great for vocals.

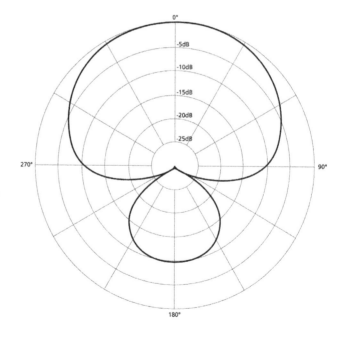

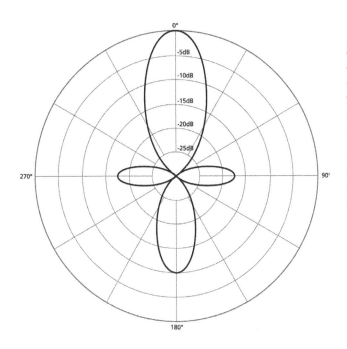

Directional: In this polar pattern, the mic picks up the sound that comes from directly in front, while rejecting a lot of the sound to the left and right. The sound directly behind the microphone is rejected quite a bit as well. Because of how narrow the pick-up pattern is, it is known as a *directional* (or *shotgun*) pattern, picking up only the sound that it is directly pointed at.

Microphones

Now that you are familiar with the patterns, you can better understand how different types of microphones are useful in different situations. As we discuss each type, I will also share with you the mics that I currently use, suggest a range of equipment for building your own collection, and offer some usage tips.

Lavalier Microphones

Lavalier microphones are small and meant to be pinned to the clothing of an interview subject. The lavalier is a sensitive, omnidirectional microphone that allows you to capture as much audio information as possible. When you use these microphones, remember that noises made by the movement of the subject's clothing also can be picked up. To minimize this, make sure that the microphone is clipped on properly or taped to the subject to minimize movement.

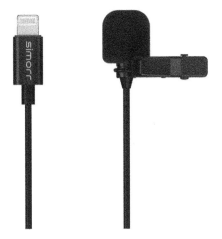

FIGURE 4.2 The SmallRig simorr Wave L3 Lavalier Microphone for Lightning Devices is compatible with iPhones and iPads (with Lightning ports).

 GAFFER TAPE

A *gaffer* is the lead electrician of a production. To secure wires on a set, they need a type of tape that does not leave residue behind when they remove it. *Gaffer tape* is made of fabric, is heat resistant, and doesn't leave anything behind when it is pulled off. Don't be tempted to use duct tape instead: it is reflective, leaves a residue or marks when removed, and is made of a type of resin that can strip off paint from surfaces when it's removed.

Placing a lavalier microphone 6 to 8 inches under the chin of the talent should give you good sound. Shirts with buttons make this easy; the gaps between the buttons are a great place to clip a microphone. If your subject is not wearing a buttoned shirt, finding a good place to attach the mic can be problematic. One solution is to attach the microphone to the collar. While this is acceptable, the sound you capture will be different.

If I have the opportunity, I place the mic under the subject's shirt in the sternum area with a small strip of gaffer tape. If you're worried that the subject might have an allergic reaction to gaffer tape, you could place a strip of medical tape on the person, position the microphone, then attach the gaffer tape to the medical tape. Provided that you are recording a person who is not sweating during the interview, this should hold well.

While it's not unusual for a lavalier to be visible in video created for news reporting and general video content, for some types of theater productions it's preferable that the microphone be hidden. You may often see a mic taped under the bill of a hat or attached to the hair. These microphones are often more expensive than regular lavalier mics because they need to be much smaller so that they can be concealed.

When placing a mic on a subject, keep in mind that you are going to be very close to an unfamiliar person, and that closeness may be stressful to them. I let the person know of my intentions before I begin by saying simply, "I am going to need to place this mic on you to capture sound. Is this okay?" Most people will be fine with this, but it will show that you are mindful of the person's personal space.

If the mic needs to run under a shirt, I usually tell the person, "I need to have this wire go underneath your clothing to hide it. Let me hand it to you, and I am going to turn around. When you are done, just let me know and I will turn back."

A final piece of advice: Be consistent in minimizing discomfort with every person that you are working with, regardless of gender.

Handheld Microphones

Handheld microphones are usually cardioid or omnidirectional microphones. These microphones usually have a *frequency response* that's tailored to capturing good vocals. This means that the microphones are designed to be especially sensitive to the sound frequencies used by the human voice. The microphone has a metal housing and may have a foam cover that minimizes the wind noise. They are intended to be used in close proximity to the speaker.

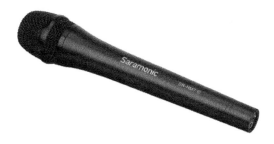

FIGURE 4.3 A Saramonic SR_HMY handheld microphone, a favorite of journalists and musicians

When working with one of these microphones, be mindful of how you place it, known as *cueing* (or *pointing*) the mic. When you ask a question, keep the mic in front of you, under your chin, and pointing back at you. While the person you're interviewing answers the question, point the mic toward them, keeping it under their chin. This will not only make them sound their best, but it will also respect the subject's space and make sure that viewers who are deaf or hard of hearing will be able to see the lip movement.

As a general rule, cue the mic back to yourself to ask your next question or otherwise add to the conversation. If you speak while cueing an omnidirectional mic at another person, your voice will be less audible than theirs. A cardioid mic might not pick up your voice at all.

Popular handheld microphones include:

- **Shure SM-58:** This mic has been around for a long time and is widely used because it captures vocal sounds well. You'll see it used not only by singers, but by creators of other kinds of content as well. Built like a tank.

- **Røde Reporter:** Aside from the sound of the mic, my favorite feature of the mic is its length. This lets me sit a little farther away when I am pointing the mic at someone. Some have complained about the fact that you can hear your hands fumbling on the mic, but I don't find that to be a problem.

- **Sennheiser MD46:** This mic's built for taking a beating. Its cardioid polar pattern also tunes out a lot of sound that the mic is not directly pointing at, which lets you get cleaner interview audio.

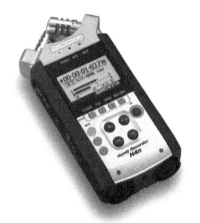

FIGURE 4.4 The Zoom H4n Handy recorder, a "handy" field recording device

Field Recorders

Extremely versatile for newsgathering, *field recorders* combine a recorder with microphones that typically allow you to replicate multiple polar patterns. They can be used in omnidirectional mode for capturing natural ambient sound and can be switched into a cardioid pattern to be placed closer to a speaker for interviews. Some types of field recorders also contain inputs to which you can attach other mics, including handheld, lavalier, or shotgun mics to use alongside the onboard microphones. One thing to keep in mind when using field recorders is that they save the sound onto a removable memory card. You will need to import that sound file into your project and add it to the video you've recorded.

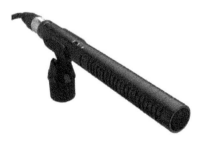

FIGURE 4.5 The Røde NTG4 Supercardioid Condenser Shotgun Microphone

Shotgun Microphones

Shotgun microphones are generally tube shaped and have a very directional pickup pattern. They are excellent at the direct capture of sound, such as vocals, while rejecting other ambient sounds in the environment. You can find many types of shotgun microphones—from short models that can fit on top of your phone to extremely long shotgun tubes that can be held above the subject for recording.

When choosing one, remember: The longer the tube, the more directional the sound pickup is going to be. Shotgun mics usually require power to work (a feature that is sometimes called *phantom power*), so make sure that whatever you are connecting them to has a source of power or that the mic has a place to insert a battery

A shotgun mic is a great choice for capturing spoken word, but I recommend you also use one for capturing specific environmental sounds for your story. Whirring machines, doorsteps, busy streets—these sounds are all things you can add to your story later to enhance the experience.

Wireless versus Wired

When using microphones, you have the option of working with either wireless or wired technologies to capture sound.

WIRELESS MICROPHONES

Wireless microphones offer a great amount of freedom in capturing sound, but there are some things to consider before relying on them as your sole solution.

- **Range:** Wireless microphones have built-in transmitters that relay the sounds they pick up to a remote receiver. A mic's *range* describes just how "remote" the mic can be from its receiving base unit before the signal quality degrades. More inexpensive microphones will transmit the sound they capture across a short distance, while more expensive microphones will allow you to capture sound from farther away from the receiver.

- **Frequency interference:** Wireless microphones communicate with their base units at 2.4 GHz and 5 GHz, frequencies that are common to many other household devices, including baby monitors and phones. Because of this, they can be susceptible to interference, which produces static in the audio. To guard against this, you must monitor the sound you are capturing with wireless microphones.

- **Power:** Every wireless microphone will require some form of battery power, whether from rechargeable or traditional batteries. As the batteries deplete, the microphone will suffer from a decreased transmission range and be more susceptible to interference. Worse, you could find yourself attempting to record an interview with completely dead batteries.

▶ USING A BOOM POLE AND BOOM POLE HOLDER

When you are working with a shotgun mic, it's essential to place it as close as possible to the subject. A *boom pole* will enable you (or an assistant) do this, while at the same time keeping the mic out of the video frame. This usually requires a second person to hold the boom pole for you in a fixed place.

If you are working on your own, I highly recommend investing in a light stand, boom pole, grip head, and boom pole holder. The latter will let you articulate the boom pole in any direction you need and keep it completely steady. I usually keep this gear in a bag, so it's handy when I need it.

FIGURE 4.7 A boom mic in a typical studio setup

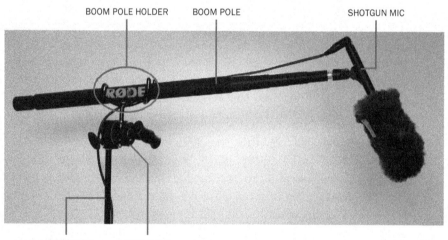

BOOM POLE HOLDER BOOM POLE SHOTGUN MIC

LIGHT STAND
(OR MICROPHONE STAND) GRIP HEAD

FIGURE 4.6 A shotgun mic mounted on a boom pole

WIRED MICROPHONES

Wired microphones use long cables to accommodate a variety of audio capture needs. Higher quality cables are also sheathed in one or more layers of protective material to provide shielding and prevent noise from electrical interference. Wired microphones are often more cost effective than their wireless counterparts. The downsides of wired cables include the inconvenience of keeping the wires hidden in your videos and the inability of your subjects to move around freely.

Sound Recording Tips

No matter which microphones you decide to use, you need to keep in mind a couple of things to make sure that you are getting the best sound possible.

Clipping

Microphones have a built-in sensitivity to sound that can sometimes be adjusted. If the microphone is set to be very sensitive and someone speaks very loudly, the captured sound will be very distorted and unintelligible. This is known as *clipping*. One way to understand what is happening is to think of how your eyes react to dark and light. While you're sitting in a dark room, your eyes increase their sensitivity to take in the smallest levels of light. If someone suddenly turns on the lights, your sensitized eyes will be overloaded. The temporary blindness or distorted vision you experience is the visual equivalent of audio clipping.

Audio Clipping
Use the QR code to hear an example of clipped audio. If you're reading a print book, scan the code with your mobile device. If you're reading an ebook, tap or click the QR code.

To avoid clipping, you can use a *levels meter,* an application or device that lets you visually monitor the intensity of the recorded audio. Levels meters are graduated in decibels (dB), which is the standard unit of measurement for sound pressure. Oddly enough, the highest level on the scale is 0 dB, and all sound levels are measured relative to 0 as negative numbers. When recording audio, you want to keep the highest audio levels (the *peaks*) between –10 and –20 decibels (dB). The closer you get to 0 dB, the closer you are to clipping.

Similarly, you should increase the sensitivity of the microphone when working with individuals who speak softly. Be aware, however, that if you make a big increase in the recording level for a soft-spoken person, you can also end up capturing unwanted background sound in the audio track.

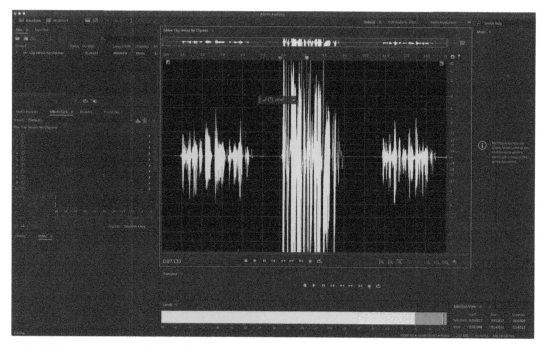

FIGURE 4.8 The waveform of an audio track as displayed on a timeline in Adobe Audition. The height of each peak represents the level of the audio at the instant in time marked by the red vertical playhead, The level is also displayed in the Levels panel at the bottom of the window. Notice that in the middle section of the sample, many of the peaks run up against the top of the graph, which is the 0dB level. The peaks are thus cut off and flattened, or *clipped*, producing distorted audio. The Levels panel shows the audio in the bright red range, another indicator of clipping.

New Technology: 32-Bit Float Audio

Recently introduced, *32-bit float recording* technology enables you to record the full range of audio from the softest to the loudest levels without clipping or setting microphone sensitivity. Field recording devices, such as the Zoom F2 and Zoom F3, use 32-bit float recording to record the audio onto a removable microSD card. The Zoom F3 has inputs that allow you to use external microphones to capture sound, while the F2 is a field recorder with a lavalier mic that has a built-in recorder. If you want the most pristine sound possible without worrying about distortion, 32-bit float audio is something you should investigate as your production activity increases.

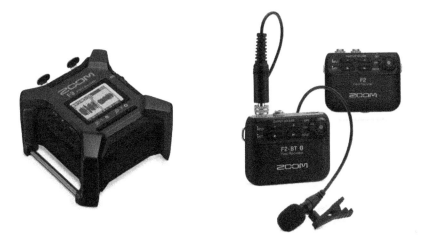

FIGURE 4.9 These Zoom field recorders can use 32-bit float recording when capturing audio.

Room Tone

Even silence has a sound. If you're sitting inside a quiet room, the hum of lights overhead or the whir of an air conditioner could be coloring the space aurally. If you are sitting outdoors, the wind rustling through leaves or a distant bird can color the sonic landscape. The ambient sound that colors an environment is called *room tone*, and it is especially vital when working with audio.

Imagine that you recorded an audio interview and asked your subject what they had for breakfast. Consider this response:

> Well, you know I, um, had this... wow... well... This morning, it was just amazing because I had this wonderful, like, peanut butter and... what was it? Oh right... jelly sandwich.

You plan to show a closeup of your subject making the sandwich, but the audio feels unsure and scattered. How could you help this along? Suppose you cut out some of the sections to say:

> This morning... I had this... wonderful... peanut butter and jelly sandwich.

In this example, you'd want to add some pauses to emphasize the word *wonderful* and clean up the audio. Cutting the audio to create this effect, however, will produce a sudden and complete silence in the middle of the sentence. That silence will sound like someone arbitrarily muted the computer's audio. It's jarring because we expect to hear sounds that color the room in addition to the dialogue. In cutting the awkward pauses, you also removed the room tone.

You can avoid this common problem if you plan ahead: take a moment to record 30 to 60 seconds of ambient room noise without dialogue before or after your interview. This will allow you to capture the natural sounds of the room and provide a good room tone track to use. While editing the video, you can add in this room tone between the cut audio sequences. Not only will it enable you to remove unnecessary portions of the audio more seamlessly, it also will allow you to stretch and contract the rhythm of the spoken words, which can add nuance to the expression of an idea.

Always Have Audio Backup

Horror stories abound of creators coming back from an interview only to find out that none of the audio was recorded, there was static in the audio track, or their device's batteries ran out halfway through the interview. Don't be one of those creators.

Whenever possible, use multiple devices in multiple locations to record your audio in the event you find you need a backup track later. For example, I always record a sit-down interview with a shotgun microphone but also attach a lavalier mic to the person. If the person is moving around, I attach two lavalier mics on their body. If I have a small shotgun mic on my phone, I also record the audio there. As you begin to learn the capture of audio you can start with one source.

When you're first learning, capturing audio with a single source may be easier, but using multiple sources will ensure your work is backed up in the event one audio source fails.

In the bottom of my bag I keep two lavalier mics with really long cables. I rarely use them, but if they have to come out it usually means a lot of my better options, including wireless mics, aren't working. For $15 apiece, I'd rather have them available and not need them than need another recording option and not have it with me.

Use Your Mobile Device Audio as a Guide Track

With its omnidirectional pattern and long distance from the subject, the microphone on a mobile device makes a really ineffective solution for recording an interview. That said, the audio that it can capture makes for a great guide track you can use for synchronizing your audio and video. The technique is simple: Start recording on the device connected to the external microphone and the mobile device at the same time, and clap really loudly (or use a clapper board). During editing, you can use that clapping sound as a synchronization point for the video and audio from all the devices.

▶ USING THIRD-PARTY MUSIC

A little background music will enhance almost any video story, and even if you're not up to producing a soundtrack yourself there are numerous third-party sources for music.

If you do decide to use music from an outside source, be sure to obtain the proper license from the provider. Licensing terms and fees generally vary depending how the music will be used and distributed, so be sure you have read and agreed to the terms and conditions associated with the license you choose.

For more information on the rights of content creators and the responsibilities of consumers, see these useful US Government websites (of course, laws and regulations may differ in other jurisdictions):

🎬 What Is Copyright?

Use the QR code to visit the US Copyright Office webpage. If you're reading a print book, scan the code with your mobile device. If you're reading an ebook, tap or click the QR code.

🎬 Fair Use

Use the QR code to visit the US Copyright Office Fair Use Index webpage. If you're reading a print book, scan the code with your mobile device. If you're reading an ebook, tap or click the QR code.

🎬 Sources of Third-Party Music

Use the QR code to learn about finding third-party music to use in your videos. If you're reading a print book, scan the code with your mobile device. If you're reading an ebook, tap or click the QR code.

CHAPTER 5

Working with Video

It's pretty amazing that we can create so much with something that fits in our pocket. Our mobile phones have more computing power than any home computer of previous generations. The ability to capture photos and videos with these devices has completely reshaped our memories and experiences.

The other thing that excites me the most about this technology is that it allows every single one of us to share our stories. Before, the practice of moviemaking was only available to those who had the means to buy the expensive gear. Now, almost every phone comes with a high-quality camera. And because everyone has a phone, everyone can be a visual storyteller.

Some Technical Specifications for Video

Before you start recording video on your mobile device, you need to make some decisions about how that video is going to be captured. It's important that you spend a little time understanding these settings so you can make the right decision for every situation.

Video Resolution

Every video you see is made up of a series of dots (pixels) lined up in rows on the screen. The more dots that are concentrated on the screen, the more detail you'll be able to see.

Common resolutions that you'll run into are:

Resolution in Pixels (Width × Height)	Known as
1280 × 720	720p
1920 × 1080	1080p
3840 × 2160	2160p or "4K"

NOTE Even though 3840 x 2160 is often referred to as "4K," it is technically UHD, not 4K. The actual resolution of 4K is 4096 x 2160. To be sure we're all referring to the same thing, throughout the book I'll use the term "4K" to mean 3840 x 2160.

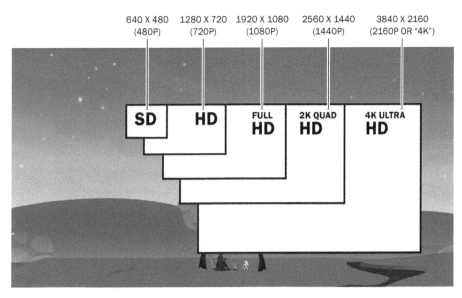

FIGURE 5.1 An overview of video frame dimensions

While your first impulse might be to want to record everything in 4K, I encourage you to consider some things. Because of the amount of detail it captures, 4K video is going to take up more space on your mobile device. If you have a smaller capacity phone, you might find yourself having to empty it before every recording session. Also, while TVs that support 4K are becoming more and more common, you may not notice a difference if the videos you make are viewed on mobile devices. Lastly, you should consider that the higher the resolution you use for recording, the more demands the assembling of the video will place on your computer.

One place where you *could* benefit from recording in 4K is if you find yourself wanting to enlarge a portion of the video when editing by cropping out extraneous material. When you zoom into any video in editing software, you lose some image detail. If you record in 4K, however, the amount of loss will be less than with 1080p video.

Video Frame Rate

Every video is made of a series of still pictures that create the illusion of motion when played—much like a cartoon flip book. The number of pictures (or *frames*) shown per second is the *frame rate* and is measured in frames per second (fps). When choosing a frame rate, you have many options, but a good portion of the time you will be focused on a few standard ones.

FIGURE 5.2 The Settings screen for selecting video recording formats on an iPhone

FIGURE 5.3 The Camera Settings screen on an iPhone

In the US, 24 and 30 frames per second are the most common for recording content. 24 fps, which is the standard frame rate for movie film, is commonly used for video that looks cinematic, while 30 fps is the standard frame rate for television broadcast. In Europe, Australia, and most of Asia and South America, a frame rate of 25 fps is the standard.

This does not mean that you can't shoot at different frame rates, however. Shooting at a slower frame rate (like 12 fps) can make something appear as if it is stop-motion. Some mobile devices allow you to shoot in 60 fps or 120 fps—great for making smooth slow-motion video. I would encourage you to explore these options, but for now, let's stick to either 24, 25, or 30 for the book's examples.

HDR AND DOLBY VIDEO

Newer mobile phones offer the option to record video that attempts to better reveal the darkest and lightest areas in a scene, similar to what the human eye can see. While options like this (called HDR Video on the iPhone) may be a boon for video creation, I believe that the results often bring more problems than benefits when editing in Adobe Premiere Pro. As you begin your content journey, I would recommend that you turn off HDR Video.

VARIABLE FRAME RATE

The video features of mobile device cameras are aimed at consumers making videos for personal use. These devices offer options, such as Auto FPS on the iPhone, that attempt to compensate for changes in light by automatically adjusting the frame rate. Varying frame rates unexpectedly when recording, however, can cause some problems when editing a professional video. I usually turn off Auto FPS and similar options as well.

Lens Choice: Ultra-Wide, Wide, or Telephoto

When we choose among the lenses on our phones, we normally think of their ability to cover wide areas or to zoom into things. Your lens selection makes a big difference in how the human face appears in a video, however, as well as how surrounding areas appear relative to your subject.

For **FIGURE 5.4**, I used the ultra-wide lens on my iPhone 12 Pro Max to take a picture of my daughter Sabine while making a video. The ultra-wide lens covers a large distance from left to right, but notice how the top of Sabine's head looks a little egg-shaped. The lens also exaggerates the size of the nose and makes the hair appear to have less volume. When you use the ultra-wide lens this close to the subject (so the field of view extends from the top of the head to just below the upper-chest) it produces a really distorted video—as if it were being stretched from the center out. Another interesting thing: Take a look at the farthest arm of the couch in the background and see how far away it appears.

I switched to the iPhone's normal wide lens on the phone for **FIGURE 5.5** and framed Sabine from the top of her head to the uppermost letters on her t-shirt. As you can see, her head looks more nearly normal. It is as if this lens has squished the image back to a proportion that we are used to seeing with the naked eye. Also, notice that the bookcases in the back of the room now appear a little closer than in the previous picture.

FIGURE 5.4 A photo taken using an ultra-wide lens

FIGURE 5.5 An example of a normal wide shot

FIGURE 5.6 Shooting with the telephoto lens compresses the space between the subject and the background.

Next, I switched to the telephoto lens and reframed the shot again. In **FIGURE 5.6**, notice that the head looks even more compressed now, and the arm of the couch looks just a few feet behind her. I tend to prefer how Sabine looks when using this lens for recording, as it makes her nose look less exaggerated and her hair has more volume.

▶ BEYOND STOCK LENSES: MOMENT LENSES

While experimenting with more elaborate filmmaking, I have been looking at ways to make video captured on mobile phones stand out more in quality, which led me to the lenses from Moment. Moment offers a suite of lenses that produce edge-to-edge sharpness for photos and video and have characteristics similar to what you would find on cinema cameras.

My phone is in a Moment case, which serves as the mounting system; the external lenses simply screw into the case. See "External Lenses: Moment" later in this chapter for more information about how I use Moment lenses. Additionally, you can further augment these lenses or your camera's built-in lens with the addition of the company's Neutral Density filters. Neutral Density (ND) filters act like sunglasses for your camera, allowing less light to enter the camera. This makes your images darker and appear more saturated in color.

FIGURE 5.7 The Moment ND filter attached to an iPhone

For additional cinematic flair, I like Moment's anamorphic lens, which captures 16:9 widescreen video with a warm tone and gold flare or a cool tone and blue flare as the camera crosses in front of bright light sources. This, combined with Moment's CineBloom diffusion filters, really steps up the video experience on the camera, softening hard edges and adding a "bloom" around light sources. To see a comparison between the image you get from a bare lens and one from a lens with CineBloom filter, use the QR code to visit the company's website.

Can you make a great video without these? Absolutely. Do you need to dive into an external lens system? Not really. Once you've mastered the process of working with video and want to make your videos look even better, however, external lenses and filters are the way to go.

I'll share a sample video using the Moment lenses on the book's website, so make sure you check it out.

🎬 Moment CineBloom Diffusion Filters

Use the QR code to learn more about the CineBloom filters and see sample footage. If you're reading a print book, scan the code with your mobile device. If you're reading an ebook, tap or click the QR code.

🎬 Sample Video Made with Moment CineBloom Filters

Use the QR code to see the CineBloom filters in action. If you're reading a print book, scan the code with your mobile device. If you're reading an ebook, tap or click the QR code.

The change in facial features and relative distance between foreground and background is commonly known as *lens compression*. Without getting into a deep technical dive, the longer the focal length of the lens, the more "compressed" the elements in the picture appear. The iPhone 12 Pro Max photos demonstrate this: The ultra-wide lens is the equivalent of a 13mm lens, the wide is considered a 26mm, and the telephoto is a 65mm lens. In photography, the focal lengths commonly used to render facial features as we would expect to see them are usually between 85mm and 105mm.

My recommendation is to consult the manufacturer's website for your phone to find out the millimeter equivalents of your device's lenses, and then use the one that makes your video look its best.

Using a Video Tripod

Unless you intend to move your video camera, getting a stable shot is extremely important. A good video tripod will enable you to set your camera in a fixed position and stabilize your shot. When looking for a solid video tripod, you should consider its construction, height, and ease of adjustment.

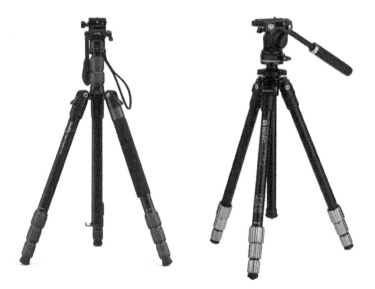

FIGURE 5.8 The SmallRig CT180 (left) and the Benro Slim are two solid starters for mobile phone video.

Tripod Construction

Tripods can be built from plastic, aluminum, steel, wood, or carbon fiber. Plastic ones are cost effective but lack the stability of an aluminum or wooden tripod. Aluminum tripods offer stability, but at a tradeoff of greater weight. If your desire to use a tripod is dampened by its weight in your gear bag, you may find yourself reluctant to carry it around. On the high end of the spectrum, carbon fiber offers a lightweight and sturdy solution, but carbon fiber tripods are far more expensive than their aluminum counterparts. All these factors will invariably affect what you shoot, so you need to consider your options carefully.

Tripod Height

The height of a tripod is usually determined by the number of sections its legs contain. Three-section tripods have three shafts on each leg, extending to a specific height. Five-section tripods will be taller when fully extended, enabling you to place your camera at a much higher point of view. If you find that you need to make video shots above crowds, you should consider getting a tripod with more sections on each of the legs. That said, the more sections a tripod has, the heavier it will be.

Another factor that affects the height of a tripod is whether it has a center column. Be aware, though: While a tripod with a center column might get your camera a little more height, that height may place your camera in a less stable position. The center column also affects how low you can adjust your tripod, so you should consider your need to make low-angle shots as well.

> **TIP** *If you adjust your tripod to a extremely high position, make sure you can see the frame of video you are trying to shoot. Some video cameras have an articulating screen so you can see your shot. If yours doesn't, you may need a stepladder, which would be hard to transport!*

Ease of Adjustment

With any tripod, the ease of getting a stable, level shot is absolutely key, as is the ability to make smooth adjustments to the camera orientation. To adjust their height, some tripods lock each leg section with a screw lock, while others use locking levers on the legs. I find lever locking systems are faster to adjust than the screw type and can shorten the time it takes to be ready for the shot. Some tripods even have bubble levels attached, making it easier to get a level shot.

FLUID VIDEO HEAD

The *head* is the unit responsible for adjusting the orientation of the camera. *Fluid heads* encase the moving parts in fluid like a hydraulic system. This dampens sudden motion and allows for smoother movement, which is important when recording video.

FIGURE 5.9 The Benro S8 fluid video head

The main function of the fluid head is to provide you with pan and tilt functionality. A *pan* is a horizontal camera movement, while a *tilt* angles your camera vertically. A pan/tilt head has a handle that allows you to perform these functions smoothly. In many instances, the video tripod you purchase will come with a head, but purchasing a separate head will often give you better features that translate into increased production quality.

360-DEGREE ROTATION

Make sure that the tripod head you use provides as much rotation as possible. This eliminates the need to pick up and reposition your tripod for another shot, saving you time.

PAN/TILT DRAG

Pan and tilt movements can be done at a variety of speeds to enhance the aesthetic of the shot. Some heads contain a drag control that uses friction to increase the resistance to pan and tilt movements. The more resistance, the slower you can pan and tilt. Another benefit: This eliminates the jerky motions from camera movement when the operator doesn't have the steadiest of hands.

COUNTERBALANCE

Imagine you are on a seesaw sitting on the ground while your friend is high in the air at the other end. If you were to get off, your friend's weight would bring them crashing down. This is exactly what can happen if your video gear is unbalanced on a tripod head. As you tilt your camera past the vertical either up or down, your tripod head will need some amount of counterweight to prevent your camera from dropping quickly. This problem is exacerbated when you add lights, microphones, or other attachments to the camera. On some tripod heads, you can set the counterbalance to take into account the extra weight and provide an even balance, no matter the tilt.

▶ HANDHOLDING YOUR PHONE: CAGES

While it's perfectly fine to handhold your mobile device while recording videos, doing so presents three challenges. First, you need a way to hold all of your auxiliary recording gear (microphone, lights, etc.). Second, you need something that will stand up to rough handling on the road, and third, you need to have a solid contact with your device to minimize camera shake.

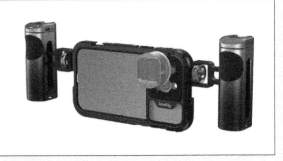

FIGURE 5.10 The dual-handle SmallRig Mobile Video Cage Kit for the iPhone 14 Pro Max

A solid mobile phone cage, such as one from the SmallRig line, solves all of these problems for you. A good cage provides an easy way to mount your phone inside, multiple attachment points for devices, and hand grips that give you a solid hold as you record. These cages also allow you to place your phone camera on a tabletop or on a full-size tripod for even more versatility.

Lighting for Mobile Video

In a perfect world, we would not need to carry extra lighting gear—but in this world we often do. As the scene you are recording gets darker, your camera will attempt to adjust its sensitivity to light to make the scene visible. The tradeoff is that more visual noise also appears in your video, which can be distracting. Adding additional lighting to your scene gives you more control, but also comes with the tradeoff of having to carry more gear—not only the lights themselves, but also additional tripods, batteries, and accessories. Another entire book could be written on the concept of lighting, but here let's focus on a few things that you should know about gear and light theory that will definitely help you to make informed decisions later.

LED All the Way

A relatively lightweight lighting option for mobile video recording is LED (light-emitting diode) gear. LED lights consume smaller amounts of power than older lighting technologies, allowing you to use them on battery power for longer periods of time. Plus, they are cool to the touch, so you don't have to worry about handling the light with a bare hand. The technology behind LED lighting sources has improved greatly in recent years, offering you a ton of options for how to light. You should, however, keep two characteristics in mind: the light's color temperature and Color Rendering Index (CRI) rating.

FIGURE 5.11 A selection of LED lights of various sizes by Fositan and Nanlite

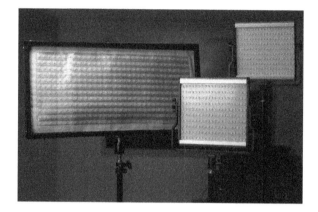

FIGURE 5.12 A setup of three LED lights illuminating an interview subject

COLOR TEMPERATURE IS IMPORTANT

In lighting, white is a subjective color. Warm white light will give your scene a very different feel from cool white light, but how do you know you'll get the white you want when you choose a light? Check the light's color temperature. The various shades

of white have specific temperatures, noted in degrees Kelvin (K). An LED light that is listed as warm white may have an orange hue at 2000K, while a neutral white at 5000K has a slight yellow cast. As you move over to the 10,000K area, you'll notice that the light starts to have more of a blue cast. While the lighting you use will be largely dependent on taste, you may want to consider using lighting equipment that allows you to adjust the temperature to match the feel of the video that you are making.

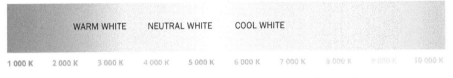

KELVIN COLOR TEMPERATURE—SHADES OF WHITE

WARM WHITE NEUTRAL WHITE COOL WHITE

1 000 K 2 000 K 3 000 K 4 000 K 5 000 K 6 000 K 7 000 K 8 000 K 9 000 K 10 000 K

FIGURE 5.13 As the color temperature of light increases, white changes from warmer (orangish) tones to cooler (bluish) ones.

CRI IS VERY IMPORTANT

Just like all whites aren't neutral white, not all LED lights are the same. An LED light might appear fine to the naked eye on the set, but when you open your recording in a video editor, you may notice that the light appears hazy—as if a colored filter was placed over the video. You can prevent this disappointment by being aware of your light's Color Rendering Index (CRI) number. The CRI, which ranges from 0 to 100, measures the quality of artificial light (LEDs included), rating how natural an object looks under artificial white light when compared to sunlight. The higher the CRI rating, the more natural looking the light quality will be. Lights that have a CRI of 95 or higher are great for video.

Three-Point Lighting

Video producers who frequently record interviews often use *three-point lighting*. This common technique uses three lights, each on its own tripod, to illuminate the interview subject:

- A *key light* is placed to one side of the camera, aiming at a 45-degree angle toward the subject. This light is the main light on the subject. When using this light, you'll notice that a shadow appears on the opposite side of the subject's face.

- A *fill light* is used to counteract that shadow. This second light is placed on the opposite side of the camera at an angle toward the face. This light will be at a lower intensity so as to "fill" that side of the face with a little light.

FIGURE 5.14 A sample of a key light placed to camera right of the subject and its result

FIGURE 5.15 The fill light is placed camera left and fills in the shadows on the opposite side of the face.

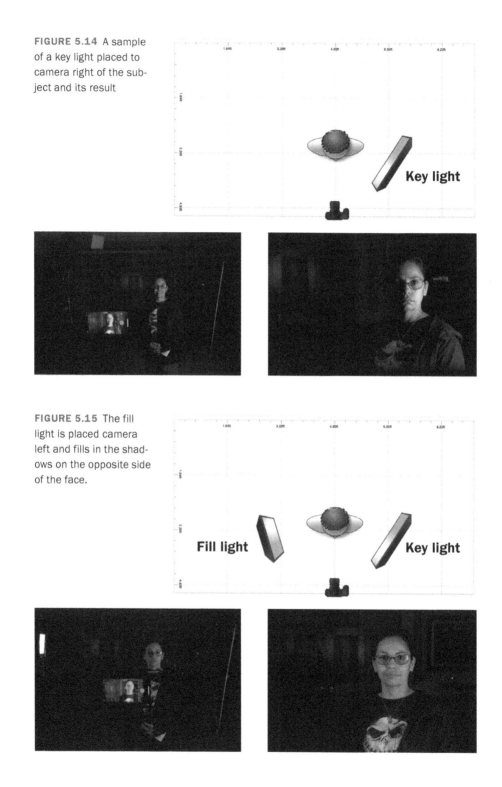

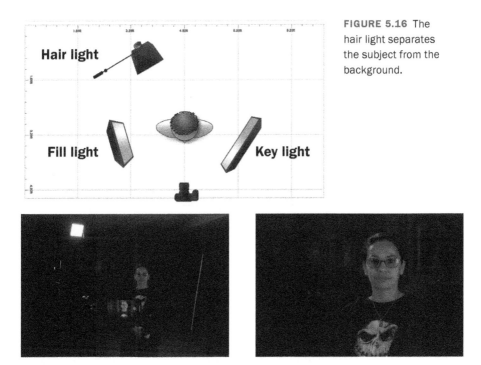

FIGURE 5.16 The hair light separates the subject from the background.

- A *hair light* or a *kicker* is usually set at an angle behind the subject. Its purpose is to create some definition between the subject and the background, "kicking" them off the background so you see some separation.

When natural lighting is not possible, three-point lighting is standard fare for interviews because it helps give your scene a more dimensional look.

On-Axis Lighting

Another common approach, *on-axis lighting* illuminates a subject from the same angle as the camera—usually from a light just above the camera. While not as elaborate as a three-point setup, an on-axis light is great to have in a pinch when you need to make sure you can light your subject quickly. This will happen often in run-and-gun scenarios, when action you need to shoot is happening rapidly.

An on-axis light is also extremely valuable in daylight shooting scenarios. For example, if you have a subject with their back toward the sun, their face will be extremely dark (it's in the shadow). By using an on-axis light, you can illuminate your subject's face with a fill light and solve the problem quickly.

FIGURE 5.17 On-axis lighting in an interview with Olivia Stomski

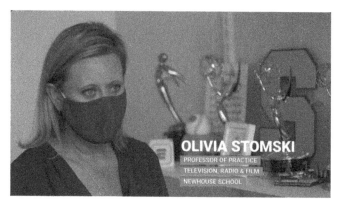

What's in My Rig?

Now that you've learned some general information about the equipment to consider when building a mobile video rig, I bet you're wondering "So what's in your rig, RC?"

You can use the QR code to fast forward to the answer, or read on to learn more about each of the components I use for my own productions and my reasons for choosing them.

🎬 Mobile Storytelling List

Use the QR code to view my list of video gear on Amazon. If you're reading a print book, scan the code with your mobile device. If you're reading an ebook, tap or click the QR code.

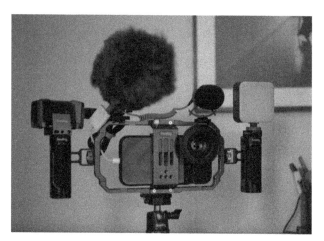

FIGURE 5.18 The video rig that I assembled for my own work

Camera Cage: SmallRig All-In-One Video Kit

The amount of stuff that I got with the All-In-One Video Kit (**FIGURE 5.19**) surprised me quite a bit. The camera cage and the two handles are made out of metal. The cage has a series of holes that allow you to place the handles in portrait *or* landscape orientation. There are additional holes throughout the cage where you can screw on other attachments, such as lights. The Kit also includes a small LED light whose temperature you can change from Warm to Daylight, a small shotgun mic with cables, a tripod plate, and a desktop tripod. All of this comes in a nice soft case—and provides a one-stop shop for getting started.

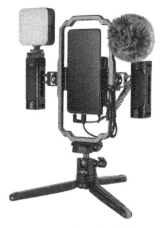

FIGURE 5.19 The SmallRig All-In-One Video Kit for Smartphone Creators

Tripod: SmallRig CT180 Video Tripod

Whenever I ask students to work with a desktop tripod kit, I'm guaranteed to see videos that are taken from a low vantage point, showing the individuals' nostrils. To me, there is no substitute for what an actual tripod can give you:

- The ability to adjust your camera height to match an eyeline.

- Pan and tilt movements. These are the most important movements you can make, and moves that you can't recreate with a desktop tripod or by handholding.

- Stability. The tripod legs will make sure that you have solid, shake-free movement.

The aluminum SmallRig CT180 Video Tripod performs each of these functions for a mobile phone quite well for its price.

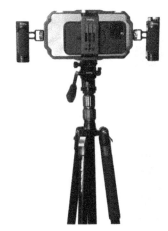

FIGURE 5.20 The SmallRig CT180 Video Tripod

External Lenses: Moment

While new mobile phones include multiple lenses, I like using external lenses, especially Moment lenses.

I carry several in my bag: the 10mm Macro, 18mm Wide, 58mm Telephoto, and 1.33 Anamorphic lenses. Looking at pictures side by side, I prefer the overall look afforded

by the Moment lenses over the stock lenses on my phone. True, that's a matter of personal opinion, but the 58mm lens and Anamorphic lens give me clear advantages over my built-in options.

FIGURE 5.21 The Moment 58mm lens

The 58mm lens gives me more flexibility. My iPhone 12 Pro Max has three options: a 13mm Ultra Wide lens, a 26mm lens (the standard focal length), and a 65mm Telephoto lens. For my videos, however, I like a spot in between 26mm and 65mm, which I am able to get with the 58mm lens. I also prefer "zooming in" with an actual, physical lens rather than using the iPhone's digital zoom function. For interviews and close-up shots, I like a lens that's a little longer than 65mm. By mounting the 58mm lens on top of the built-in 65mm lens, I get over 120mm of telephoto in one lens. This extra zoom can look great for some video shots.

The Anamorphic lens provides a look that can't be replicated with my built-in lenses, a look that is closer to what you would see in a feature film: a stretched video that's cropped to a narrower rectangle and has a specific blur on the edges. Additionally, Anamorphic lenses are also great for "Hollywood" moments when you pivot the camera toward the sun to create a lens flare. While not common in journalism stories, the look can be a good differentiator if you are trying to stand out.

Another reason I use Moment lenses is the range of control I get when making videos in bright-light scenarios. Having the ability to add a Neutral Density (ND) filter to my lens to make the scene darker allows my videos to have a soft focus in the background. When I first purchased the ND filters, they required you to use an adaptor that would connect only to one of Moment's lenses. Now, the company offers an adapter that you can use to connect an ND filter to your phone's built-in lenses—and that's very welcome.

Sound: Zoom F2 & F3, RØDE NTG-1

The SmallRig All-In-One Video Kit gave me a start-to-finish solution that was far underpriced for the value I got. That allowed me to invest more in what I thought was important: sound. I pair the Zoom F3 Field Recorder with the RØDE NTG-1 shotgun mic so I can get very direct audio with minimal background noise; and because the F3 uses 32-bit recording, I have no worries about audio clipping. (You can find more information on 32-bit float recording in Chapter 4, "Working with Sound." There, see "New Technology: 32-Bit Float Audio," or use the QR code "Audio Clipping" to hear a sample of what clipped audio sounds like versus unclipped.)

As a backup, I can attach the F2 lavalier mic, which is also a 32-bit recorder, to a subject. This gives me another clipping-free recording source just in case. Once my spoken-word portions are complete, I can detach the F3 and the shotgun mic from the cage (leaving the cage on the tripod) and record ambient sound to add to the production. The SmallRig shotgun mic can serve as a third backup, as well as provide a guide track for audio sync.

FIGURE 5.22 My preferred wireless devices for sound recording

Start Small and Build Up

Building your own rig can seem daunting at first. Just know you don't have to add *all* of these components at the start of your video recording career. Consider the tradeoffs we discussed and the budget you have to spend. Remember, you can get up and running with just an all-in-one solution and make great videos. As your needs evolve, your gear can evolve with you. Hey, I'm still working toward my dream tripod: the Sachtler aktiv6 flowtech75 MS Tripod. Its cost? Over $3,000. That tripod is going to have to wait for a bit more room to open in my equipment budget. Will it be worth it? Absolutely. But remember, too, without a compelling story to tell, even your dream tools can't save you. The story is the most important part.

CHAPTER 6

The
Importance
of Dialogue

The stories that you create are not just limited to moving pictures and sound. At some point, you will need to add the spoken word. Whether it's an interview or a fictitious story, your goal is to make sure that whatever is said in dialogue moves your story forward. In an interview setting, the use of the interviewee's words will further your story more than your narration ever could.

FIGURE 6.1 It's important to make sure that dialogue moves the story forward in a convincing manner.

A Few Well-Chosen Words

Moving your story along while keeping your audience engaged is incredibly important. One way to do so is to keep your dialogue as brief as it needs to be to convey your point and fit your character. Remember, it's not just *what* characters say that matters, but *how* they say it, as well. How a character speaks in a story attributes a sense of personality to them. Because of this, it's important that you keep some basic principles in mind when choosing their words.

Stick to the Appropriate Generation

Make sure that the character uses words and phrases that are typical to their generation. Imagine if a Gen-Z character greeted everyone with a hearty "Huzzah!" The word would sound a couple of centuries out of place and break the character's believability. Likewise, having your elderly professor greet a student with "Yo, what's

good?" might immediately erode the believability of the scene. Obviously, these are big temporal exaggerations, but even subtle shifts can be equally noticeable. That said, if you intend your Gen-Z character to be obsessed with the 1500s, then this quirk could really move the character's development forward.

Keep the Language Basic

When we write out dialogue, we often, however unwittingly, tend to construct very complicated sentences that, unfortunately, do not translate well to the spoken word when voiced by our story's actors (my editor is very likely cringing right now). When a character is speaking, try to keep their sentences as simple as possible. If you need to express an idea, use multiple sentences to do so. This will keep the talking brisk and the ideas moving forward.

The Four-Letter Word

When I start reviewing student videos early in the semester, I can see the word coming from a mile away. There's always one video that includes it. In the middle of the story, one character looks at the other and drops it right into the conversation. I often think that the student is in the back of the room laughing at the fact that they were finally able to say it without consequence.

At least that's how it appears when it audiobombs a video.

FIGURE 6.2 Everyone's heard it already. Don't use *that* four-letter word unless absolutely necessary.

You know the word. Everyone knows the word. Unless the use of the word is tied to the character and their development, it won't add a lot of value to your story. I'd argue it may even take away from what you are trying to do. In instances like this, my advice is always to find words with more letters that express the same type of feeling. I bet this would give you dialogue that is even more colorful than a four-letter word.

Quirky Can Be Memorable

One of the ways that you can make your characters' dialogue memorable is by adding a little bit of quirkiness to it. My colleague Evan Smith at the Newhouse School at Syracuse University wrote a great article for *Script Magazine* titled "Fine-Tuning Flaws to Make Characters Timely." In it, Smith states that a popular way to write a comedic part for a character is to start by putting the character in a situation that requires growth. This creates a flaw that can be seen as quirky. The quirky flaw is also ripe for development as the character recognizes and tries to overcome it, stumbling along the way.

While Smith's advice is geared toward comedy, developing something quirky in how a character speaks can certainly make a story stick. The short, fast-paced dialogue of *Gilmore Girls* gives it a very distinctive style. A similar yet dramatic style can be seen in *The West Wing*. The construction of the sentences as well as key catch phrases make characters stand out and stories feel more realistic and engaging.

The Interview

In journalism, there is no better way to tell a story than through the thoughts and feelings of the people who are on its front lines. This form of storytelling is often more convincing to the viewer than a recitation by a narrator because the information is coming straight from the source. In addition to presenting the facts of the story, it is the responsibility of the interviewer to make sure that the facts are presented in the most compelling way possible. For this, you need not only the story, but also emotion.

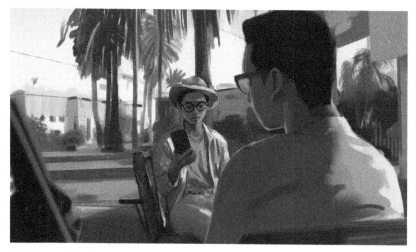

FIGURE 6.3 Setting up for the interview

A great interview still follows a story format but brings in your audience emotionally through the use of the first-person narrative. The narrative alone will not make your story successful. To really make it stand out, you need to be able to convey the interviewees' feelings about what is being said so they can bring the viewer along for the ride. Your interview will be more compelling if you can focus on trying to get your subject to talk about experiences and share their thoughts and emotions about them. These topics will elicit emotion—which is the core of the story.

Preparation Is Key

Some of the best interviewers out there make the process seem effortless, but there is a great deal of work that goes into getting a good story in an interview. With a solid plan, time, and practice, you can level up your interviewing skills and really focus on the story at hand.

THE BEDSIDE MANNER OF THE DIGITAL INTERVIEWER

While it's easy to dedicate your time to learning the technical aspects of lighting the scene, recording video, and capturing audio, the most important part of making your video is capturing the emotions of the person you are interviewing. Sitting in front of lights and a camera while someone is asking questions is unsettling to almost everyone, no matter how excited they may be to share their story. To get the best possible interview, you must prioritize establishing a level of trust with your subject. The subject must recognize that you are there to help them tell their story in the best way possible, and they must feel that you are capable of doing this.

FIGURE 6.4 The most important skill of the interviewer? Their bedside manner.

To ensure the best possible outcome, you need to project confidence in the process and sympathy for the interviewee's situation. This does not mean that you need to be sympathetic to the story you are about to hear, but you do need to understand what it feels like to be on the other side of the camera and how to handle the situation professionally—no matter what happens. My advice? Think like a duck: calm on the surface but paddling at full speed just underneath.

KNOW YOUR GEAR INSIDE OUT

One of the best ways to project confidence in the process is to make sure that you are completely familiar with the gear you are using and how to set it up. I usually keep all of the gear that I am going to use for an interview in one bag so that I can grab it and go quickly. Before the interview, however, I take out every item I plan to use and set it up in my studio as if I were going to conduct the interview on the spot. This allows me to see every piece of gear set up and test all of the components to make sure I can reproduce the setup on location as painlessly as possible. I cannot count how many times I've gone through this process only to see that I'd forgotten headphones, a specific cable, charged batteries, or a memory card. The dry run will eliminate a lot of these problems and make sure that you are not stressed during the interview setup.

> TIP It's a good idea to make sure you have every manual for every electrical device you are using on hand in the event that something goes wrong during the setup. I like to download every manual I need as a PDF file and store it on my device. If I need to figure out how to reset a piece of equipment, I don't have to waste time fishing around the internet for it, because it's always on hand.

FIGURE 6.5 The digital tools of the trade

RESEARCH SHOWS ATTENTION

Every interview is based on some facts that may not be immediately known to or remembered by your audience. The best interviews require some form of research on the subject and the topic so you can steer the story in the direction that you need it to go. A simple Google search can provide a good bit of information and give you a solid jumping-off point for your questions. In this research, you may even find past interviews, enabling you to see what kinds of questions were asked, how the subject responded to them, and if there were any additional follow-up questions that you want to take further. You may even surprise yourself and find a new angle that you decide to use in your own interview.

FIGURE 6.6 A little research goes a long way.

There is an emotional component to this, too. When you research a subject and come to the interview with some knowledge of your own, it shows your subject that you have a level of care about what you are doing. If you don't prepare and you ask simplistic questions, your subject could find themselves wondering, "He wants to know this? I thought this was so basic. Does this person know anything about me or this topic?" Those doubts erode confidence in the process.

When you come to the interview prepared, after doing your due diligence, you show that the interview was important enough for you to take the time to learn something about the person. Your subject will appreciate the work and respond well through the process.

GET THE SUBJECT'S NAME RIGHT

This should go without saying, but before you start any interview, make sure that you get the subject to state their name and spell it out for you. This makes sure you have the proper information handy if you need to create any additional graphics, as well as gives you the opportunity to learn how to pronounce the person's name during the interview.

SMALL TALK AND WARMUP

Every interview I do usually starts with a "cold" subject that gradually warms up over time. As the interviewee gets a feel for who you are and what you are doing, this warming up progresses. You want to get this done before you start on your interview questions, because it is not a good use of time to do the warmup during the interview.

FIGURE 6.7 This is one time where talking about the weather can be really helpful!

You are going to have some time setting up or confirming the setup of your camera, microphone, and lights before the interview begins. This would be a great time to engage with the subject and start a conversation. Any back and forth here would be good—you just want to start a dialogue to get the process going.

I'll give you a peek into my bedside manner in these instances. When I am interviewing someone, I always feel like there is a power imbalance in my favor. I am the expert with the questions, and they are in the hot seat. To counter this, I often use the setup time to attempt to push that power imbalance in favor of the subject. I ask questions about what they do and what they are working on, and let them talk to me about their ideas and passions from a position of authority. I don't try to counter or one-up the subject in this process. In fact, if there's any contribution on my part, I

tend to go for some self-deprecating humor: "Lord... I would never be able to do that. I'm all thumbs." Or "Are you kidding me, I would have passed out after the first mile!" If I know the person has a family, I'll almost always try talking about that. In the worst-case scenario, I can get some parenting tips out of the process.

It's important to note that this does not mean that you need to be insincere. You are not faking submission in this process—doing so can backfire spectacularly and appear condescending. Think of this as a dance. At this moment, you are allowing yourself to be a curious person and letting someone lead. Your subject will appreciate the process, and may reciprocate when it is time for you to lead the next dance.

PREPARE QUESTIONS, LISTEN, EXPAND

To have a good interview, it is vital to prepare a series of questions that follow the overall structure of the story you are trying to tell. Without this, your interview can feel like it is disengaged and meandering, and the viewer will lose interest. A well-structured set of questions can inspire confidence, but it can also be a very bad choice if you let it be your only guide.

Beginning interviewers often rely on their list of questions as the single source for the interview and move through them regardless of the answers. This approach is very apparent to the interviewee. To your subject, it can feel like you are moving down a laundry list and not really concerned about what is being said. This is a great time for you to go back to your curious personality.

Take the time to listen to the responses that you are getting and ask a follow-up question, such as "Oh... I hadn't thought about this. Can you walk me through how that works?" These moments can give you an opportunity to let the subject expand on an idea and give you additional information that could be valuable to the story being told.

Even further, this process allows you to create that conversation that you are looking for with your subject. You can always go back to the line of questioning that you have written down.

Conducting the Interview

All right, you've done your research on your interview subject, you've planned your questions, and you've got your equipment squared away. All that's left is to plant your subject in front of the camera and start firing questions, right? Wrong! You have a greater chance at a successful interview if you stay on your toes and be ready to adapt when the conversation goes in unexpected directions.

OPEN QUESTIONS: PEANUT BUTTER AND JELLY

The hallmark of the interview is that the story you are telling is told through the words of your subject. To do that, it's important that you have the soundbites that allow you to string the story together. You can achieve this by making sure that the questions you ask cannot be answered with a simple yes or no. These types of questions are called *open* questions. If I were to ask a subject "Did you enjoy your time at school?" their response could be "Yes." That would be a closed question, and I could not use it in an interview. I want the interviewee to elaborate on their answer and to provide something that allows me some flexibility in editing.

You can also move this process along by helping your subject understand how to answer a question. A general practice in interview responses is to try to get the question stated inside of the answer. When I start working in an interview, I often tell the subject "It will make the recording of this interview better if you respond to the question with the question in your answer. For example, if I were to ask you, 'What did you have for breakfast today?' A good answer would be, 'Today, for breakfast, I had a peanut butter and jelly sandwich.'"

FIGURE 6.8 Use the peanut-butter-and-jelly approach to interview answers.

I like using this method because it allows me to model to the interviewee how I would like a question answered and shares a fun way for them to keep the structure in mind. If I am going through an interview and the subject goes back to answering in a closed manner I can always say, "Oh, we're going to have to peanut butter and jelly that quote!" Then we both have an idea of what we are trying to do without having to make the engagement confrontational. No, I don't always use peanut butter and jelly; sometimes I modify the approach for different kinds of foods based on my subject.

(Do you really want to ask a head of state to peanut butter and jelly something?) The foundation is the same, however: Take the opportunity to model the question on the response you want and refer back to it should you need to elaborate on a soundbite.

PLAN FOR THE HEART

As each interview should be infused with emotion, you want to make sure that you are capturing feelings in your responses. Stating names and facts can only go so far. You want to include moments of reflection during the interview. A great technique is to ask the person what they thought of a particular situation at that moment in time: "You just landed on the moon. What was going through your mind as you were about to take the first steps onto the surface?" Or "How did your point of view change as you were walking on the moon?"

These kinds of questions evoke responses that bring out your subject's voice and show their feelings at a moment in time, enabling them to tell a story rather than recite a set of facts or processes.

I often use the word *why* when I ask about emotions. Why did you feel a moment of pride? Why was this such an important moment for you? Why did your outlook change? The more that we can get to the heart of the subject, the more we can get to the heart of the matter.

WORK UP TO HARDER QUESTIONS

Keep in mind that the interview is a conversation that will warm up as you go; it requires that a sense of trust develops along the way. This trust is something that you can get to faster if you have a series of small successes in the early part of the interview. To help that along, keep the simpler questions toward the start of the interview. As you work on the back and forth, your subject will start to warm up and trust the process a little more. This will set you up to have more successful soundbites later on, when your subject is more warmed up.

THE PLACES YOU WILL GO

Unless there is a specific reason you are looking for an element of surprise, it's a good idea to inform your subject about the overall scope of the interview. You can always create some spontaneity with the types of questions that you ask, but you can set the emotional stage for the subject if you can give them a general direction for the interview.

FIGURE 6.9 An interview can take you to some incredible places.

Technical and Logistical Concerns

As excited as you may be about your first interview, I would be remiss if I didn't share with you tales of individuals who have set off to their first interview with this same excitement only to come back crushed. Perhaps their audio was unusable, or their video material could not be put together in a coherent way. This unfortunately happens to the best of us. To try to counteract this, you should make sure that you plan for problems—and be thrilled if none occur.

USE TWO AUDIO SOURCES

One of the biggest fears for an interviewer is having to go back to a subject and say, "I'm sorry, but we have to do this over. The audio is not useable." You can avoid this nightmare by having a backup plan: Record two separate audio tracks; you can use any combination of microphones you like. If one of the mics causes a problem, you can always switch to your backup recording.

FIGURE 6.10 Making sure that you have multiple audio sources is key.

For example, if I can record using a shotgun mic in the field, I often set up a lavalier as a second source. The shotgun gives me the option to choose the better of the two audio sources later. If, say, the lavalier rubs against clothing and the extra noise results in a bad audio recording, I can use the audio from the shotgun mic. If I cannot use a shotgun mic, I will set up two lavaliers a little apart from one another to try to minimize risk.

If you're starting out and only one microphone is available to you, that's fine, but two is the ideal way to go.

DON'T BE AFRAID TO RESTART

Sometimes the responses that you get to your questions may not be exactly what you were looking for. Don't walk out of the interview knowing that you didn't get what you needed. It is completely okay for you to say to your subject, "I think we may need to do this question again if you don't mind." After a brief pause, you can restate the question and move ahead.

When this happens to me in an interview, I tend to move the question to the end and come back to it by suggesting, "You know what? What you said here was great. Let's see if I can get that level of _____ with that other question you answered earlier." This way, the restatement of the question does not feel punitive.

What if you need to restart an entire interview because you realize you're not capturing any sound or video? Fuss with the camera and audio then announce, "You know... let's take this from the top. I think this change that I just made is going to make the recording so much better." The *actual* change you made was pressing the Record button for real. *They* don't have to know that's what you meant, but it saves the situation and moves the interview along.

Remember, think like a duck.

DON'T STEP ON THE INTERVIEW

While an interview is a type of a conversation, it's important that your subject be the driver of it. This means that you want to stay out of the audio as much as possible. When you ask your question, ask it clearly and immediately stop talking. This will make sure that your voice is not captured on the microphones, and your subject is left to tell the story.

The hard part about this is that you will still need to keep the conversation going. This is when non-verbal cues are really helpful. An emphatic head nod is always good to encourage a person. Sometimes I use an enthusiastic thumbs-up to let the person

know that it is going well or that I agree. I will overemphasize my physical expressions to make sure that I am moving the interview along. When the subject finishes their answer, allow some time for a pause, then proceed to ask the next question.

GIVE THEM A CHANCE TO ADD TO THE INTERVIEW

When you have asked all of the questions that you have prepared, take an opportunity to ask your subject if there is anything else that they would like to cover in the interview. Sometimes your subject may offer additional insights or a different way to look at your questions. If your subject is providing this information, there is a good chance that they will be animated about what they are presenting. This can offer more emotional notes to the interview that you may not have expected.

CAPTURE ROOM TONE BEFORE YOU LEAVE

After you conclude the interview, make sure you spend a couple of minutes capturing the sounds of the room with no one talking. Having this ambient sound will make stitching together your interview easier and help the result sound as professional as possible.

FIGURE 6.11 Before the interview is finished, make sure you capture room tone.

 CHAPTER 7

Everything
in Its Place

Working on video is all about assembling your idea. Much as with cooking, you start off with an idea of what you want to make and develop a recipe. You gather all the items that you need, then place them on the table and begin preparing your vision. Imagine if you were set to prepare your meal, then spent all of your time digging through your kitchen looking for the onion you needed or the saucepan you totally thought you had in the cabinet but could no longer find...only to then discover you'd definitely misplaced the salt. At best, your meal preparation would take a lot longer. At worst, the meal might end up tasting terrible. To avoid this frustration and disappointment, professional chefs use *mise en place*, the habit of preparing and organizing all their ingredients before they cook.

Video production works the same way. Your ideas start from an outline and morph into a script and shot list. From there, you create storyboards and get ready to go out and record. You'll return with a basket full of video, audio, and pictures—your *assets* for the project—that you will need to organize so you can work as efficiently as possible when you get to Adobe Premiere Pro, where you put it all together.

Use a Project Folder

Video projects all share a core of common elements. You need scripts, shot lists, storyboards, and other documents that you can reference on the shoot. You'll have static images captured in the field, as well as video and audio. Because you'll be using the same types of elements for all of the projects that you make, it makes sense to follow the same organizational structure each time too. A project folder with a standard set of subfolders will help you keep organized and speed up your workflow.

Let's make a standard set of video project folders that you can duplicate as needed for new projects. **FIGURE 7.1** shows the template we'll use.

FIGURE 7.1 Using the same organizational structure for each project will help you work more efficiently. Here's the sample project folder and subfolders I use as a template.

First, create a folder and name it *Sample Project Folder*. Inside of it, make seven sub-folders named as follows:

- Output

Audio

Documents

Footage

Images

Premiere

Scratch Disk

When you name the first folder in the list, be sure to include a space, a hyphen, then another space, before the word *Output*. Folders are sorted alphabetically, but spaces and symbols come before letters, so adding the spaces and hyphen ensures that the folder designated for output appears at the top of the list. In it, you'll store all of the final videos that you create using Premiere Pro.

Next, I recommend that you compress the Sample Project Folder into a ZIP file and keep it in a dedicated area on your computer. Having this set of folders in one ZIP file will ensure you always can create a fresh set of empty folders from the template and prevent you from inadvertently filling the originals with project files.

Sample Project
Folder.zip

Each time you start a new project, you can unzip this template file, rename the Sample Project Folder for your project, and be ready to start working. In the sections that follow we'll discuss how to fill this folder hierarchy systematically so you are always organized and can easily find assets when you need them.

FIGURE 7.2
My Sample Project
Folder, now neatly
packaged as a
ZIP file

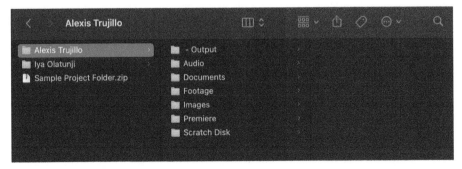

FIGURE 7.3 The Sample Project Folder put to use in an actual project

▶ USING REMOVABLE DRIVES FOR PROJECTS

When it comes to editing video, your drives need to have fast read and write speeds to ensure that they're able to play back video as smoothly as possible. The hard drives in your computer can send the information through Premiere Pro a lot faster than an external USB drive can, but USB drives are catching up.

USB 2.0 flash drives write data at around 4–10 MB/s and read at 15–25 MB/s, for example, but USB 3.0 flash drives can write at 10–20 MB/s and read at 40–50 MB/s. New USB 3.2 flash drives boast file read speeds of around 520 MB a second or more, which is quite fast. These speeds are dictated by the technology the drives use to communicate with the computer (e.g., USB 3.0), as well as the actual hardware inside them.

FIGURE 7.4 Some drives that I use

On the hard drive front, solid-state drive (SSD) devices, which do not use moving parts to store data, are increasingly common and faster than traditional drives with spinning-disks. Combine that with the data-transfer speeds enabled by USB-C, and you start to see drives like the SanDisk 1TB portable SSD at 1000+ MB/s.

I use SanDisk SSD drives for storing files, and occasionally editing, with no problem. I love using these as backups and archives because of their lack of moving parts. In my classroom, I'm still using a SanDisk SSD that I've thrown across the floor at least five times a semester for the last five years. To this day, it still plugs in and connects without a problem. (Watching a drive do cartwheels on the floor really shocks students into paying attention.)

So how much speed do you need? Any read speeds under 300 MB/s are going to result in a fair bit of delay in Premiere Pro based on my experience, but you can use the newer SSDs that transfer data at 520 MB/s in a pinch as a good tradeoff between price and performance. If you are looking for a drive that is a step up from this, the SanDisk Extreme Portable SSD can read and write at about 1000 MB/s.

For editing projects, especially when I plan to hand off some of the editing to someone else, I use the SanDisk Professional 1TB G-Drive Pro SSD. As of this writing, the drive transfers at an insane 2400 MB/s. The catch? It's not cheap. But if you begin doing professional video work, it will be worth it.

Import Your Video Footage

Within your project's Footage folder, all of the video footage that you record should be sorted into subfolders by camera for easy reference. I like to make folders called A Camera, B Camera, and so on. If your video shoot spans multiple days, make a folder for each day and place the individual camera folders inside of that parent folder. Your filenames could then be the camera name plus the date.

If your video footage takes up more than one memory card of space (it could happen if you need multiple takes of a shot or are shooting at higher resolutions), name the folders A Camera-C1, A Camera-C2, and so on. Keeping this format consistent across your projects will help you find the work you are looking for a lot faster. (I'll talk more about file naming in the next section.) In **FIGURE 7.5** I'm using only one card for the project, so A Camera and B Camera will suffice.

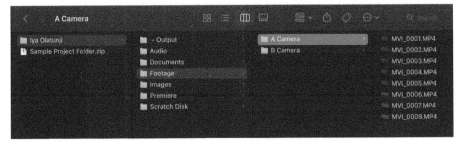

FIGURE 7.5 Dedicate separate folders to storing clips from individual cameras.

With your folders ready, you can import your footage from your phone or other device into your computer. Because video files are large, wireless methods like Air-Drop can be time intensive. Instead, I recommend that you take advantage of your computer's built-in software. On a Mac, connect your phone to your computer and start Image Capture from the Applications folder. When the alert appears, click OK to confirm that you trust the mobile device. A list of all of the media on your phone will appear, sorted by date. On a Windows system, simply connect your device and use File Explorer to navigate to the folder on your device that contains your footage. In either case, you can now select which files you would like and which folders you would like to transfer them to.

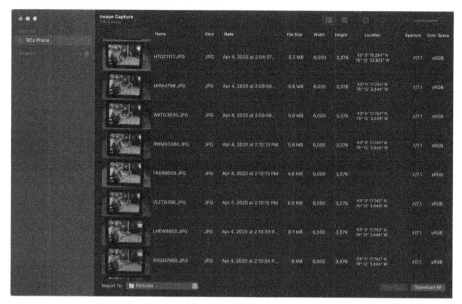

FIGURE 7.6 The Image Capture interface in macOS

Name Your Files

The names of the files you download from your mobile device rarely provide a clue to the file's contents. More often than not, the filenames will be a combination of letters and numbers that are just serialized numbers within the camera's file system and not something that corresponds to your workflow (like a date, location, or name). What can be even more frustrating is that this naming convention can reset itself, making it entirely possible to have two DSC0001.MP4 files on your computer that may come from two different cameras. Depending on the device you're using, this may happen on a job-by-job basis. To stay organized, you need to make sure that the files from each camera in use have a specific naming convention. Thankfully, you can use Adobe Bridge to automate renaming your files.

> **NOTE** If you are using cameras that are not mobile phones, your workflow may
> be different and may require you to keep the original filenames intact.

Select all of the video files by pressing Command+A (macOS)/Ctrl+A (Windows), then choose Tools > Batch Rename. This opens the Batch Rename dialog box, which allows you to choose how to rename the selected files. My naming convention starts

the filenames with the letter assigned to their camera (e.g., files from the A camera start with A), followed by the date of the shoot, then a four-digit sequential number. Let's set up Bridge to do that for us.

In the New Filenames area of the dialog box, choose Text from the first menu, then type the letter **A**, a space, a hyphen, and another space in the text box to the right. In the next row, choose Date Time from the first menu, Date Created from the second menu (to add the date of the shoot), and YYYYMMDD from the third menu (to format the date; e.g., 220927 for September 27, 2022). Add another hyphen and space by choosing Text from the menu on the next row and typing them in the field that appears. To add a four-digit sequential number to the end of the name string, choose Sequence Number from the first menu in the next row down. Then, type the digit that should start the sequence (**1**, in this case) then choose Four Digits from the menu on the right. Using four digits provides 9999 unique filenames for each card. (I figure if I have more than 10,000 files, I probably need another strategy.)

Click the Rename button, and Bridge does the hard work for you.

> **TIP** *If you need to add a row to the New Filenames definition area, click the + button at the right end of the preceding row.*

You can then select the files in your next camera folder and repeat this process.

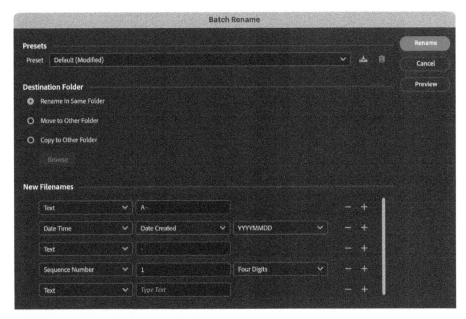

FIGURE 7.7 The Batch Rename dialog box

When working with audio files, you'll notice that they're often named completely differently from any files you get from your video recording device. I tend to label the audio files with a unique letter in my workflow (in this scenario, maybe C for audio files), in addition to the date. If I stopped and started an audio recording device at the same time that I pushed the record button on the video device, these two sets of files should have similar names (you can tell by the times inserted into the filenames).

FIGURE 7.8 Some typical audio files as named by the recording device

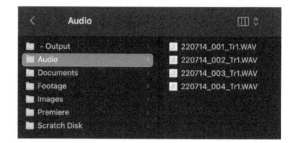

Set Up a Premiere Pro Project

Once you have all of your assets placed in their respective folders, you're ready to start working in Premiere Pro. To do so, you first need to create a Premiere Pro project, then bring in your files. So start Adobe Premiere Pro, and in the Home screen, click New Project in the upper left to create a new project for your video. Enter the name of your project in the Project Name field at the top left, then click the down arrow at the right side of the Project Location field and click Choose Location. Use the dialog box that opens to navigate to the Premiere folder inside of your project folder and click Choose. Then, click Create at the bottom right to save your PRPROJ file there.

Now let's bring in the files: With the Premiere Pro workspace open, drag the Footage and Audio folders from your Finder (macOS) or File Explorer (Windows) window onto the Project panel in Premiere Pro (this is called *ingesting* media in Premiere Pro). The folders that you drag into Premiere Pro will be turned into virtual folders in your project, called *bins*. These bins will then mirror the organizational structure that you created on your computer. See why it pays off to be organized from the start?

There are a couple of things that you should keep in mind when you are using Premiere Pro in terms of files, bins, and locations. For one, changes you make to the bin structure in Premiere Pro won't be reflected in the folders on your computer. For another, Premiere Pro is a program that enables you to assemble components in one place—but it doesn't produce a final video file until you choose what type of video you want (based on what you will do with it) and export it.

FIGURE 7.9 First, give the new project a name and tell Premiere Pro where to save it.

FIGURE 7.10 A close-up of the project name and location

FIGURE 7.11 shows the size of a six-minute promotional video that I recently worked on for Gregory Heisler. Although this project used multiple 4K video files, the actual project file size is really small at 1.2 MB. The Premiere Pro project file is actually a type of a text file called an *XML file* that contains information about where the footage files are and what kinds of adjustments you are performing on them. If you were to open the project file with a text editor, you would see the guts of the file and gain a basic understanding of what is happening with the assets. Think of the contents of the project file as the "instructions" for what to do with the assorted video, image, and audio files that you add to a sequence in Premiere Pro. When you send your finished

sequence out for encoding, Premiere Pro sends the file to a companion program called Adobe Media Encoder, which follows these instructions and "bakes" the video into its final form or performs the baking of the file right from Premiere Pro itself.

> **NOTE** *You assemble video and audio clips, graphics, and effects into a sequence by placing them in the Timeline panel in the order you choose. You'll learn more about working with the Timeline panel in Chapter 8, "Assembling Your Story in Adobe Premiere Pro."*

FIGURE 7.11 Selecting a Premiere Pro project file in a macOS Finder window set to Gallery View displays information about the file in the Preview pane.

FIGURE 7.12 Here's what the inside of a Premiere Pro project file looks like.

SETTING THE LOCATIONS OF SCRATCH DISKS IN PROJECT SETTINGS

Because Premiere Pro doesn't connect individual files together until you export a completed video, it needs to have a way to show you the videos that you are playing and the edits that you are making to the timeline. To do that, Premiere Pro creates a series of video files on the fly as you need them so you can view your progress as you edit. These files are stored in areas called *scratch disks*, and you can customize their locations in specific folders. It's a good idea that you check your settings by choosing File > Project Settings > Scratch Disks. Make sure that each option is set to be the same as your project folder or to a dedicated Scratch Disk folder inside of your project folder. This makes it easier for you to work with your project, as the temporary files needed to make the timeline run efficiently will always be available.

FIGURE 7.13 The Project Settings dialog box

File Management

To make sure you have all of the shots you need for your final video, we'll go back to our shot list and match it to the video files we have.

FGURE 7.14 The Footage folder in a sample project

Once you have all of your data ingested into the project folder, it's time to return to your shot list and add a couple of new columns: Folder Name and File Name. Here you can add details about the files that correspond to the shots you needed and where to find them. To do so:

1. In your shot list, find the take that you want to use. For instance, **FIGURE 7.15** shows we decided to use take 5 for shot 1A.

FIGURE 7.15 The shot list spreadsheet

2. Open the Footage folder and navigate to the appropriate camera's subfolder (if necessary) in your file browser.

3. Select the first file in the folder, then press the Down Arrow key to move down the list of video files until you see the slate for Take 5. If you used your slate for each of the shots, you'll see the take number as the first thumbnail image for each of the videos.

4. Enter the name of that file in the File Name field of the shot list. This is where all of the preparation that you did in the planning stage really pays off—reducing this process from hours to minutes.

5. Continue through your shot list, entering all the locations and filenames you need. To make sure that you don't lose anything, save a copy of the shot list file in the Documents folder of your Project when you finish.

When Files Go Missing in Your Project

As much as we would like to keep all of our work organized, there will be times when we risk damaging that organization by moving files around outside of Premiere Pro. Because Premiere Pro is an assembly program, it needs to know exactly where all of the files are in order to work with them. When it loses track of the location of one or more files, the Link Media dialog box opens and lists the missing files.

FIGURE 7.16 The Link Media dialog box displays files that are part of your project but that have been moved without the knowledge of Premiere Pro.

To tell Premiere Pro where to look for a missing file, select its name in the list and click Locate in the lower-right corner of the Link Media dialog box. Another dialog box opens in which you can to navigate to the file's correct location on your computer. An added benefit? Premiere Pro will use the location you select as the foundation to look for other files that it believes are missing and relink all of the files in the series

as best it can. If it cannot find any of the files based on the location, you have the option to set the file or files to be *offline*.

FIGURE 7.17 Premiere Pro lets you know in no uncertain terms if you try to play a sequence whose media has gone missing.

When you try to play a file that's offline in Premiere Pro, you will see a red screen with the words *Media Offline* in multiple languages. In the Timeline panel (where you assemble *clips* of the video and audio for your project), any elements you have designated as offline will appear red as well. You can continue to play the timeline from any point, and the files that are not offline will play as normal.

If you would like to bring one of the individual clips back online, you can right-click the clip and choose Link Media from the menu. The Link Media dialog box opens, and you can use it to find the missing clip.

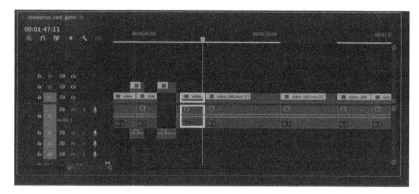

FIGURE 7.19 Right-clicking a clip opens this context menu.

FIGURE 7.18 The Timeline panel showing a sequence with missing media (colored red)

Naming Exported Files

As your production skills advance, you might need to create multiple versions of the same video for different situations. These videos could require different encoding options or formats (portrait versus landscape orientation, for example) dictated by where or how they'll be used. As a general rule, I rename the final exports of my files with the title followed by an underscore and the name of the location where they will be hosted.

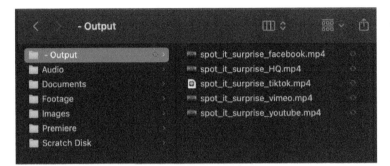

FIGURE 7.20 The - Output folder showing files exported for various social media platforms

Go Slow to Be Faster

Having a consistent process for creating and finishing your projects makes the time you spend on the development of the idea shorter because of the workflow's repeatability. You don't have to wonder how you are going to store something, or where you may have stored a portion of a project, because you have the same storage routine for project after project. I guarantee that the process of organizing your storage will feel a little slow and cumbersome at first. I also guarantee that your future self will thank you for investing this time at the outset. The slower you work through it, the smoother the processes will become. As your development process becomes smoother, you'll notice that the setup will become a lot faster.

Another benefit of having a process established from the outset becomes noticeable when it's time to hand off your project. As your projects become bigger, you'll notice that the development of your ideas will involve more people: editors, motion graphics artists, colorists, and more. Video is a bit of a team sport, and at times you will need to hand off a project to someone else to work on and hopefully move it closer to completion. If all of the assets that you need for a project are located in one place, you'll be much less likely to run into problems with offline media when you hand off

work. Likewise, it is a lot easier and faster to get an editor up and running if Premiere Pro doesn't have to re-create all of the scratch disk information because it doesn't know where the original scratch disk is. All of this is handled because you did some planning on the front end.

You could even go one step further by creating a text file called README.txt that explains where you have stored everything, along with why you made those choices. Again, because this document will be talking about your general workflow, you need to make it only once and save it in the Documents folder to be included in the sample project template ZIP file. Every time you start a new project by unzipping the file, you'll have the general instructions for how to work with the project in case someone needs it.

In the next few chapters, you'll find several projects, complete with assets, that you can use to develop your editing skills in Premiere Pro. As you move through them, you'll develop your workflow skills and get much faster. Before long, the workflow will be second nature and you'll have a ton of brain space to use on what is *really* important: telling your story.

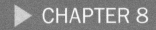 CHAPTER 8

Assembling Your Story in Adobe Premiere Pro

After you record the individual parts of your videos, it's time to assemble your collection of clips into one complete video. To do this, you'll need nonlinear editing software, such as Adobe Premiere Pro. As part of Creative Cloud, Premiere Pro also enables you to leverage the power of all the other Adobe applications to help you bring out the best of your story. From editing audio in Adobe Audition to adding motion graphics using Adobe After Effects, the process is pretty seamless. In this chapter, we'll focus on the Premiere Pro skills you need to build a video from your clips, but you can find instructional videos with ideas and tips on combining Premiere Pro with other Creative Cloud apps on my website.

A Practice Project: "The Spot It Surprise"

If you are completely new to the concept of making video stories and using Premiere Pro, having to juggle the story creation, pre-production, shooting, and editing can make the learning process unnecessarily daunting. Focusing on one phase at a time and some organization helps.

FIGURE 8.1 The project folder for the video you will edit

The Spot It Surprise
Use the QR code to watch my edited version of "The Spot It Surprise" on YouTube. If you're reading a print book, scan the code with your mobile device. If you're reading an ebook, tap or click the QR code.

In Chapter 7, for example, we used a basic "recipe" to set up a project folder structure. In this chapter, we'll fill that folder structure with ingredients (downloadable video clips) with which you can cook up a sample of my short film "The Spot It Surprise." Focusing on Jennifer and Sabine (my wife and daughter) playing cards for some cookies, the film contains no spoken audio but has a music track attached.

Assembling this story in Premiere Pro will give you practice with the common tools and techniques needed to create a simple story. Along the way, you'll also get a feel for how detailed you need to be in pre-production, with things like your shot list, to make the production and editing phases easier. (You'll appreciate this even more in Chapter 13's more challenging project.)

The rest of this chapter and the next will focus on providing general details of what to consider when working with Premiere Pro, as well as give you overview instructions you can use with the companion videos.

In case you need more thorough step-by-step instruction than this chapter provides, or you are a visual learner, I created a companion series of videos that take you through the entire process of editing the video: "The Spot It Surprise—Editing Basics." Note that the first video in the series contains "The Spot It Surprise" linked to earlier in the chapter. Follow the same link and rewind to the start of the video to watch the entire introduction to the course.

The Spot It Surprise—Editing Basics

Use the QR code to go to the playlist for the video course. If you're reading a print book, scan the code with your mobile device. If you're reading an ebook, tap or click the QR code.

Download the Sample Project's Files

Before you dig into Premiere Pro, however, you need to download the sample project's ZIP file (spotit_surprise.zip), which contains all of the footage files needed to re-create "The Spot It Surprise." Keep in mind that these small video clips, when added together, will create the whole story, and it is your job to assemble them in an order that makes sense. To help you, the ZIP file also contains a listing of the video files that I used to create my story in the order that they appear in the video. To download spotit_surprise.zip, go to rcweb.co/spotit-sample, ignore the warning about a file-previewing problem, and click Download.

When the ZIP file finishes downloading, you might need to unzip it if it doesn't do so automatically. In Windows, double-click the ZIP file to reveal the project folder in a File Explorer window. From there, you can drag the folder onto your desktop. In macOS, double-click the ZIP file to open a copy of the project folder in the same location as the ZIP file, then move that folder to your desktop.

Review the Footage Folder

With the spotit_surprise folder uncompressed, navigate to the Footage folder. As you can see, it contains a Camera A folder only. For this project, I recorded all the necessary videos with one camera, so I didn't need to create any additional camera folders. Inside the Camera A folder are all the videos, which I renamed to make finding the ones you want easier. You can preview any of the video clips in File Explorer or Finder to check them out.

In each of the video files, you'll see a lot of restarting and repeating of the action that I wanted to capture. This means that you might record a 2-minute video clip, when all you need is 10 seconds of it for your story. Shooting extra gives you more flexibility and shot choice. As with cooking, it's always better to have more of an ingredient than the exact amount you need. You can use the editing tools in Premiere Pro to trim out only the parts you need from each video.

The Shot List: Your Video Storytelling Recipe

Navigate to the Documents folder, and take a look at the PDF in it. This file, Video Listing.pdf, contains a shot list of all of the videos that you'll use for the production of this short film, organized in the order in which they appear in the story. It's also important to note that just because a video is in the Footage folder, that doesn't mean it will be used in the final video. You don't add every spice in your spice rack to every dish, do you? Think of Video Listing.pdf, and shot lists in general, as your ingredient list for creating your video, telling you what to use to spice your story.

Creating the Premiere Pro Project

🎬 Creating a New Project in Premiere Pro

Use the QR code to watch the video. If you're reading a print book, scan the code with your mobile device. If you're reading an ebook, tap or click the QR code.

With the files downloaded, you're ready to go. Start Premiere Pro, and click New Project in the Home screen or choose File > New > Project. The window that opens will look similar to the one in **FIGURE 8.2**. In Premiere Pro 2022, Adobe made some changes to the way you start creating a project, so if you've used an earlier version of the program, this interface may take a bit of adjustment. The change was meant to help casual users get up and running quickly because they can now see their footage first—but I think it's important that we focus on developing a repeatable workflow here.

Click inside the Project Location field at the top left and a menu of previous locations pops up; choose Choose Location. Use the Finder/File Explorer window that appears to navigate to the folder where you want to save your Premiere Pro project. Next, give your project a specific name in the Project Name field; in this case, name it **The Spot It Surprise**.

FIGURE 8.2 The Import mode in Premiere Pro

FIGURE 8.3 Giving the project a name and choosing where to store it

Make sure that you have all of the import settings on the right unselected, as we will not use those for now. Then, click the Create button in the lower-right corner. Premiere Pro will set up your new project and open it in the Edit interface, ready for you to start working with all of the footage that you've recorded.

The sight of the main Edit interface has been known to raise a new user's blood pressure or start them hyperventilating and reaching for a paper bag to breathe into. Don't worry, it will all feel familiar sooner than you think. Let's take a closer look, section by section.

FIGURE 8.4 The main Edit interface for Premiere Pro

The *Project panel* holds all of your assets while you're assembling the video. Here you will store all of the individual video clips, audio, and images you'll splice together. Think of this as the pantry where you store the ingredients for your recipe.

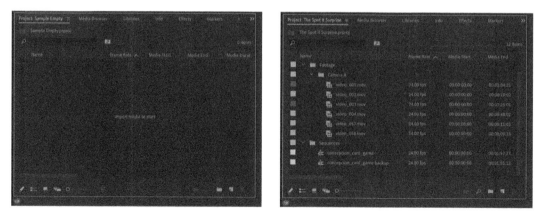

FIGURE 8.5 The Project panel, before importing footage and with footage imported

Directly above the Project panel is the *Source Monitor*. When you double-click an asset in the Project panel, its contents will appear here. For example, you may have a 3-minute video clip, of which you may only need 20 seconds. In the Source Monitor, you can review all 3 minutes and decide which part and how much of that video clip you want to add to the Timeline panel. Think of this as your cutting board.

The panel to the bottom right is the *Timeline panel*. Here you place the pieces of the assets that you select, arranging them chronologically on a timeline from left to right. This area will contain audio, video, text, and graphic information as needed. Think of it as the pot where you place all of the ingredients you chopped on the cutting board.

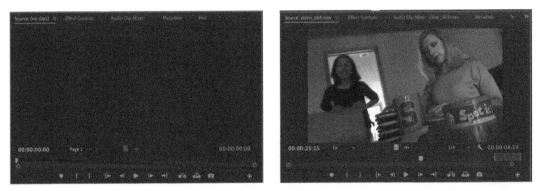

FIGURE 8.6 The Source Monitor, empty and showing a video clip

FIGURE 8.7 The Timeline panel, before making a sequence and with a completed sequence

Finally, the *Program Monitor* is where you see the results of your work laying out elements in the Timeline panel. Here you can give your story a final review. In our video kitchen, this is the dinner plate.

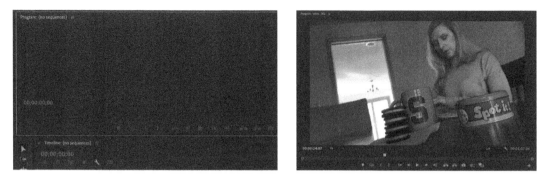

FIGURE 8.8 The Program Monitor, empty and displaying a sequence from the Timeline panel

Premiere Pro offers many other panels that enhance your editing experience, but the Project panel, Source Monitor, Timeline panel, and Program Monitor are the ones you immediately need to get started on your work. The specific arrangement of these panels is known as a *workspace*, and Premiere Pro comes preloaded with a series of workspaces. Each one shows and hides panels as needed to optimize the workspace for

FIGURE 8.9 The Workspaces icon and menu

its intended purpose. Because we're focused on editing, choose Window > Workspaces > Editing to display the Editing workspace.

You can modify any preloaded workspace, as well as create your own. In the process of working through a project you may find yourself moving panels around, only to find that you don't recognize your layout. Should you switch to a workspace and it doesn't look like you expect it to, choose Window > Workspaces > Reset to Saved Layout. For faster access to these workspaces and the reset option, you can always click the icon at the top right of the Premiere Pro window.

With so many panels, how do you know which is selected? A blue box around the inside edge of a panel lets you know it's selected. If you click another panel, then *it* will have a blue line around it and become the active (selected) panel.

FIGURE 8.10 In this example of a near-finished project, the solid blue line around the Timeline panel indicates it is selected. The Project panel does not have that line.

Sometimes you will want to make a panel bigger. To maximize a panel to fill the screen, hover the pointer over it and press the accent grave (`) key (this may be different on non-English keyboards), or you can double-click the panel's name. Press the same key or double-click the panel name again to shrink it back to its original size. Easy enough.

You also can resize any panel in Premiere Pro by dragging its edges. In the Editing workspace, try dragging the left edge of the Program Monitor to the left to see a bigger version of the video in the Program Monitor. Now we're in a good place to begin!

FIGURE 8.11 I chose the Editing workspace, then made the Program Monitor bigger.

▶ WHY IS MY PREMIERE PRO PROJECT FILE SO SMALL?

If you navigate into your Premiere Pro project folder, you'll notice that the file saved there has a .prproj extension and is relatively small. The file here seems to be about 6 kB in size. This file is actually a text file that tells Premiere Pro how to assemble the assets you've imported into a sequence (technically, it's a type of XML file). It specifies which videos (or audio files or images) to use, which sections of the footage files to use, and what order to place them in. The Premiere Pro project file is really just the software's recipe for how to assemble all of your videos; it is not the actual dish itself. That's important, because when you save a project, you need to make sure that you not only save the Premiere Pro file, but that you also save all of the other media associated with it. Storing all of the individual "ingredients" in a project folder is one of the most important habits to get into when working in video.

FIGURE 8.12 The project file is really just Premiere Pro's recipe for your final video.

Importing Your Footage

There are several ways to import your footage into your Premiere Pro project. Luckily, you need to import the footage for The Spot It Surprise project, so you can try out some common methods.

The first way is to use the new Import mode. Click Import mode at the top of the Premiere Pro window, and then you can navigate to the specific folder that holds your project's assets. In this instance, navigate to the Camera A folder inside of the Footage folder. Here you will see a series of thumbnails for each of the video clips in the folder. To select all the clips, press Command+A/Ctrl+A. If you change your mind, press Shift+Command+A/Shift+Ctrl+A to deselect all of the clips, and then select only those you want.

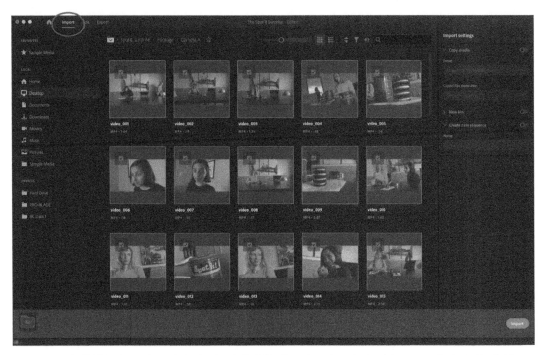

FIGURE 8.13 Clicking Import mode in the top left of the Premiere Pro window lets you navigate to the folder of files you want to import.

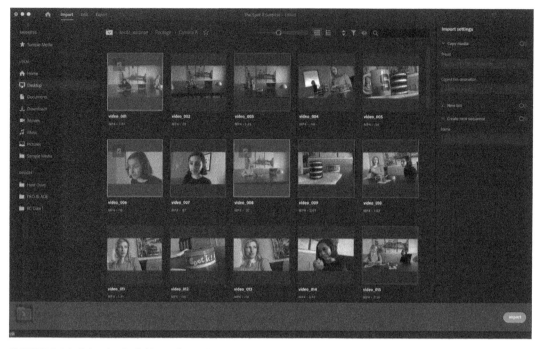

FIGURE 8.14 Selecting individual clips in Import mode

Import mode is a great way to find all of the assets that you need to include in your project, showing you exactly what is inside of each folder. Additionally, Import mode enables you to navigate to any external media (such as SD cards or other folders), find the assets that you are looking for, and copy them into the project. To do that, turn on the Copy Media option in the Import Settings at the top right of Import mode and make sure that you are copying the media into a specific folder in your project. All of the footage we want to use for the Spot It project is in the Footage folder, however, so you can leave Copy Media turned off.

Another way to import footage is to double-click inside the Project panel to open the Import dialog box, then navigate into the Project folder and the Footage folder. Once all of the videos are visible, click the first one, then Shift-click the last in the series, and click the Import button. Premiere Pro will quickly process the videos and place them in the Project panel.

FIGURE 8.15 Double-clicking in the Project panel opens the Import dialog box.

The third way for you to import your footage is with the Media Browser panel. To open it, click the Media Browser tab to the right of the Project panel. In the Media Browser, you can navigate through the folders on your hard drive to find a specific directory that holds your files. Navigate to the Camera A folder, and you'll see the thumbnails for each of the videos. From here, you can grab the videos by just clicking the first one, then Shift-clicking the last one you want to select, or you can press Command+A/Ctrl+A to select all of them. Right-click one of the selected videos and choose Import from the menu to import them into your project.

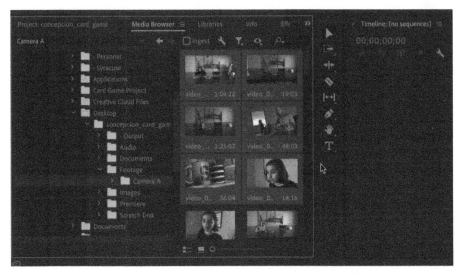

FIGURE 8.16 Using the Media Browser panel to find the footage from Camera A

Inside the Media Browser panel, you can hover over each of the clips and scrub through them. However, they're really hard to see. Hover the pointer over the panel and press the accent grave (`) key to enlarge it. The panel will fill the screen. Now you can drag the slider at the lower left to make the thumbnails larger, making it easier for you to see the individual clips and make better selections. As before, you can click the first video you want and Shift-click the last video in the series to select all the videos in between as well. You can also Command-click/Ctrl-click individual videos that are not next to one another to select them. Once you have selected the video footage you would like to import, right-click and choose Import from the menu.

FIGURE 8.17 Pressing the accent grave (`) key while hovering over a panel maximizes it to fill the screen.

There is one more way to import footage that you should know—and it's one that I use the most when working with smartphone footage. With a Finder or File Explorer window open, navigate to the Camera A folder, then press Command+A/Ctrl+A to select all the videos in the folder. Then, drag them into the Project panel.

So why would I use something like Import mode or the Media Browser? This has a lot to do with what you're shooting with at the time, and what you may be shooting with in the future.

FIGURE 8.18 Dragging the contents of the Camera A folder into the Project panel

This book focuses on you making videos with your smartphone. Our smartphones are pretty straightforward in recording video: every time you press the button, you get a video. This makes them easy to find in a folder when you download them, and you can associate each video with a single attempt to record.

If you get to a point where you are making videos with different types of cameras, that one-to-one relationship may not be the case. For example, if you record videos with a camera that uses the AVCHD format, you could find yourself guessing which folder contains which files for the video you are trying to make. For someone just starting out, that can be very confusing.

FIGURE 8.19 Two different video formats look very different when they are on your computer.

Premiere Pro's Import mode and Media Browser do not have that problem. These two options automatically know how to sift through all of those confusing folders and files and show you previews of the videos that you need. From here, just select the files, right-click them, choose Import, and you're good to go. In fact, since the arrival of the new Import mode, many people are using the Media Browser panel less and less.

Making and Using a Bin

After importing all of your assets into the Project panel, you might notice that an asset list can become really unwieldy really fast. To create some order, you can create a *bin*. Think of a bin as a virtual folder that lives *inside* of the Premiere Pro project. To create a bin, click the folder icon on the lower right of the Project panel. While the default name (Bin) is still selected, rename it by typing **Camera Footage**. Then, drag all of the video assets that you imported inside the bin you just created. This will go a long way toward keeping your project organized.

> **NOTE** *If you don't see the folder icon at the bottom of the Project panel, drag the right side of the panel to the right until the icon is visible.*

FIGURE 8.20 The Camera Footage bin has just been added to the Project panel, ready for footage files to be dragged into it.

If you are using Import mode to place all of your footage, you can speed up the process of making the bins by creating them right from inside this panel. Simply click the Import mode's New Bin button and give the bin a name.

FIGURE 8.21 Import mode allows you to create bins as you import, making your organization faster and easier.

If you want to save yourself time during the bin creation process here, you can drag the Footage folder directly into Premiere Pro. This will not only import your footage, but also create a bin with the same name as the folder, as well as bins for the sub-folders inside of it. Bins are great for keeping yourself organized inside of Premiere Pro, and importing your footage like this will let you mirror what that organization looks like on your computer. The only downside is that the reorganization that you do in the bins will not reorganize your folders on your computer. The bin is just an organizational tool from within Premiere Pro.

Changing the Project Panel View

The bottom of the Project panel offers controls that enable you to view all the assets in your project in different ways. Because beginning Premiere Pro users often find these various views confusing, let's review them. Clicking the second icon switches the panel to *List view*, which resembles the list views in Finder and File Explorer. Clicking the arrow to the left of a bin's name lets you expand and contract that bin to see its contents, while still seeing the full bin structure.

FIGURE 8.22 The bottom of the Project panel

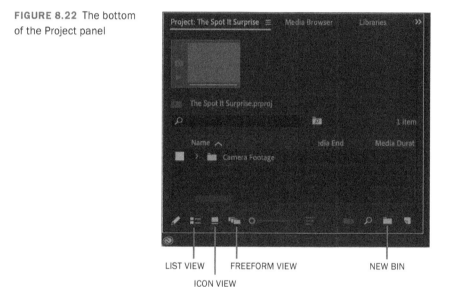

LIST VIEW FREEFORM VIEW NEW BIN
ICON VIEW

Clicking the icon to the right of the List View button changes the Project panel to *Icon view*. This view shows you all of your assets as icons and thumbnails. Although it's great for viewing the thumbnails of videos, this view behaves differently when you open an individual bin. For example, double-clicking the Camera Footage bin shows you the thumbnails of the video project in it, but you can no longer see any other bins or their contents as you can in List view. This is because the Camera Footage bin has been opened in another panel to the right of the Project panel.

You can close this panel by clicking the hamburger icon to the right of the panel name and choosing Close Panel from the menu or by pressing Command+W/Ctrl+W.

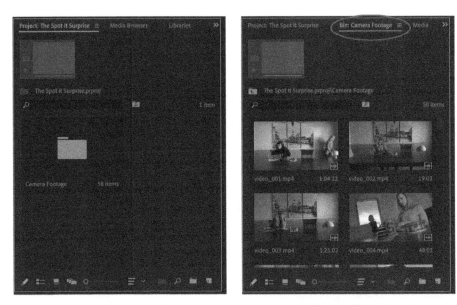

FIGURE 8.23 The Project panel is set to Icon view.

FIGURE 8.24 Double-clicking the Camera Footage bin in the Project panel displays its contents in a new panel.

FIGURE 8.25 Click the hamburger icon to open the panel menu.

Creating a Sequence

Now that we've organized the footage into a bin, let's create the timeline that will hold the assorted video and audio pieces together for a final video. This is known as a *sequence*. To create this sequence, choose File > New > Sequence or press Command+N/Ctrl+N.

The New Sequence dialog box opens, allowing you to configure your sequence depending on the format of your source material. To save you the effort of choosing all of the settings manually, Premiere Pro provides a number of presets for standard combinations of settings. For this project, I recorded all of the video sequences on my phone using an HD setting—1920 x 1080 pixels at 30 frames per second. Because of

that, I recommend choosing the DSLR 1080p30 for this project. Name the sequence **The Spot It Surprise**, which will be the name of the file that is exported when we are done. Next, create a bin, name it **sequences**, and place the sequence in it.

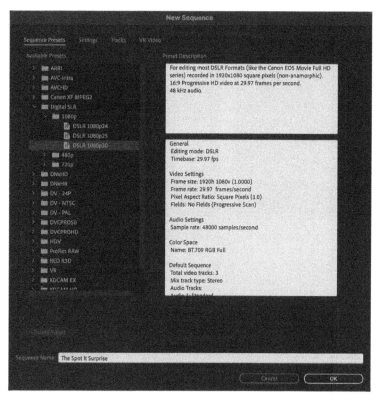

FIGURE 8.26 The New Sequence dialog box showing the preset we'll use for this project

You can have as many sequences in a video project as you want, with each sequence tailored to a specific need. In fact, I recommend using duplicate sequences as a backup strategy, but we can talk more about that later.

Previewing and Adding Footage

Once Premiere Pro has ingested all of your clips and you have created a sequence for the project, it's time to start looking through the footage, trying to make sense of what you have and which parts of it you want to use. To do this, let's continue with the Spot It Surprise sample project that you've been working on. In this project that

I recorded for you, I placed all of my footage inside of the Footage folder, and more specifically, inside a Camera A folder.

At this point, I can almost hear you reaching for that paper bag again, but I guarantee you'll get through this.

Looking at the Camera A bin in this project, you'll see that there are 58 individual videos—for what may be a 90-second project. How many of these videos are retakes because something was missed the first time? How many of these videos are re-do videos because a person you were working with sneezed? Looking at them in a list like this makes it really hard for you to make judgements, and makes the process appear a lot more painful than it needs to be. This is where all of the preplanning for the video project will pay off.

📽 **Previewing and Adding Footage to a Sequence**
Use the QR code to watch the video. If you're reading a print book, scan the code with your mobile device. If you're reading an ebook, tap or click the QR code.

Inside the Documents folder for this project, you'll find a PDF shot list for it, a short list that was the result of planning ahead. During the preproduction part of this video project, I outlined all of the individual steps that I knew were required for this piece and placed them in numerical order. I printed this list and had it with me on a clipboard during the filming process—and (intentionally) flubbed a couple of scenes, so that the project would simulate the problems you may have in a real project. Once that was done, I went back into the list and outlined which of the videos belonged to which part of the action, so the job in Premiere Pro will be easier.

The Spot It Surprise

Shot Number	Shot Description	Video File Name	Shot Type
0001	Push in shot of Jenn reading a book	video_002	ES
0002	Match action of Jenn fliping book. Reveal oreo.	video_004	MED
0003	Tight shot of cup and oreos	video_005	CU
0004	Sabine licking lips and run.	video_007	MCU
0005	Sabine runs in and gets hand slaped	video_008	WS
0006	Match action hand slap	video_009	CU
0007	Jenn saying no - no.	video_010	MCU
0008	Jenn saying no - no. and point	video_011	MCU
0009	Point to spot it	video_012	ECU
0010	Jen - you want this?	video_013	MED
0011	Sabine - bring it	video_014	MED
0012	Jenn - pick up spot it.	video_015	MED
0013	Match cut shuffle.	video_016	CU
0014	Match - Jenn shuffling	video_017	MED
0015	Sabine - looking	video_018	MED
0016	Jenn putting down card	video_019	WS
0017	Jenn - you ready	video_020	CU
0018	Sabine - yes - hair flip	video_021	MED
0019	Card game begins	video_022	ES
0020	Jenn looking at card	video_023	MCU
0021	Card with picture	video_025	ECU
0022	Sabine looking at card surprised	video_026	MCU
0023	referer back to card	video_025	ECU

FIGURE 8.27 The shot list for "The Spot It Surprise"

Going back to the kitchen analogy, I've already made your recipe (shot list) on a piece of paper. You just need to transfer the ingredients to the Timeline panel (your pot), and you're good to go.

Opening Files in the Source Monitor

Let's explore how to work with individual videos in a project to organize them in the timeline. Double-click the video_002 file in the Camera Footage bin to bring up the entire video in the Source Monitor. The Source Monitor panel has a series of controls at the bottom to play, rewind, and fast-forward the video; mark points within the video; and perform other useful functions. Clicking the Play button (or pressing your spacebar) will let you move the video forward to review.

A quick look at this video shows that we really need only two seconds of it, from the moment the camera pushes in on Jennifer with the book until she flips a page. Everything else is superfluous.

You can also use the J, K, and L keys to play your clips. J plays the video backward, K stops the video, and L plays the video forward. You can press J and K multiple times to change the speed at which the video plays. These keyboard shortcuts are very useful in speeding up editing; we'll cover how to use them more in Chapter 10.

> **TIP** You can speed up the process of making your videos by creating a timeline right from inside of Import mode. Click the Create Timeline button at the bottom right of Import mode to make a timeline.

Drag the Source Monitor playhead back to the spot where you would like to begin the piece of video you want to keep and press the I key. This will set an In point (noted by a blue left brace). From here, play the video until you reach the end of the portion of the clip you want to use. When you get there, press the O key to mark the Out point. For this video clip, I want to use the push shot moving closer to Jennifer looking at the book, similar to what you saw in the sample video. See if you can set the In point and Out point to match the area in the notes in the shot list.

Now you have several options available to you here for getting the video into your sequence. If you drag from the video display in the Source Monitor into the Timeline panel, it will place both the audio and video in the existing sequence. If you drag from the Drag Video Only icon into the timeline it will bring the video only. If you drag from the Drag Audio Only icon, it will bring only the audio into the sequence in the Timeline panel.

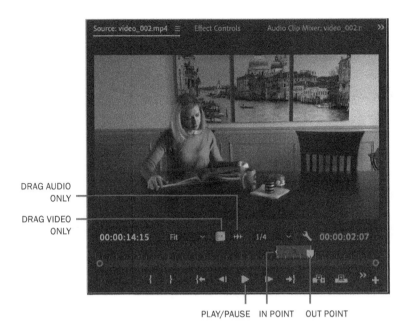

DRAG AUDIO
ONLY

DRAG VIDEO
ONLY

PLAY/PAUSE IN POINT OUT POINT

FIGURE 8.28 The Source Monitor, showing the In and Out points that I marked

FIGURE 8.29
Dragging from the
Drag Video Only icon
in the Source Monitor

Once the video is in the timeline, you can zoom in to see it better by dragging the circles at each end of the navigator at the bottom of the Timeline panel. Bring them together to zoom into the timeline. Dragging them apart zooms out. If you have the \ key on your keyboard, pressing it will automatically zoom you out to show you all of the clips that you have assembled on the timeline and zoom you back in with no problem.

However, there is one problem here: You have only one clip on the timeline! It's time for you to follow the recipe I provided in the shot list. Open the shot list (Video Listing.pdf in the Documents folder), and start assembling your video to look like the "The Spot It Surprise" video. When you're finished putting it together, it will look similar to the timeline in **FIGURE 8.30**.

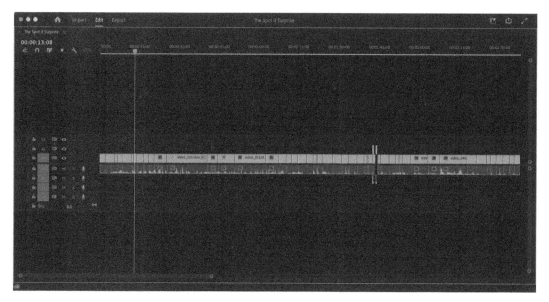

FIGURE 8.30 The Spot It Surprise sequence as seen in the Timeline panel with all of the video clips in place

At this point, just focus on getting the In and Out points in the videos at a rough state. If it is not exactly at the spot that you want each clip to stop or end, don't worry. The next chapter is going to show you how to get the video tuned up very fast.

 CHAPTER 9

Basic Edits: Sharpening Your Point in Premiere Pro

In the previous chapter, you imported your project's footage into a Premiere Pro timeline by following an established shot list. This process of assembling a series of video elements into an initial sequence is commonly known as creating a *rough cut*. The rough cut gives you an overall feel for your story, helps you test its duration, and conveys a general impression of what you are trying to say. The next step is to focus a little more on each clip and tighten your edits.

Why? Because editing is a "Game of Frames." The difference between something looking like your first video and looking like a professional production is often the removal or addition of a series of frames, usually at the beginning or end of a video segment. You can achieve that same level of professionalism by including additional elements, such as images, music, text, or other graphics, as well. Again, though, watch your frames: You can raise the level of professionalism even further by *when* the elements appear in the video. Paying attention to the timing of all of these elements sharpens the message and makes you stand out.

▶ FOLLOW ALONG WITH THE VIDEOS

Although reading about editing is helpful, it can't fully convey just how much of a change you can make by adjusting a couple of frames or paying attention to timing—or how easily you can do it. For that, you need to see the editing techniques and tools in action and the difference in the resulting clips. So as you read this chapter, I encourage you to follow along with the companion instructional videos linked throughout. Read a section to gain a sense of how the discussed technique or tool works, then scan the associated QR code (or click the link) to see the video of it in action.

Once you've seen the instructional videos and gotten the hang of editing in Premiere Pro, you can use the book as an overall reference. Should you need to go back to the videos, they're just a QR code (or link) away.

To download the sample project, go to rcweb.co/spotit-sample.

To download a blank sample project folder to use with your future videos, go to rcweb.co/storytelling-sample-project-folder.

🎬 **"The Spot It Surprise" Sample Project**

Use the QR code to go to the download files. If you're reading a print book, scan the code with your mobile device. If you're reading an ebook, tap or click the QR code.

🎬 **A Blank Sample Project Folder**

Use the QR code to download the file. If you're reading a print book, scan the code with your mobile device. If you're reading an ebook, tap or click the QR code.

Using the Selection and Ripple Edit Tools

When you work in Premiere Pro, you assemble a series of video segments (*clips*) together into one cohesive video on a timeline. That does not mean, however, that you need to use the full length of each clip. In fact, you might use only 10 seconds of a shot that runs for 3 minutes in its entirety. So when you work in Premiere Pro, you actually assemble *sections* of various clips together to form one longer video.

To do that effectively, you need to learn how to select an individual clip and isolate a specific section of it. I'll start by explaining the blunt instruments you can use for the task, and work my way down into the finer ones.

The Selection Tool

The Selection tool (keyboard shortcut: V) enables you to select audio or video segments on the timeline. Click a clip with the tool to select it, or hold the Shift key and click multiple clips in a sequence to select all of them. When you hover over a clip (but don't click) with the Selection tool, a tool tip appears telling you the clip's name.

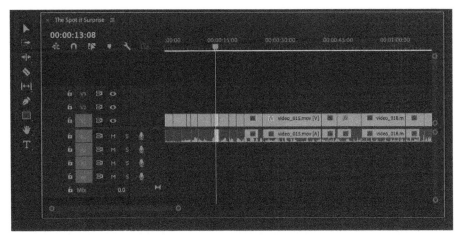

FIGURE 9.1 The Timeline panel in Adobe Premiere Pro with the Selection tool active

You can also use the Selection tool to change the length of clips or reorder them in the Timeline panel. The ends of each clip are known as the clip's *edit points*, and they correspond to the In and Out points that you selected in the Source Monitor. Dragging a clip's end edit point to the right with the Selection tool reveals more of the original video to lengthen the clip. Dragging it inward (to the left) makes the clip shorter. In both cases however, the original footage is still available. In Premiere Pro,

you never alter the original video; you simply make references to how much of it you are using. You can even use the Selection tool to move the videos around in your sequence, completely reordering the story as you see fit.

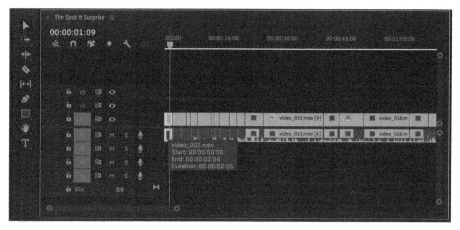

FIGURE 9.2 A tool tip shows you the clip's name.

Let's use this tool to solve an immediate problem of continuity in the sample project.

If you are following along with the example project's files and companion videos, you'll notice a continuity problem: In the rough cut of "The Spot It Surprise," Jenn turns a page in the book with her right hand, but in the following clip, she turns the page with her left hand. To make the edit a little tighter and fix the continuity break in the story, we want to remove any gesture that Jenn makes with her right hand that indicates she's going to turn the page. To do so, use the Selection tool to drag the first clip's end point right (inward) so the clip ends with her hand resting on the page. You can also use the Selection tool to remove a few more frames at the start point of the clip.

Now the shorter clip better fits the story, but you're left with gaps on the timeline to the left and the right of it. With the Selection tool, simply drag the clip to the left to close the first gap. Click the next clip to select it, drag it left until it is next to the first one, and repeat that process for all of the other clips.

Notice that as you drag the end or the beginning of the clips, you can see more than the individual selection that you made in the Source Monitor. Remember that although you made a smaller selection of the video, the original, full video is still available to you. You can expand and contract that individual clip knowing that the rest of the footage is still there.

There are much faster ways to perform an edit like this, as you'll see in the next section.

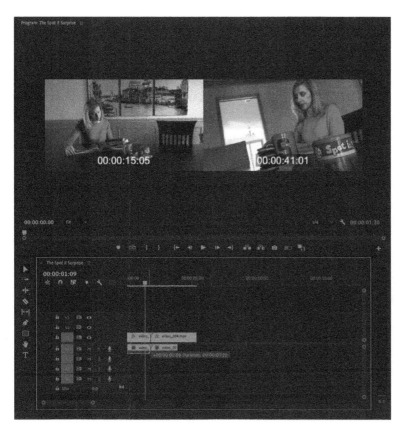

FIGURE 9.3 Removing the end of one video clip to keep continuity

The Ripple Edit Tool

Similar to the Selection tool, the Ripple Edit tool (keyboard shortcut: B) enables you to select the start or end point of a video clip and adjust it but with a powerful added benefit. When you release the tool after dragging one end of a clip, the clips adjacent to the edit move along with it, automatically closing any gaps. The edit, in effect, "ripples" along the timeline to ensure it leaves no blank spaces in the sequence of clips. When you drag the ends of the clip with the Ripple Edit tool, Premiere Pro also displays thumbnails in the Program Monitor. The thumbnails show you the start or end of the adjacent clips in the sequence to help you to refine the edit even more.

▥ Using the Select and Ripple Edit Tools

Use the QR code to watch the video. If you're reading a print book, scan the code with your mobile device. If you're reading an ebook, tap or click the QR code.

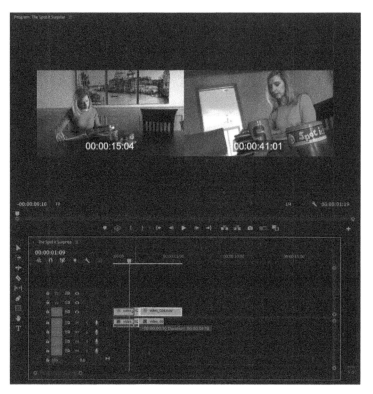

FIGURE 9.4 The Ripple Edit tool eliminates the blank spaces as you work.

Exploring More Editing Tools

Believe it or not, you can accomplish most basic editing tasks with only the Selection and Ripple Edit tools, expanding or contracting the timeline as you need it. Premiere Pro does offer some additional tools that make certain modifications easier in the timeline. You may not need all of these tools, but you should at least be aware of them.

Using the Razor and Rolling Edit Tools

Use the QR code to watch the video. If you're reading a print book, scan the code with your mobile device. If you're reading an ebook, tap or click the QR code.

The Rolling Edit Tool

The Rolling Edit tool (keyboard shortcut: N) is a powerful tool to use when you want to change the Out point of one clip and the In point of the adjacent clip at the same time. With it, you can change when you cut to the next clip without lengthening or shortening the sequence. I

particularly like using the Rolling Edit tool when I want to match the action of one clip with that of the next one a little more clearly (a technique called a *match edit*).

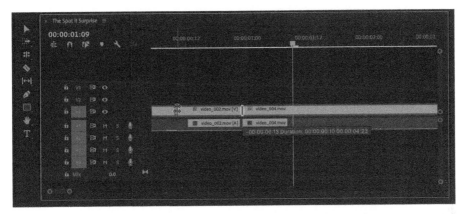

FIGURE 9.5 The Rolling Edit tool enables you to match the clips without changing the length of the sequence.

The Rate Stretch Tool

Imagine working on an edit and noticing that the usable amount of video in a specific clip does not fit the space in the timeline that you need it to cover. Don't panic, just reach for the Rate Stretch tool (keyboard shortcut: R). It enables you to slow down and speed up a clip to fit a specific space. With the Rate Stretch tool, drag a clip's end (Out) point to the right, and Premiere Pro slows the video down so that the same material is presented, but over a longer time to fill the larger space in the timeline. Dragging the Out point to the left speeds up the video so the same amount of material appears in a shorter amount of time. When you grab the clip's start (In) point, dragging right speeds up the clip, while dragging left slows it.

Yes, you could also right-click an individual clip and choose Speed/Duration from the context menu to change the speed, but this method requires a fair bit of guesswork. How much will 103% lengthen the clip? Enough? Too much? Instead, use the Rate Stretch tool, and let Premiere Pro figure out exactly how much to slow the clip down to best fill the space.

> **TIP** *The Rate Stretch tool is a great rescue tool if you unexpectedly need to cover a small number of frames on a timeline. If you use it to fill too large a stretch of time, however, the result will be choppy and unusable.*

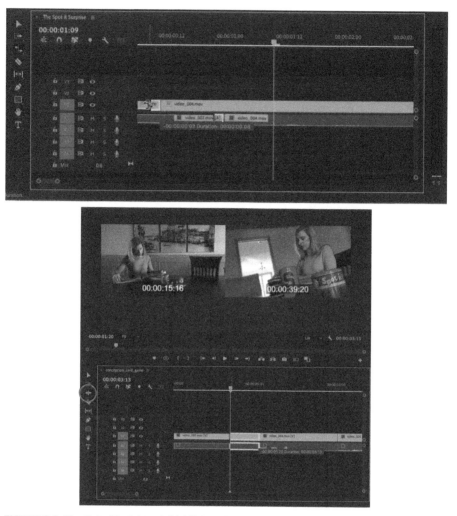

FIGURE 9.6 The Rate Stretch tool (highlighted in the toolbar on left, in action on the timeline on right) helps you fit a clip to the space available.

The Remix Tool

Recently added to Premiere Pro, the Remix tool is going to be game changing. Remix uses Adobe artificial intelligence (AI) technology to intelligently extend or contract a music track to fit a specific scene. This is helpful when you are working on, say, a 2-minute video but your background music is only 1 minute and 55 seconds. How do you fill those extra 5 seconds? Remix to the rescue!

Using Basic Effects in Premiere Pro

Premiere Pro includes a host of effects that you can use to enhance or correct your videos. While I encourage you to explore and experiment with many of these, I want to bring one especially useful one to your attention now: Dip to Black.

Two of the most common things you'll do with your video and audio are fade into the start and fade out at the end. To add a video fade element, you can use the Dip to Black transition. To find it, go to the Effects panel and look in the Video Transitions > Dissolve section.

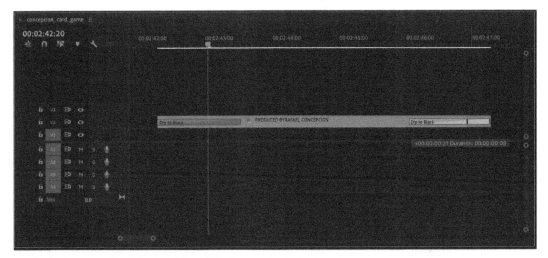

FIGURE 9.7 Adding a Dip to Black transition to the start and end of a clip

To add the Dip to Black transition, drag it onto the start or end of the desired clip in the timeline. A graphical overlay representing the duration of the fade appears on top of your clip. Click the transition and drag either end of this overlay to adjust the length of the dip visually. To fade in a clip, drag Dip to Black to the clip's start point. To fade out a clip, drag the effect onto the end of a clip. If you drag the effect to the point between two video clips, it will perform a fade out and fade in automatically.

> **TIP** *Find yourself using the same several effects frequently? Create a bin to store them in one handy spot: Click the New Custom Bin button at the bottom of the Effects panel, then drag your favorite effects into the newly created bin.*

Final Touches

As you become more adept at editing your videos, you will want to increase the production value of your work by adding additional elements to it—from a lower third identifying a person to an attention-grabbing graphic to B-roll footage that enhances a message. Premiere Pro can handle all of these elements in separate layers. Working in a multilayered document makes focusing on what you are editing a lot easier and reduces the time needed to get a final cut of your idea.

Working with Multiple Layers

When you select an individual clip of video in a timeline, you'll notice that both the audio and the video are selected and highlighted with a white outline. By default, the video appears in the V1 (Video 1) layer and the audio in the A1 (Audio 1) layer. You can move the video into a new layer by dragging it up and do the same for the audio by dragging it down. When you play the sequence in the timeline, the element that is in the uppermost video layer will be visible to the viewer. The layers below will be visible only if the element in the uppermost layer, such as a graphic, includes transparent areas. This is often the case when you include graphics in these uppermost areas. The audio in stacked layers will blend with one another.

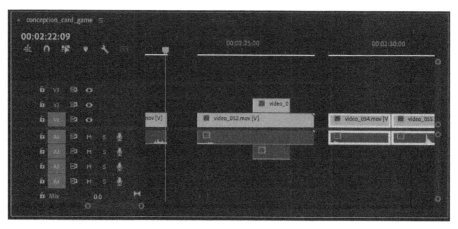

FIGURE 9.8 Working with multiple layers in Premiere Pro

Being able to cut from the video in one layer to a different video in another layer can have some benefits. Imagine that the video in V1 is an interview of a person talking about how they like to be outdoors. You can use the V2 layer for B-roll, which can

be footage of that person walking in a forest, and the audio on the A2 layer can be the person's footsteps and ambient outdoor sounds. When you play back the layered sequence and the timeline's playhead reaches the video in the V2 layer, Premiere Pro will cut to playing the B-roll, and A2's audio of the outdoors will blend with the spoken track of A1, raising the production value of your story.

Once it's all organized as you need it, you can later fine-tune how much of the outdoor elements you hear by adjusting the audio level of the clips on the A2 track only, a technique we'll talk about in the next chapter.

By default, when you drag video and audio clips into a layer on a timeline, the video clip will be linked to the audio that was recorded at the time. For more creative control, you can unlink the audio and video and then move them independently. To do so, right-click the video clip and choose Unlink from the context menu. You can also click the Linked Selection button in the Timeline panel to link and unlink layers.

FIGURE 9.9 Click the Linked Selection button to link and unlink layers in the timeline.

Adding Graphics to Your Video

When you want to add a title, box, or simple graphical element inside your sequence, you will likely use the Type tool (keyboard shortcut: T) and the Rectangle tool. Select the tool and click in the Program Monitor to create your element on the screen. Premiere Pro places the new graphic element in its own video layer; you can then move the graphic to a specific area or adjust its duration and more in the Essential Graphics panel.

Although the Essential Graphics panel might feel daunting at first, it is incredibly helpful, as it puts all of the characteristics you can adjust in one place. In **FIGURE 9.10**, for example, I used the Type tool to add a title. If I decide to change the typeface, I can select the text with the Type tool and change it in the Text section of the Essential Graphics panel. Here you can also change the leading, tracking, kerning, and alignment for a paragraph of text, as well.

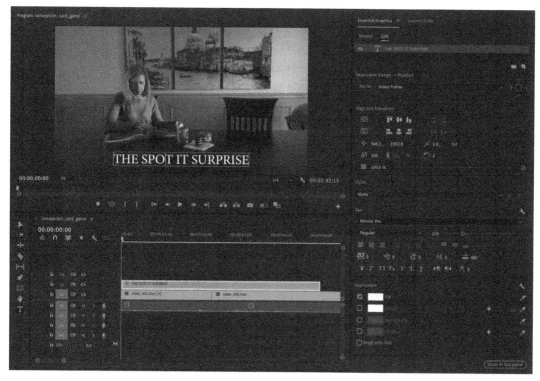

FIGURE 9.10 A graphical element added to a clip

Another very common thing you'll do with text and graphical elements is align them to the center of the screen. You can do this quickly using the Horizontal Center and Vertical Center buttons in the Align and Transform section of the Essential Graphics panel.

Using the Essential Graphics panel, you can also create layered graphical elements, which can streamline your production work immensely. Individual layers display at the top of the panel, so you can edit an individual layer if necessary. The best way I can explain how helpful layered graphics are is with an example.

Imagine you are working on a video clip and want to create a lower third with the subject's name (Rafael Concepcion) above their title (Photojournalist). This graphical element would consist of two elements. If you clicked the Premiere Pro timeline to create them, they would occupy V2 and V3, respectively. Now, imagine you want to add shapes—say, a box of one color behind the name and a thinner box of another color behind the title. These two additional elements would take up V4 and V5. Not only would this clutter the timeline, but it would mean any changes made to this lower third—a move, for example—would need to be adjusted *on all four timeline layers*.

FIGURE 9.11 The Essential Graphics panel (left)

FIGURE 9.12 The Text area of the Essential Graphics panel

FIGURE 9.13 The individual graphical element in the Essential Graphics panel

A better approach is to use the Essential Graphics panel. Here, you can create the lower third as a single graphic composed of four grouped layers. On the timeline, the layered element would occupy only V2, and a single change to location, scale, or opacity would affect the whole group. If you needed to edit one of the individual layers of the lower third's group, you could select and edit that layer in the Essential Graphics panel. This approach will speed up your work exponentially.

Adding Titles and Credits

Once you have the hang of creating text graphics on a new layer, turning them into titles or end credits is just a matter of where you place them on the timeline.

If you want a title to appear on a black background, you can move all of the video clips over to the right and place the graphical element alone with nothing underneath it. If you want some black to appear before the title does, you can just adjust the starting frame of the graphical element to leave some empty space to the left of the clip. Press the spacebar to preview the video and test the amount of time you have for a blank area and how long the graphical area will stay up. Once you are comfortable with the timing, you can move all of the video elements into the area where you would like them to start.

CHAPTER 10

Editing: Beyond the Basics

Editing a video in Premiere Pro is a straightforward process that you can learn in an afternoon. The *art* of editing, however, can take much longer to learn. Beyond the mechanics of which clip goes where and syncing video and audio tracks, the artistic side of editing involves adding more visual variety to keep the viewer engaged. For instance, you can control the pace of your story by speeding up and slowing down specific clips. You can even add motion graphics to your project without having to move into Adobe After Effects. All this and more adds a professional polish.

Once all the mechanical and artistic work is completed, you also need to know how to leverage your sequences for maximum compatibility across various video platforms. Tips to better your workflow and increase your artistic punch could fill another whole book, but for now, I'll stick to the best ones to keep handy when you make your first video stories.

▶ FOLLOW ALONG WITH THE VIDEOS

Although reading about editing is helpful, it can't fully convey just how much of a change you can make by adjusting a couple of frames or paying attention to timing—or how easily you can do it. For that, you need to see the editing techniques and tools in action and the difference in the resulting clips. So as you read this chapter, I encourage you to follow along with the companion instructional videos linked throughout. Read a section to gain a sense of how the discussed technique or tool works, then scan the associated QR code (or click the link) to see the video of it in action.

Once you've seen the instructional videos and gotten the hang of editing in Premiere Pro, you can use the book as an overall reference. Should you need to go back to the videos, they're just a QR code (or link) away.

To download the files for the sample project, go to rcweb.co/spotit-sample.

To view the instructional video playlist, go to https://rcweb.co/storytelling-premiere-basics.

🎬 **"The Spot It Surprise" Sample Project**

Use the QR code to go to the download files. If you're reading a print book, scan the code with your mobile device. If you're reading an ebook, tap or click the QR code.

Artistic Editing Techniques in Adobe Premiere Pro

Whether you need creative cuts to add visual variety, B-roll footage to add context, speed changes to add dynamism, or a filter to mask camera shake, Premiere Pro has you covered. In this section you'll learn how to add some finesse to your video stories—as well as fix common problems.

The J-Cut and L-Cut

Imagine a scene with two individuals talking to one another. When the first person speaks, you could cut to a medium close-up of person 1. When it's time for the other person to respond, you could then cut to the corresponding shot of person 2 speaking. This back-and-forth method of cutting would be your natural way to edit this scene, and very appropriate in many situations. But that same back-and-forth process can produce an interaction that feels very mechanical. It also moves the story at a slow pace. What if you could move the story along a little faster and give it a little bit of visual variety? You can!

Enter the J-cut and the L-cut. Both these techniques use the video from one clip along with the audio from a second clip. Which video is used for which clip denotes which type of cut you are using. In a *J-cut*, the audio from a second clip starts to play while the video track of the first clip continues to play. In a timeline this looks like a letter J. (To make this easier to see in **FIGURE 10.1**, I added a magenta tint to the clip whose audio starts playing early.) In an *L-cut*, the video and audio of the first clip play, then the video from the second clip appears while the audio from the first clip continues to play. In a timeline this looks like a letter L. (In **FIGURE 10.2**, I added a dark orange tint to the clip whose audio continues playing.)

> *TIP To tint a clip a specific color, right-click the clip, choose Color Label, and then pick the color.*

These two edits offer a great amount of visual variety, because they enable the viewer to see the visual response of someone hearing dialogue. This compresses the amount of time to get a point across and varies the visual aspect to make it more engaging. If you watch any television shows (whether actually on a television or streaming on another device), you will find the J- and L-cuts used all of the time, so it's worth getting comfortable with using them pretty quickly.

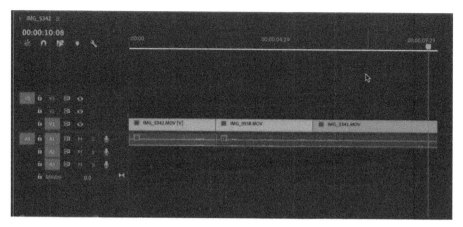

FIGURE 10.1 The audio from the clip IMG_5341.MOV (tinted magenta here) plays while the video from IMG_0558.MOV is visible. The resulting shape of the magenta clip resembles the letter *J*, which gives the J-cut its name.

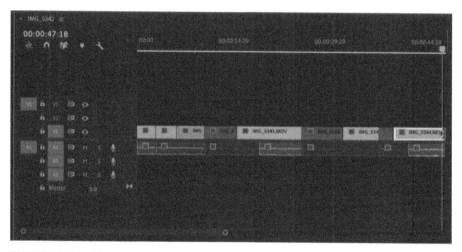

FIGURE 10.2 In this example, the audio from the dark-orange-tinted clip continues to play after the video has switched to a different clip. This is an L-cut, named for the shape of the dark orange clip as edited on the timeline.

The Importance of B-Roll

When making video of a story, the primary footage that you use to advance the story is called the *A-roll*. This footage normally has your spoken word audio attached to it. The purpose of the A-roll is to present the main part of the story and any dialogue that's associated with it. While it is certainly possible to create a video with only A-roll, your story will lack visual variety.

To make your content more engaging, you need to use some B-roll too. *B-roll* is additional video footage that provides a closer look into specific details of your story. This footage serves as the connective tissue for your story. If your story includes a restaurant owner talking about the benefits of adding bacon to your hamburger, for example, B-roll footage showing a close-up of glistening bacon being placed atop a steaming hamburger will make your point more enticingly than the A-roll dialogue alone. B-roll footage allows you to dive deeper into a specific topic and move the story forward visually. As a rule, you can never have enough B-roll.

While this additional footage increases the visual diversity of your video, it has another great practical use as well. When done properly, the B-roll can be used as a visual Band-Aid to cover up problems and smooth editing sequences. What if, for example, your bacon-loving restaurant owner flubbed a line in the A-roll?

Of course, during the shoot you asked your subject to repeat the passage to capture a clean take. When you attempt to edit this new version into your original take, however, you end up with a jarring skip in the sequence, known as a *jump cut*. No matter whether your subject stands as still as possible, there will always be something that changes between the two versions of the clip—ambient sounds, a shadow across lighting, a slight breeze kicks up, you name it—and the juxtaposition of those changes will be disconcerting to the viewer.

Luckily (or by clever planning), you captured B-roll video of one of the cooks placing bacon on a hamburger; instead of using a jump cut, you can go to B-roll. This time when you edit the sequence, you cut to the correctly delivered line and place your B-roll of the bacon on top of the A-roll. The viewer gets to see something with more variety while you get to cover an error in the dialogue. This is a win-win for both you and your video editor.

Speed Ramping Video Footage

A great way to add some dynamism into your video is to adjust the speed at which a clip plays. You can do this easily with the Time Remapping feature in Premiere Pro.

FIGURE 10.3 The speed line, known as the rubber band, on a video clip in Adobe Premiere Pro

In the Timeline panel, start by dragging up the upper border of the video track to make it taller. Next, click the FX button on the video track and choose Time Remapping > Speed from the menu to change the horizontal line that spans the length of the video track to a control for adjusting the overall speed of the video. Drag this control, called the *rubber band*, upward to speed up the clip. Notice that to compensate for this, the clip's length decreases on the timeline. To slow down the video, drag the rubber band downward; the length of the clip in the timeline will expand, if there is no clip immediately after it. If there is a clip after it, Premiere Pro essentially hides the frames at the end of the expanded clip. You'll have to move or trim the adjacent clip to recover those end frames.

> **TIP** *To increase or decrease the video track height, you can press Command++/ Ctrl++ or Command+-/Ctrl+-, respectively. To increase or decrease the audio track height, press Option++/Alt++ or Option+-/Alt+-. (These shortcuts may not work if you are using a non-English keyboard.)*

FIGURE 10.4 Drag up on the top edge of the video track.

FIGURE 10.5 Choose Speed from the FX context menu.

FIGURE 10.6 Dragging up the rubber band will show you the speed percentage.

You can take this remapping technique even further by setting different sections of a clip to play at different speeds. To specify which part of a clip speeds up or slows down, hold the Command (macOS) or Ctrl (Windows) key and click the rubber band; a set of blue handles, called *keyframes*, appears on the clip. Now when you drag the rubber band up or down Premiere Pro changes the speed of the video between those keyframes only. If you Command-click/Ctrl-click another point on the rubber band, you can adjust the speed of the section between those keyframes. You should keep in mind however, that adjusting the speed of the video will result in your video and audio being out of sync.

FIGURE 10.7 The handles on the ends of each clip let you change how something slows down or speeds up.

You can refine this adjustment even further. Each of the keyframes where you changed the speed is composed of two handles. You can use these to control how quickly or slowly the speed of the clip changes. Drag one handle away from the other to add a slope to the rubber band, which creates a gradual change in speed. You can also select one of the handles to access a Bezier curve control, then adjust this curve control to introduce a gradual change in speed.

FIGURE 10.8 The final result of adjusting keyframes creates a clip that slowly speeds up, then slows down.

Fading Audio Volume for Additional Control

The rubber band on the audio track works similarly to the one on the video track, but it controls the clip's volume instead. Dragging down decreases volume, and dragging up increases volume. Command-clicking/Ctrl-clicking the line adds a keyframe (displayed as a blue dot), enabling you to adjust the volume at that specific moment. To fade the audio on an individual clip, add two keyframes to the audio track to denote the start and end of the audio adjustment. Click the rightmost dot and drag downward to fade the audio down.

FIGURE 10.9 Adjusting the volume line in an audio layer in the Timeline panel

FIGURE 10.10
Dragging the keyframe downward decreases the volume.

Adjusting the audio levels on each of the clips will create smoother transitions between them, increasing the production value of your story. Knowing how to control audio will help you mix different audio sources to add more aural depth to your story.

Duplicating Sequences

Whether you want the security of a backup in case of an app crash or power loss, or you need to create multiple copies of your work for different social media formats, having duplicates of sequences can be a really good thing. To duplicate a sequence, right-click it and choose Duplicate from the context menu. Now you have a copy of the original that you can rename and use for whatever purpose you'd like.

Backup duplicate sequences aren't just handy for emergencies. Many times, I sit and fine-tune an edit of a sequence for hours, only to find myself not liking what I did and having to go back to the first edit. Instead of relying on a previously saved file or the History panel, I can perform the new edits on the duplicate sequence (named V2), knowing that if I don't like *those*, I can always go back to the original version.

Duplicates also make great shortcuts when you need to share your work in a variety of channels with different time constraints. Perhaps you want to create a 15-second teaser for Facebook that links to the larger video on YouTube, as well as a 90-second trailer for Instagram. Instead of re-creating the timeline from scratch for each target platform, you can create duplicate sequences of the work that you have already produced and adjust the individual timelines to match the duration that you need. You can also open the settings for each sequence (Sequence > Sequence Settings) and adjust the width and height of the video to suit the format you are exporting to.

Stabilizing Shaky Footage

Video requires a very steady hand. Although technology is making great strides in stabilizing footage in-camera, there will be times a bit of shakiness creeps in. To help minimize it, you can call on a filter inside of Adobe Premiere Pro: the Warp Stabilizer filter. In the Effects panel, navigate to the Distort folder and select Warp Stabilizer from the list. Drag the Warp Stabilizer on top of the video clip in the Timeline panel, and Premiere Pro will begin to analyze the clip and offer a potential fix for the video.

Depending on the level of shakiness of your video, you may need to go into the Effects Control panel to change the amount of adjustment. Too much stabilization can give the video an overprocessed, jelly-like appearance.

FIGURE 10.11 Drag the Warp Stabilizer effect onto a video clip to make it look steadier.

Going Beyond Premiere Pro

Putting the final touches on a story and exporting the final version often requires leveraging the full suite of tools in your Adobe arsenal. A couple of shortcuts can save you time and effort, though: Creative Cloud Libraries enable you to share assets across various Adobe programs, while Motion Graphics templates can give your production a new level of polish without your having to learn how to design complex moving graphics. We'll take a look at both in this section, then wrap up with some tips on using Adobe Media Encoder to export your story to a wider audience.

Using Creative Cloud Libraries

After working on a few video productions, you'll notice that you're frequently using a set of common elements. Rather than remake them for every project, you can save one set of these assets in a Creative Cloud Library and use it across all your Adobe applications and work sessions. The assets you save in a library don't have to originate in Premiere Pro, either. You could create a logo for your video in Adobe Illustrator, save it to a Creative Cloud Library, and access it from Premiere Pro. Should you need to use that logo in a printed piece, you could grab the logo from the library and place it into an InDesign or Photoshop document. You can also view and manage all of these library assets in Creative Cloud. If you move to a new computer and sign in with your Creative Cloud account, you will have access to your Creative Cloud Library assets there as well. This can save a lot of time and open up a lot of opportunities to work with your Creative Cloud assets on any device.

FIGURE 10.12 Creative Cloud Libraries are accessible in all Creative Cloud applications, making it easy to access assets across a range of projects and devices.

Using Motion Graphics Templates

You can add a lot more production value to the clips that you are putting together by including motion graphics. As we discussed in Chapter 9, a clever lower third introducing your speaker and their title can add some visual flair to your video. Or perhaps you need to emphasize how high a firefighter had to climb to save a cat from a tree; add an onscreen marker that shows the distance to the ground and it elevates your news production to another level.

The problem with incorporating such visual sophistication has been that you generally needed to use Adobe After Effects to create the graphics—and that meant learning a new program or commissioning the motion graphics from an After Effects artist. In both cases, the time, expense, and hassle involved was a daunting mix.

Adobe made the process a lot easier with the introduction of Motion Graphics templates (MOGRT files). These are individual animation files that you can download and import into your local Templates folder. The files also are displayed in the Essential Graphics panel. You can drag these motion graphics into the timeline and immediately see the effect—no more waiting for an After Effects artist to create, render, correct, and re-render. If you need to make an adjustment to the graphic, just open the Essential Graphics panel, where you can access individual controls for the graphic's various elements.

Motion Graphic Template Set
Use the QR code to watch the video. If you're reading a print book, scan the code with your mobile device. If you're reading an ebook, tap or click the QR code.

Beyond Adobe's collection of MOGRT files built into Premiere Pro (and those on Adobe Stock), you can download Motion Graphics templates for your productions from many resources. Some offer free templates, some let you purchase templates individually, and others are subscription services that allow unlimited downloads. As with most things, you get what you pay for, so it's wise to spend some time downloading a number of these templates to see how they might work in your productions. The choices can be overwhelming, but I recommend you first focus on lower thirds graphics (for identifying individuals) that highlight a specific area of the frame, and news tickers.

It's important that you have a starter tool kit that will get you up and running, so I've provided a set of Motion Graphic templates in the book's asset files that you can use to make your projects look more professional and give you an edge over other creators. Use the QR code to watch a video about downloading these files, importing them into the Essential Graphics panel, adding them to an existing timeline, and editing them to suit your needs.

Using Adobe Media Encoder

When you finish compiling all of your individual clips into a sequence, you're ready to export. Depending on the specs of your machine, this may be a frustrating or exhilarating moment. If you export straight from Premiere Pro, however, you will not be able to edit other projects with the program until the export finishes.

A better approach is to offload the export to Adobe Media Encoder. An invaluable part of your workflow, Media Encoder is a separate program that installs when you install Premiere Pro. In the Premiere Pro Export tab, you can choose to send the file out to Media Encoder. While it is busy encoding that footage, you can proceed to work on another project in Premiere Pro. Media Encoder can also export finished video files using the appropriate dimensions and compression settings for a variety of social channels.

> **NOTE** You are asking your computer to do a fair bit of work when you are exporting. Any other work that you may be doing at the same time may slow down the export.

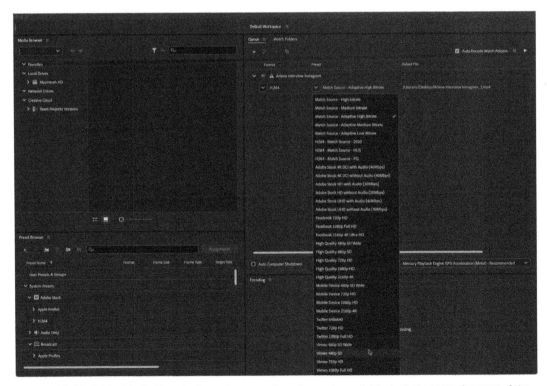

FIGURE 10.13 Adobe Media Encoder has a large number of presets available, including ones for most of the social channels.

Source

Video 1080x1920 (1.0) 29.97 fps Progressive 00;00;27;10
Audio 48000 Hz Multichannel

Output

Video H.264 1080x1920 (1.0) 29.97 fps Progressive 203 (75% HLG, 58% PQ) Hardware Encoding 00;01;01;17 VBR 1 pass Target 19.00 Mbps
Audio AAC 320 kbps 48 kHz Stereo
Estimated File Size 148 MB

Send to Media Encoder Export

FIGURE 10.14 At the bottom of the Media Encoder window, you will see the source video's properties, as well as those of the output file.

External Drives for Encoding

Use the QR code to watch the video. If you're reading a print book, scan the code with your mobile device. If you're reading an ebook, tap or click the QR code.

Here's another power tip as you move along your video journey, especially if you are a student working in a computer lab. If you have your Project folder set up correctly, you can move the entire project to a fast SSD drive via a USB-C or Thunderbolt connection. You can then move the SSD to another machine with Media Encoder installed and add all of the sequences you want to export into its queue. From there, click Export, and you can go back to your main computer to work. (Scan the QR code to watch a video about drive speeds and see how to use an external drive to encode a file in Media Encoder.)

 CHAPTER 11

Mobile Journalism Project

Asad reality of journalism today is that it is a victim to cost-cutting and slowing budgets. In our work to bring truth to power, we are asked to do more and more with less and less. Technology is key to bridging that gap, and widening the field of individuals who can become journalists. Newsrooms around the world are realizing that one of the most powerful tools for newsgathering rests inside journalists' pockets: the mobile phone. Instead of carrying heavy, expensive gear to locations and requiring several people to produce one story, journalists now can shoot, edit, and share their stories with gear that all fits in a backpack. Because of this, more and more organizations are adopting a mobile strategy for their journalists around the world.

Technology makes it affordable to share the news and allows more people to be a part of it. It's a good idea for you to have this skill under your belt; you never know when you may need to tell a story.

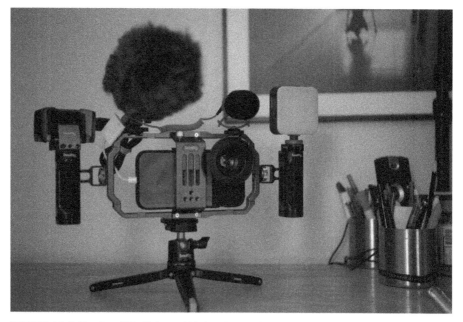

FIGURE 11.1 The SmallRig Universal Mobile Phone Cage and Desview teleprompter on a SmallRig CT180 tripod

My Sample News Story: A 35,000-Foot Overview

In this project, we will create a sample news package about the use of mobile devices to tell stories (how meta, I know). The piece will focus on how the field of journalism is changing and how students are learning to make stories using their phones. For the story, I plan to record a couple of students speaking about their experiences with using their phones to create video stories and offering insight as to how their opinions changed about using a mobile phone.

I will write a script and ask a journalist to review and comment on it. Once that script is polished, I will record it for the A-roll using a portable teleprompter.

After the A-roll is complete, I will gather a series of interviews to add to it, rounding out a more complete story. In the middle of the package, I would like to have sample footage of students working on their computers to cover a majority of the A-roll's video. The goal here is to see the journalist about only 10% of the time in the entire package.

Once all of the video is laid out, we'll add a lower third graphic and a ticker through the use of Motion Graphics templates. The result will be a complete story that can be submitted online.

While this type of story is easy for a single journalist to shoot, edit, and share, we're going to work together. I'll prepare and record the script and video, then you can download and edit the footage into a finished story. Before you jump ahead to fire up Premiere Pro, however, let's walk through my half of the project.

Your News Story May Vary

It's important to keep in mind that this sample news package is based on *one* specific recipe. If you decide to work in journalism, you will find that there are a ton of different recipes and formats out there, and those formats will be dictated by your newsroom. That said, in every news story you can count on common elements:

- A-roll: The primary narration of the story.

- B-roll: Video footage without sound that emphasizes key parts of the story.

- SOT: Interviews with individuals are usually known as *sound on tape* (SOT). They allow the subjects of the story to move the story forward.

- Supers: Any graphic that goes on top of the video (short for *superimposed*). The most common super is a graphic that occupies the lower third of the video, identifying a person, also known as a *lower third*.

- Screen grabs: You may have to show a website; when you do, make a copy of it as a graphic and place that graphic in the video.

Keep in mind that going through the process of becoming a journalist is something that requires study and is outside the bounds of what I'm trying to share with you in this book. With this project, I am more interested in you being prepared to capture the elements that you need and put them together.

Going back to that food analogy, this project is about learning how to move around the kitchen and use the pots and pans by making some simple meals. If you want to learn the intricacies, culture, and craft of a complex food like sushi, you'll need to go to a cooking school. We're just learning the basics here.

From Bullets to a Script

To start the script, I generated a series of bullet points that I wanted to cover:

- I want to talk about newsrooms moving to mobile devices.

- I want to talk about how we are teaching journalists to use mobile devices at the S.I. Newhouse School of Public Communications at Syracuse University.

- I want to share the benefits of using a mobile device in various situations.

- I want to showcase how you can set a mobile device to record on its own to add more dynamism to the story.

- I also want to include a small soundbite from myself, as well as some student opinions.

- I want to add motion graphics, simulating breaking stories, and lower thirds for all of the subjects.

I wanted to make sure that the script talked about these general ideas and had a transition from one to the next. I forwarded the bullet points to Louise Rath, a senior journalism student at the Newhouse School, to develop the bullets into a usable script. I planned to have Louise speak on camera about making a script, as well.

FIGURE 11.2 Louise preparing the script to place in the teleprompter

Here's the resulting script:

In life and in our careers, everyone is looking for that next step. For journalists, that next step might already be available to us and we might be advancing with our technology without even realizing it. The reality is that the face of news is changing and we journalists work in a fast-paced environment. It's becoming more and more important to put cameras in unique places, turn content quickly, and travel light while doing it.

The reality is that now all you need is your cell phone and a story to tell. This is how first-year students at Syracuse University's S.I. Newhouse School of Public Communications are learning to tell their stories. These students are putting together competent, quality news packages without all the clunky, heavy equipment that news stations are known for. And it's just that phones are easier, are more mobile, and can take you places generic news cameras can't.

Plus, smaller cameras can fit in small places and offer a new perspective. Take a look at this shot of COVID tests being transported through Syracuse University's testing center. This was shot on a cell phone. Professor Rafael Concepcion teaches how to use mobile technology in his classroom. His newest book covers the technique, story, and developments, and offers practical examples students can follow along with.

You see anyone has the tool set to become a journalist. There are little things we can do to enhance the quality of storytelling with the mobile phone. But as you can see, it's quite literally at the touch of our fingertips. For the Sample Practice News Show, I'm Louise Rath.

With the script complete, it was time to record.

Recording the Video

To record the video, we used an iPhone held with a SmallRig Mobile Video Cage on a SmallRig tripod. We used a SmallRig shotgun mic attached to the iPhone via the lightning port for backup audio and a scratch track to sync later in Premiere Pro.

FIGURE 11.3 Getting ready to record the A-roll of the video

To get better audio, we used a Rode VideoMic NTG shotgun microphone mounted on a container of whiteboard wipes. The audio was recorded to the Zoom F3 field recorder. The F3's 32-bit recording capability meant we could increase and decrease the volume without fear of clipping.

FIGURE 11.4 Side view of the shotgun mic and "dead cat" (the wind screen, which isn't really needed indoors)

While we were prepared to place the mic overhead on a boom arm, we were lucky to have a ledge right where Louise was recording the video. Using the wipes container allowed us to work more quickly and got the microphone just out of the camera frame for good sound. Sometimes, you have to improvise.

When it's time to edit, we will go through the video with the audio from the Small-Rig shotgun microphone. This audio serves two purposes. First, it provides a *guide track*, a good audio track to help sync the audio from the Zoom F3. Second, the audio from this microphone serves as a backup in the event something goes wrong with the Zoom F3 track.

I placed Louise in front of a window so that the light is on the camera's left side (to her right). This framing allows the viewer to see farther into the hallway, offering a little bit more depth to the shot.

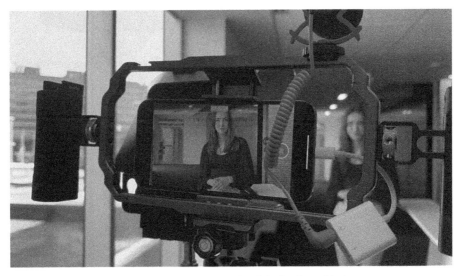

FIGURE 11.5 Using the main window light as a key light for the subject

Using a Mobile Teleprompter

For this project, I decided to have Louise read from a teleprompter. True, journalists often memorize blocks of content like this script in the field or record a majority of it reading directly from their script. When they do, they know that the video of them looking at the script will be covered with B-roll. I actually resisted the use of a teleprompter for a long time, until convinced by a colleague to switch to it. Oddly enough, the switch had nothing to do with reading.

FIGURE 11.6 A front view of
the teleprompter

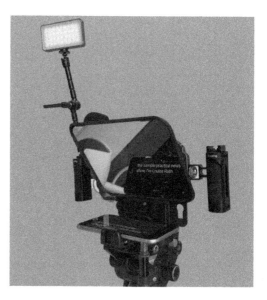

I became a teleprompter convert because the use of it offers the flexibility to develop a script in the writing process, making sure that the messaging is as concise as possible. Without a script, I felt that I would add a lot of unnecessary words to what I was trying to say or take longer to get to a point. This amount of vamping took away from the professional polish I wanted in my videos. Writing the script ahead of time kept me concise and to the point. The compact, iPhone-compatible Parrot Teleprompter Kit from Padcaster takes up little room in my bag, so it's well worth the space to increase the quality of my message exponentially.

For this project, I loaded the script into the Parrot Teleprompter app on an old iPhone 8 that I keep in my bag expressly for this use. Then, I attached the iPhone to the Padcaster Parrot Teleprompter I had connected to the front of the SmallRig Mobile Video Cage on the tripod.

SOTs and Additional B-Roll

Once I got Louise reading the script, I moved on to getting SOTs (sounds on tape) in the form of interviews with other students talking about the program. I captured additional B-roll of students working, paying particular attention to ensure the students wouldn't be identifiable in the video.

To add more visual variety to the package, I recorded an SOT with "the author" mentioned in the script (yours truly) and captured exterior video of the Newhouse School at Syracuse University to use in the introduction.

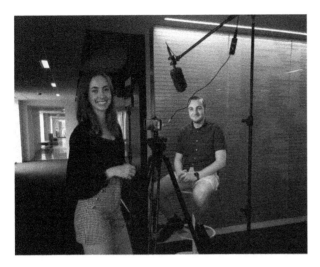

FIGURE 11.7 Preparing to record sound on tape (SOT) for the package

Finally, I recorded B-roll of Louise in a couple different places where someone would not normally carry a heavy news camera (from the top of a ninja warrior structure to the inside of a refrigerator and an airplane cockpit). These shots offer the intrigue that Louise and I thought would be important to the piece.

I then sorted the footage into individual folders and placed them inside the project's Footage folder to keep everything organized. When working on a tight timeframe, it's important that each folder contain a different source of video to keep yourself organized. I also copied the audio track from the Zoom F3 and placed it into the Audio folder.

The resulting project looks like the folder in **FIGURE 11.8** and is available for you to download. You can find the 1.7 GB ZIP file at rcweb.co/st-sample-news-project. Download it now, because your half of the project—editing and polishing the story—is about to begin. As before, you will need to unzip the project onto your desktop in order for you to follow along.

The Sample News Project

Use the QR code to go to the download files. If you're reading a print book, scan the code with your mobile device. If you're reading an ebook, tap or click the QR code. To download the sample project, go to rcweb.co/st-sample-news-project.

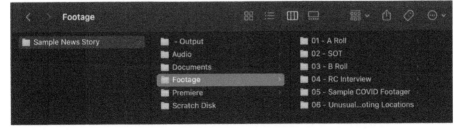

FIGURE 11.8 An overview of the folder structure I keep when working on a project

ON WORKFLOWS AND PASTA SAUCE

I've had the privilege of teaching thousands upon thousands of creatives for over 20 years. I can confidently say that the number one thing that people find the most difficult isn't learning the technology, it's the workflow.

Using software isn't always easy, but it's definitely knowable. You can go through a series of steps and learn how to apply a filter to something. As you move from inexperienced to more knowledgeable, you will invariably hit a point where you have enough software skill. From here, your task is to learn how to scale what you know and how to make it faster and easily repeatable. For that, you need to develop a specific set of steps for how to do something; you need a *workflow*.

The process of building this project is based on a workflow that I believe will get your idea out as quickly as possible. As you go through the assembly, make sure you do every step. While initially it may appear tedious and worth skipping, resist the temptation. Skipping it will come back to bite you later on. If you find at some point that the individual steps do not fit into your workflow, you can design your own. But you'll at least be designing one from a point of knowledge of what works and what doesn't.

Workflows are a lot like pasta sauce: everyone thinks that their own sauce is the best and that everyone else's is just terrible. But we all have to start with one.

FIGURE 11.9 Everyone has their own specific pasta sauce workflow.

Assembling the News Package in Premiere Pro

With all of the assets in place, create a new Premiere Pro project inside the Sample News Story/Premiere folder. This will ensure that your auto saves will be placed in this same folder, and you won't have to go searching around your computer to find where you placed the project.

FIGURE 11.10 The new Project panel and Import mode in Premiere 2022

FIGURE 11.11 I saved my Premiere Pro project file in the Premiere folder in the project folder.

Open Premiere Pro, and drag the Footage and Audio folders into the Project panel. Premiere Pro will create bins with names that are similar to those of the folders that you are importing—with a catch. If you drag in a folder containing one file, Premiere Pro will import just the file. I still recommend that you import by dragging, however, because Premiere Pro will do the heavy lifting on a majority of the folders. You can then go back into the Project panel and create the bins for the ones that are missing and drag the files into the respective bins.

FIGURE 11.12 The A-roll folder in my project

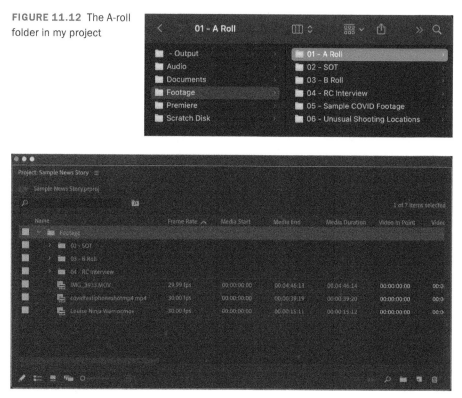

FIGURE 11.13 The footage in the Project panel

From a workflow standpoint, it's a good idea to have everything in a specific place, both on your computer and in your Project folder.

Create one final bin called Sequence, and create a new 1080p 30-fps sequence similar to the one shown in **FIGURE 11.15**.

When you are finished, you should have a project structured similarly to mine in **FIGURE 11.14**: bins for each of the components of the news piece and a Sequences folder to hold all of the various arrangements that you may make for this news package.

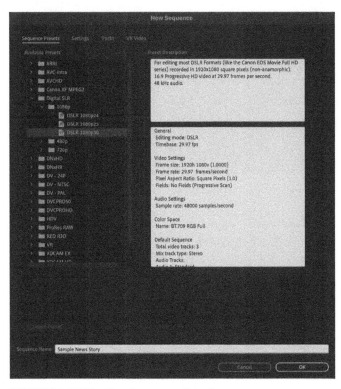

FIGURE 11.14 The Project panel with all of the items in a dedicated bin

FIGURE 11.15 The New Sequence dialog box

FIGURE 11.16 A new sequence inside its own bin

Set Up Your Timeline

The creation of a news package is relatively easy provided that you establish a specific workflow for the footage you plan to use. Let's start with just using the video and audio footage directly from the phone. Here's where to put what in your Timeline panel:

- V1/A1 track: A-roll
- V2/A2 track: SOTs (interviews with the students and author) and B-roll
- V3/A3 track: Any still graphics
- V4/A4 track: Motion graphics, such as lower thirds markers
- V5/A5 track: Ticker (optional, you can place this later)

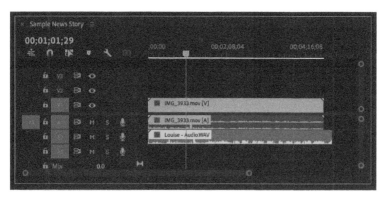

FIGURE 11.17 How to set up your timeline in Premiere Pro

To begin, open the Sample News Story sequence and drag the A-roll footage from the A-Roll folder onto the timeline. Once the video is in place, drag the F3 audio from the Audio bin into the A2 track.

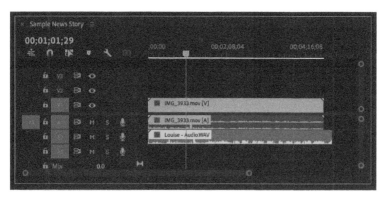

FIGURE 11.18 The A-roll footage on the external audio in the sequence

Select all of the tracks by dragging a selection around them. With all three tracks selected, choose Clip > Synchronize to open the Synchronize Clips dialog box. Here you can select which track you would like to synchronize the video clips with. Leave the defaults as they are, and click OK to synchronize the F3 audio track with the video, using the video's audio as a guide track.

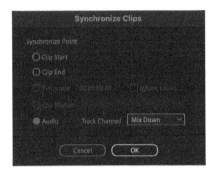

FIGURE 11.19 The Synchronize Clips dialog box

Now drag the F3 audio on top of the guide track, so the F3 recording becomes the audio in A1. Once that's complete, select both audio clips, right-click them, and choose Link so they don't slip out of sync in the future.

FIGURE 11.20 The audio and A-roll synchronized in a sequence

Edit Faster Using Keyboard Shortcuts

At this point in the process, you need to cut the A-roll into the individual sections in the script. The recording has some intentional flubs for you to practice how to trim the entire video on the timeline as fast as possible. Keyboard shortcuts will help you make quick work of this process.

The + and – keys are the basis of some handy shortcuts for seeing what you're working on. Press each alone to zoom in or out of the timeline, respectively. Hold the Option/Alt key and press the + or – key to increase or decrease the height of a selected audio track. Increasing an audio track's size lets you see its volume line, which makes adjusting the audio easier. Similarly, combining the Shift key with the + or – key increases or decreases the height of the video track. (If you have a non-English keyboard, you will have to create custom shortcuts for this.)

Zoom in, and you'll notice that the audio track starts before the video track in this example. To trim the audio and video tracks so they start at the same point, navigate to a point where both the audio and video are in sync and press Command+K/Ctrl+K, which cuts both of the tracks together. Using the Selection tool, drag in the gray area to the left of the video track to make a selection of both the audio and video tracks. Then, press Option+Delete/Alt+Backspace to delete the clips and move the remaining video back to get rid of the empty space. This is known as a *ripple delete*.

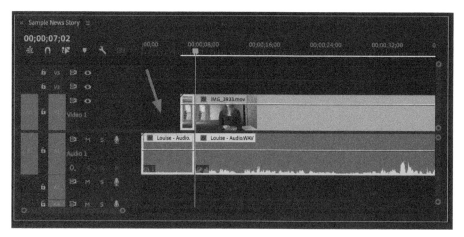

FIGURE 11.21 This section of the audio and video are not needed.

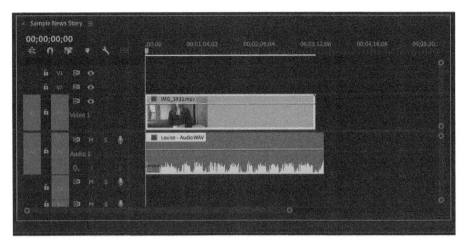

FIGURE 11.22 The sequence is adjusted after the ripple delete.

Once you have the clips even, you're ready to go. Use the audio spikes on the F3 video clip to get to the start of the package. Once there, press the Q key, and Premiere Pro will ripple delete everything to the left of the timeline, which is amazingly helpful.

Navigate to the end of the first part of the script, and press Command+K/Ctrl+K to cut the audio and video clips at that marker. With that part cut, simply navigate to the next start of the video script and press Q again to get rid of the video clips between your last cut point and the point where you marked the next start on the timeline. These keyboard shortcuts will make quick work of editing the A-roll to look like **FIGURE 11.23**.

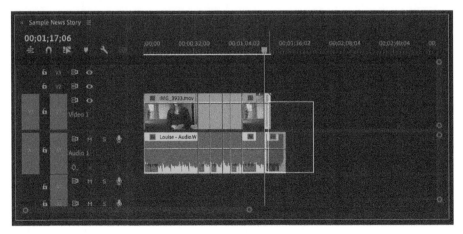

FIGURE 11.23 Making a selection of all of the audio and video clips

Build the Sequence

Once the main audio is set, you can go back and insert the individual SOT files in between the video clips by navigating to the desired breaks using the Up Arrow and Down Arrow keys.

The left side of the Premiere Pro Timeline panel shows two sets of V1 markers as well as two A1 markers. In the first column (left), you specify which tracks you will insert footage into (V1/A1, the tracks that hold your A-roll) using your keyboard shortcuts. In the second column (right), you tell Premiere Pro which track to paste the SOT footage into (V2/A2, according to our plan). Once that's completed, you can use the Up and Down Arrow keys to quickly move to each cut point on the timeline. Let's move to the first cut point in the video.

Go to the 02 – SOT bin, double-click the Alexa_Interview footage, find the first clip that you would like to add to the video, and mark the clip's In and Out points with the I and O shortcut keys, respectively.

FIGURE 11.24 Setting the first In and Out points for your first SOT

Because you switched the insert tracks from V1 and A1 to V2 and A2, Premiere Pro will place the footage you want to insert in between the points of the video clips that you already have in the timeline. The Insert function will expand the timeline to make room for the clips, but place the video and audio on their own individual tracks. Follow the same procedure to add the second student SOT, as well as the SOT with the author. When completed, the video timeline will look similar to **FIGURE 11.26**.

FIGURE 11.25 The section of the video you selected for an SOT in the timeline

FIGURE 11.26 A near-finished timeline for your news package

Overlay the B-Roll

In this news package, the goal is to cover the majority of the A-roll with B-roll so viewers see the journalist as little as possible. Thus, you want to make sure that whatever B-roll you place on the timeline overwrites rather than expands its length. To do so, use the Overwrite shortcut key: the period (.).

FIGURE 11.27

Selecting B-roll from the Source Monitor

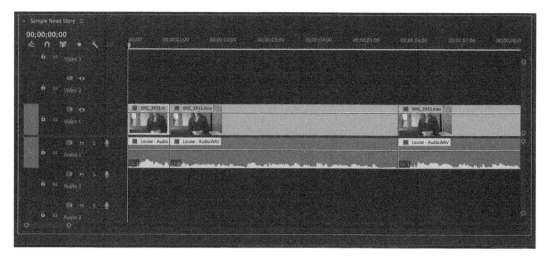

FIGURE 11.28 The timeline set to insert video on V1 and A1

Suppose you just added an In point and Out point to footage in the Source Monitor. If you switch your insert tracks back to V1 and A1 and press the period key, the new footage will replace (overwrite) all of the footage that existed in that video track and the audio track. The timeline won't expand as it did when you used the Insert command.

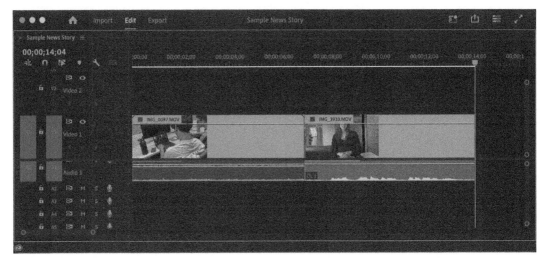

FIGURE 11.29 The B-roll video overwrites the existing video in the first track.

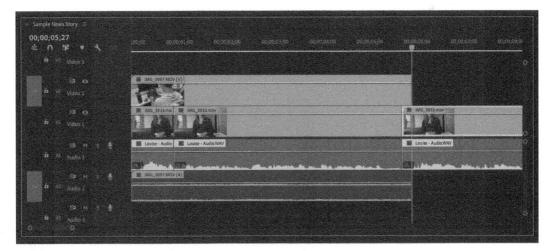

FIGURE 11.30 With V2 and A2 selected, the overwritten video is placed in a new track.

If you set the insert tracks to V2 and A2 and pressed the overwrite shortcut, Premiere Pro will place the video and audio over the video that you have for the A-roll and still not expand it. This would be an ideal solution if you wanted to include video over the narration, track, and natural sound from the B-roll all in one shot.

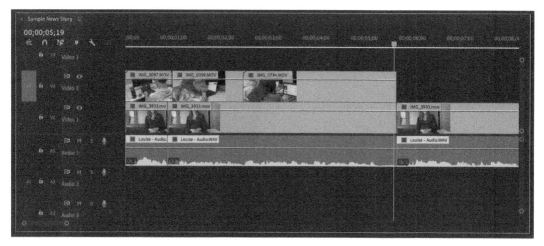

FIGURE 11.31 Selecting V1 ensures that only the video is placed on the track.

Now suppose you turn off the Insert feature for the audio altogether and leave the Insert feature at V2 for the video. This time when you select the appropriate B-roll and press the period shortcut, that B-roll will appear on the second video track over the A-roll with no audio.

You can achieve a similar effect in the Source Monitor by selecting the In and Out points of a specific clip and dragging the Drag Video Only icon on top of the second video track.

FIGURE 11.32 The Drag Video Only icon in the Source Monitor

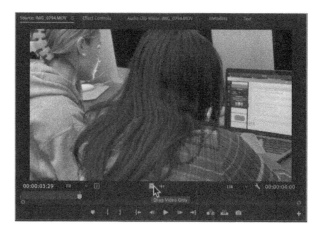

Adjust Video Speed Using Rate Stretch

One section of the video calls for the addition of a B-roll video clip (the delivery of COVID tests) that is longer than the section of A-roll that we want it to reside in. Ideally, we would like the entire duration of this video to run, but within the amount of space that we have in the script. To do this, we'll need to speed the clip up. Although you could right-click the clip, select Speed/Duration, and guess a total speed change, using the Rate Stretch tool is easier. You can access the Rate Stretch tool inside the Ripple Edit tool or by pressing the keyboard shortcut R.

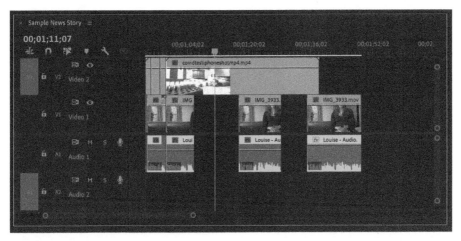

FIGURE 11.33 A gap that needs to be covered in a Premiere Pro sequence

FIGURE 11.34 The Rate Stretch tool is nested below the Ripple Edit tool.

With the Rate Stretch tool, you simply drag a piece of video footage that is on the timeline to fit a specific space, and Premiere Pro automatically adjusts the clip's speed as needed. Drag the right edge of the COVID test delivery video clip to fit the

space where the narration is. The video clip will automatically speed up so that the entirety plays in that space.

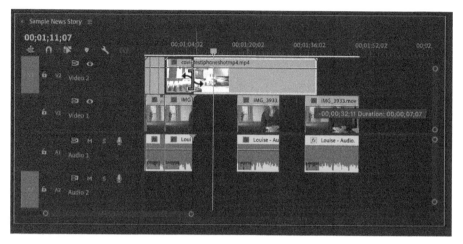

FIGURE 11.35 Adjusting a video clip using the Rate Stretch tool

After inserting all of the shots of B-roll and the sped-up video clip, the initial layout of the video is complete.

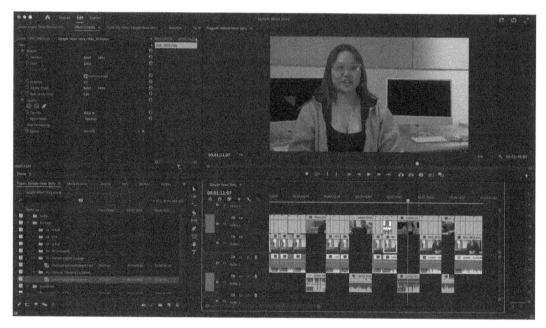

FIGURE 11.36 The initial layout of the news package—it just needs graphics.

Use Motion Graphics Templates for Lower Thirds

A good way to add production value to any video piece is to use motion graphics. This no longer means firing up Adobe After Effects, however. Recent versions of Premiere Pro have afforded creators the opportunity to use ready-made elements in the form of Motion Graphics templates (MOGRT files). Premiere Pro includes a series of stock Motion Graphics templates, or you can download templates designed by other creatives (as discussed in Chapter 10). Even better, instead of building a lower third from scratch, you can use one of the free templates provided with the book.

Installing Motion Graphics Templates

Use the QR code to watch a video about downloading and using the Motion Graphics templates that are provided with the book. If you're reading a print book, scan the code with your mobile device. If you're reading an ebook, tap or click the QR code.

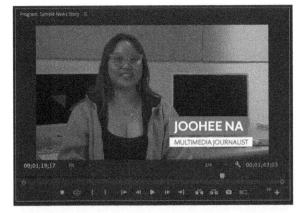

FIGURE 11.37
The lower third graphic

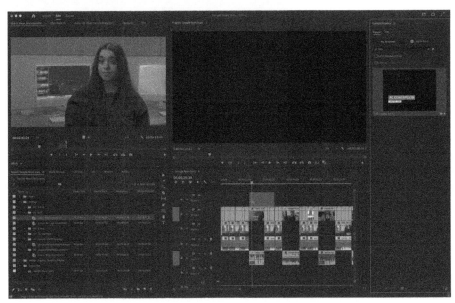

FIGURE 11.38 The MOGRT template in the Essential Graphics panel

Open the Essential Graphics panel by choosing Window > Essential Graphics. In the search option, type **Step** to find the lower third Motion Graphics template. Drag the template on top of the video, and Premiere Pro will create a new layer with the template included. Click the template, and use the Edit panel in the Motion Graphics template to change the name and title to identify the individual in the footage.

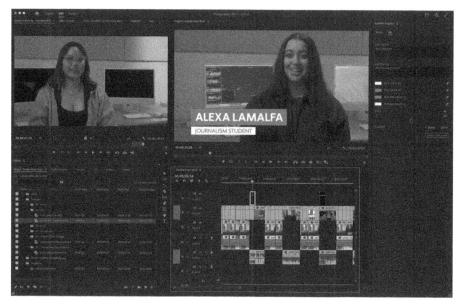

FIGURE 11.39 Adjusting the template in the Essential Graphics panel

Additionally, you can use the Rate Stretch tool to shorten the duration that the motion graphic appears by speeding it up. Make sure that you add the lower third template to any individual who is talking in the news package.

For a little extra pizzazz, you can add a ticker (another Motion Graphics template) to the V5 layer and add some sample information. This will round out the package and give it a little bit more of a professional look. Your resulting timeline should look similar to the one shown in **FIGURE 11.41**, but it may vary depending on which B-roll videos you use and their duration.

As mentioned before, using your tracks in this order is a suggested workflow for this specific type of content. The important part here is that you are consistent in how you use them across projects. Being consistent will help you quickly identify each of the components of your video for editing and troubleshooting.

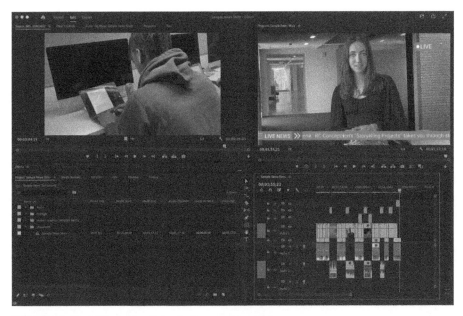

FIGURE 11.40 Adding a live ticker to the news package

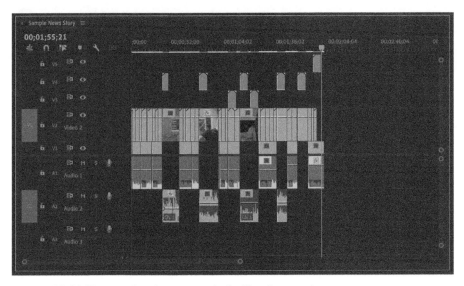

FIGURE 11.41 The completed news story in the Timeline panel

Export Your Video

To keep the highest quality setting for the video and export, I recommend that you use the Match Source – Adaptive High Bitrate preset in the Media Encoder or in Premiere Pro. Keep in mind, however, that different organizations and news stations may require you to use a specific preset for exporting. It's a good idea to ask if they have an existing preset or to develop a preset based on any requirement sheet they give you.

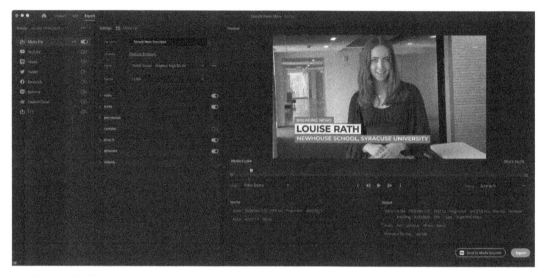

FIGURE 11.42 The Export workspace

 CHAPTER 12

Sharing Your Video Online

Y ou've created your story, and now you're ready to share the video with the world. For best success, you need to ensure that your video plays well on the platforms that will provide the largest return on investment, whether that means attention to a channel, lead generation to a particular page, or the purchase of a product. Each social media format has its own way of showcasing your creation and its preferred format for you to upload. It's important to be familiar with this process so that you know how to best tailor your video for a specific outlet.

Having the video online alone does not guarantee that you will have any success. For you to gauge how well it is doing, you also need to be able to measure any success. This will allow you to see if the length of the video corresponds to a lack of engagement or whether the topics of your stories draw views and engage the community.

Hosting It Yourself

Perhaps the easiest option for sharing a video with the world is to host it on your own website. Although this approach bypasses the constraints and requirements of third-party platforms, you do need to keep two measurements in mind: file size and bandwidth. The overall size of a file has the same implications online as it does on your hard drive. As you host more and more videos over time, the sizes of the files can add up to exceed the amount of storage space you have associated with your website. When that happens, you will need to upgrade.

The second thing to consider is *bandwidth*: the amount of data that is pushed from your server to an individual watching your video. If your video's file size is 50 MB, you are taking up 50 MB of real estate on a server. If three people ask for that video, you could be serving up 150 MB of bandwidth. While this may seem like a small amount, it can add up. If the amount of video that you are serving to the public starts to impact the servers that they are on, the video may suffer from degraded performance. I think, above all, you'd have to consider the return on investment when hosting on your own site. You spent a good bit of time making the content, only to hope that someone finds it on your website. This means you'll have to dedicate time and energy to planning and executing a strategy to get people to your website. But what if you could host this video in a place that doesn't cost you anything, can handle millions of people accessing it, and already has a developed user base you could tap into? Enter YouTube.

FIGURE 12.1 You may need to increase your bandwidth, based on the videos you upload to your website.

Working with YouTube

With millions of watch hours on a daily basis, YouTube is the largest provider of streamed video content on the internet today. Its worldwide reach and ease of use make it an invaluable tool to share your story. One of the benefits of working with a platform like YouTube is that you can share your story in many different places.

YouTube (a product of Google's parent company, Alphabet) is designed to handle a vast amount of video. As of June 2022 (the most recent numbers available), YouTube handles 500 hours of video uploads per minute (Statista, 2022). This ability to share video worldwide with such a powerful platform should make the site Destination #1 for your content.

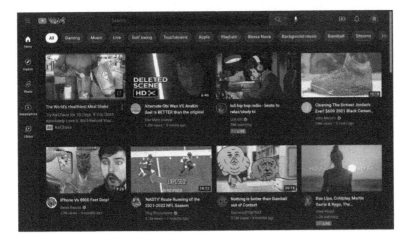

FIGURE 12.2 YouTube is currently the largest provider of streamed video content.

Uploading a Video to YouTube

Once you've created (or logged in to) your YouTube account, you can upload your video by clicking the Upload button at the top-right corner of the window. After your video begins to upload, you are presented with a screen to fill in the title and a description of the video.

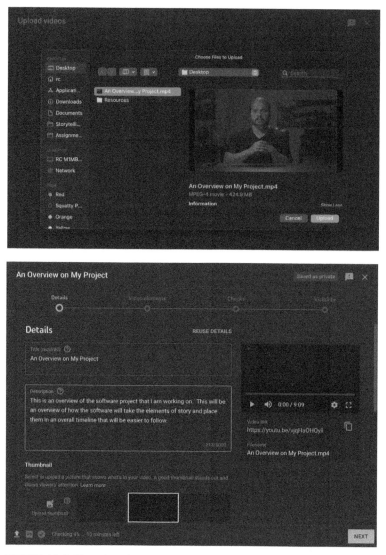

FIGURE 12.3 After choosing your video to upload, add a title and brief description.

In the next set of screens, you choose whether your content is or is not suitable for kids. You can also add the video to a specific playlist here. Click the Next button when you've made your choices, and you'll be given the chance to promote any content. To promote content at the end of your video, add an end screen. To promote content during the video, add cards.

FIGURE 12.4 When uploading to YouTube, you get many options.

While the video uploads, YouTube looks through it to make sure that it does not contain any elements that would violate copyright. If it finds violations, it gives you a chance to correct them. Do correct them, because YouTube will recheck the video later as well.

The final screen before your video goes live gives you the option to restrict the video to individual people, restrict it to individuals who have the link, or release it to the public. You will get a URL that you can use for sharing the video, as well as the option to release the video at a specific date and time. Select the option that best fits your needs, and you're good to go! At any point in time, you can come back to the video listing, click the pencil icon to return to these options, and make any changes you wish.

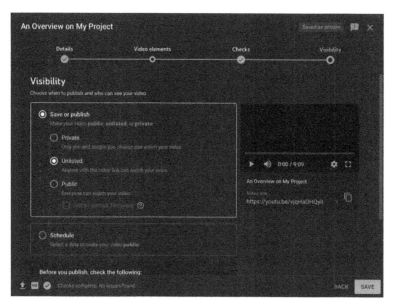

FIGURE 12.5 YouTube gives you several options for privacy (or publicity).

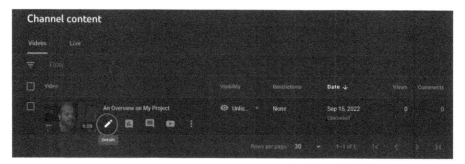

FIGURE 12.6 YouTube allows you to edit or change any of the settings you just added.

Title, Description, and Thumbnail

Merely uploading your video to YouTube doesn't guarantee you viewers. You need to make sure that your title is compelling enough for someone to click the video to watch it. Likewise, the video's description should be a good summary of what you are going to talk about and contain the keywords that you feel users will be looking for when searching for a similar video. The title and description are the most important factors for whether a video will be found on YouTube in a search. Previously, individuals would use tags to share the topic of their video, but abuse of this feature made it less important in the upload process. If your title and description are accurate and engaging, you'll be good to go.

YouTube will attempt to find thumbnails to use for your video, but often the thumbnails selected do not accurately convey the message that you would like for your video. This is a great opportunity to make an effective thumbnail.

In Premiere Pro, you can create a thumbnail of a specific frame by clicking the Export Frame button (the camera icon) at the bottom of the Program Monitor. Once you select a format for the image, you can open the image in Photoshop and add any elements that you feel are appropriate for the thumbnail. In **FIGURE 12.8**, I added a couple of text layers in Helvetica to the exported frame, as well as small graphical elements at its bottom. I will save this file in the Images folder in my Project folder, as well as export a JPEG copy of the image to use in YouTube.

FIGURE 12.7 In Premiere Pro, Export Frame enables you to save a picture of an individual video frame.

FIGURE 12.8 Adding text layers to the video frame in Photoshop

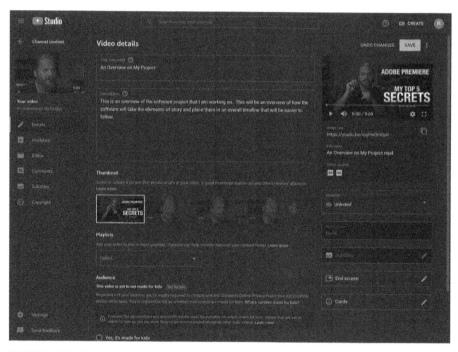

FIGURE 12.9 The video details page in YouTube

In the Thumbnail area on YouTube, click Upload Thumbnail and select the image that you created. When the upload finishes, the YouTube thumbnail changes to reflect the new image. I like to include text and images that share what the video is about to capture the attention of a person who may be scrolling through YouTube search results without reading the descriptions. How you add elements to your thumbnail may vary based on what your video is about.

USING BITLY FOR URL SHORTENING

While it is completely appropriate for you to use the short URL that YouTube provides for sharing, I like to use the Bitly.com URL shortener to make a more customized URL to share. Creating an account is free, and the site gives you a large number of URLs that you can use.

The Bitly dashboard enables you to create the short links based on the long URL that you enter.

FIGURE 12.10 The Bitly link shortener lets you change the end of your link.

FIGURE 12.11 Upgrading your Bitly account to a paid plan enables you create QR codes too.

The Bitly program not only creates a short URL that you can use in character-limited channels like Twitter, but it also lets you customize the second half of the short URL to make it more memorable. If you upgrade your Bitly account, you can use your own URL to customize this shortener even further. The goal here is to make the URL as memorable as possible.

The other benefit of using Bitly is that you have the ability to create QR codes that can link directly to your video. This enables you to add even more ways to share your URL with your viewers.

Once your video has a short link, you can share it on any social platform. On Twitter, for example, you can add a quick description of the video and the shortened link for your followers.

FIGURE 12.12 You can use a Bitly link on any social platform.

As the link begins to get more activity across your social channels, you can use your Bitly account to view detailed analytics on where individuals are clicking your link. These metrics can help you decide which social media channels are more engaging for the content that you create. Keep in mind that what you don't measure, you can't improve upon. Having these analytics can be extremely helpful not only for your video, but also for anything else that you may share online, so make sure that you take advantage of it.

Working with Transcripts in Video

We've talked a lot about audio tracks in this book, but it's important to keep in mind that individuals might not always be able to hear what your video has to say—ambient noise, the necessity to mute a mobile device, hearing difficulties, and more can sometimes get in the way. Make sure that you provide a means for individuals to get the information, such as closed captioning and transcription, and that it's compliant with accessibility standards. The ability to place text over spoken video can also be leveraged to provide an engaging way to view content. The goal is to make sure that you get the right amount of content in the best format to the widest audience possible.

Using YouTube Automatic Captions

When you upload your videos to YouTube, you have the option to set the default language for your video. When your language is set, YouTube will go through the video and automatically create a closed captioning file for it. This is a great feature if you want to make sure that your videos are compliant for accessibility. Keep in mind, however, that the machine learning YouTube uses might not correctly interpret what is actually said in the video. Double-check that what has been transcribed is what you meant to say!

FIGURE 12.13 YouTube has the option to add automatic captions.

FIGURE 12.14 You also can review the captioning for accuracy.

If you find you need to make changes, YouTube gives you the option to duplicate the auto-generated captions track. You can change the text en masse, or you can change each piece of text as it appears on the screen (known as the *timing*). If the text that is in the video was read from a script, you can replace the text of the transcript by selecting all of it and pasting in the new text. If you do not have a written script, you can always edit the text in the YouTube Edit window. Once you save the changes, you will have an accurate captions file for your viewers.

By clicking the More Options icon at the right of the video, you can also download a copy of the caption file as a VTT (video text track), an SBV (subtitles), or an SRT file (SubRip Subtitles). In almost every case, you will use SRT.

Automatic Transcriptions in Premiere Pro

In the latest version of Premiere Pro, Adobe added the ability to create a transcript of your sequence from the Text panel. Adobe's transcription technology uses artificial intelligence to create pretty accurate results. Although the default transcription language is English, you can download additional language packs from within the app.

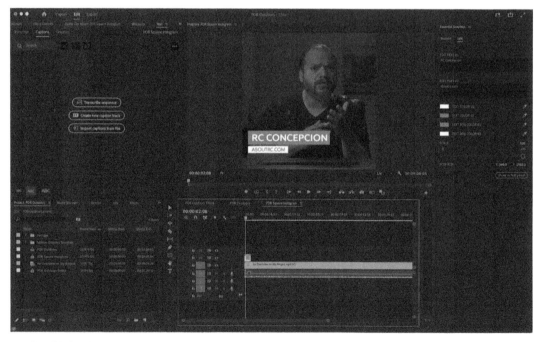

FIGURE 12.15 Premiere Pro can automatically transcribe your sequence from the Text panel.

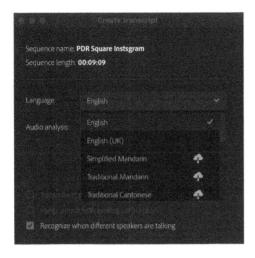

FIGURE 12.16 The default transcription is in English, but many other languages are available.

To get started, choose Window > Text to open the Text panel in the upper left of the Premiere Pro window. Click the Transcribe Sequence button to create a transcript of the active sequence. When transcription is complete, you can edit the text to make any necessary corrections, such as to spelling, capitalization, and grammar.

FIGURE 12.17 Once the transcription is complete, you can review it for accuracy.

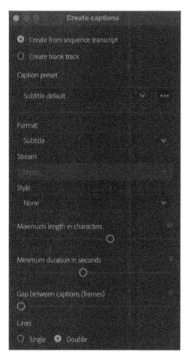

Converting Your Transcript to Captions

You can convert your transcript to captions by clicking the Create Captions button in the Text panel. Make your choices in the Create Captions dialog box, and then click Create. With the help of Adobe's Sensei machine learning, Premiere Pro adds a new track at the top of the Timeline panel with yellow markers showing where each of the text blocks will appear aligned to the audio track. You can change how the text appears by selecting any of the blocks in the Captions tab of the Text panel and editing the text properties in the Essential Graphics panel. I usually like to change the captions' typeface to Helvetica, Arial, or another sans serif font for easier on-screen reading.

When you export your video, you can choose how you would like to present the captions in the video. If you select the Sidecar option, your video will be exported without the captions and a separate captions file will be exported. These two files can then be uploaded to YouTube. The separate captions file will allow individuals that want to see captions to turn them on using the CC button at the bottom of the YouTube player. If you decide to use the Burn In option for your captions, they will be embedded directly onto the video. If you choose this option for your video, make sure the captions are easy to read around any motion graphics, such as lower thirds, that may appear in your video.

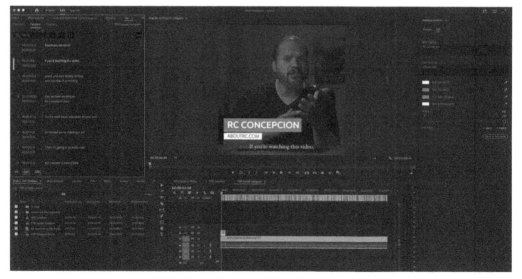

FIGURE 12.19 The captions appear in the Text panel, and a track showing their locations appears at the top of the timeline.

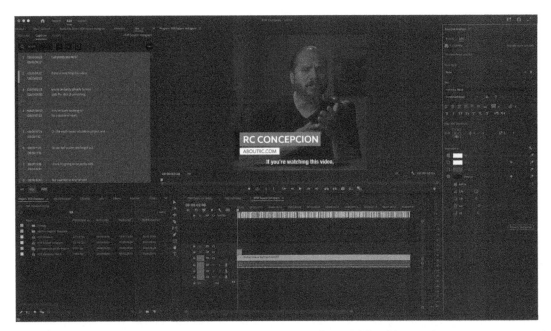

FIGURE 12.20 You can change the look of your captions in the Essential Graphics panel.

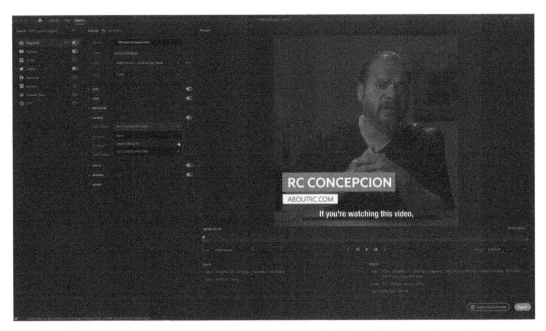

FIGURE 12.21 When exporting your video, choose whether to make the captions optional or embedded.

Customizing for Social Channels

By default, 16 x 9 formats are the preferred choice for videos, but they do not take into account that an increasing number of applications present content in different formats. Instagram originally relied on a square format for its content, while apps like TikTok tend to use a vertical 9 x 16 format. Although these formats were largely considered amateurish in years past, more and more creators now purposely design with these formats in mind to increase engagement.

Setting Presets for Sequences and Auto Reframe

When you create a sequence in Premiere Pro, you have the option to specify the dimensions you would like the video to be. You can, however, specify a different format for a video later, if you choose. In the New Sequence dialog box, to the right of the Sequence Presets tab, you will see the Settings tab. Here, you can change the width and height in pixels for the video that you are producing. If you want to create a video that is vertically formatted, switch the values of the width and the height parameters (for example, 1080 wide by 1920 high). If you want to change the parameters for a square format, make sure that both the width and the height are the same (1920 x 1920, for example).

FIGURE 12.22 When creating a new sequence, you can change the dimensions to match the social channel you are using.

You can save these changes as a preset by clicking the Save Preset button at the bottom left of the dialog box. Give it a name that suits the social channel you are using to make it easier to spot when you are selecting a preset from the Sequence Presets tab.

Also note that you can always change the sequence settings of an already created or duplicated sequence by choosing Sequence > Sequence Settings.

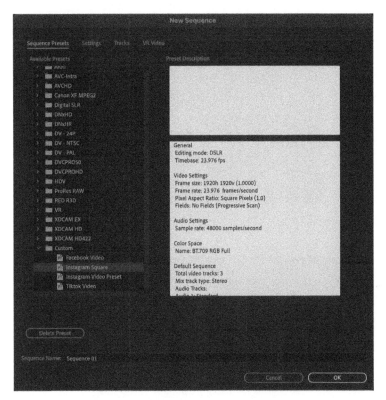

FIGURE 12.23 You can also save your settings as a preset.

If you already have a sequence composed and would like to adapt it to a different format for social media, Auto Reframe is a good option to keep in mind. Right-click the sequence and choose Auto Reframe Sequence from the menu. In the dialog box that appears, you can give the new sequence a name and choose a Target Aspect Ratio setting. In **FIGURE 12.25**, I selected the 1:1 aspect ratio for Instagram and changed the sequence name to match.

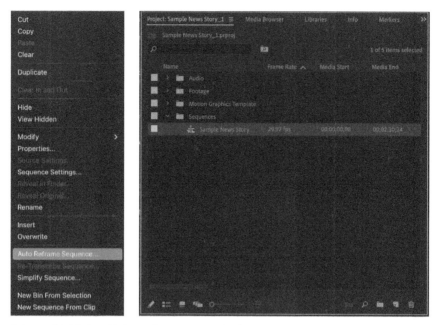

FIGURE 12.24 Auto Reframe Sequence can be found on the sequence's context menu.

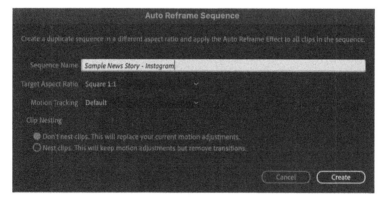

FIGURE 12.25 The Auto Reframe Sequence dialog box

Premiere Pro adjusts the video clip in the sequence to the new aspect ratio, using AI to determine where the action is and cropping to that. As with anything automatic, you may need to make some fine-tuning adjustments to graphics and text, but Premiere Pro takes care of a lot of the heavy lifting for you.

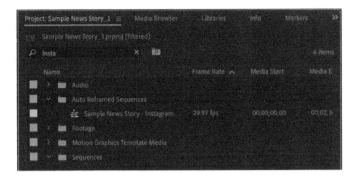

FIGURE 12.26 The new sequence in its own bin

Instagram, Twitter, and Facebook

When you upload your content to social channels, keep in mind that each will display that content differently, if at all. The amount of time that you can show your video can change, the thumbnail of your video can change, or the interaction with the video can be completely different. Because of that, you must consider which social channel you are uploading your video to and make any changes necessary to ensure maximum engagement before you post it.

As I mentioned, Instagram originally was biased toward creating square content, but now allows for the creation of horizontal content in posts and vertical content in reels. Many Instagram accounts, however, have limits on video length. Older accounts can share longer videos, but newer accounts may limit them to 60 seconds. Because of this, I recommend creating a video sequence that shares the key concepts of your story and asks your viewers to see the longer video at a link in your bio. When you upload a video to Instagram, you can change its cover photo. Take advantage of that and create a custom cover that shares the content of the video as engagingly as possible.

FIGURE 12.27 You can upload a horizontal video to Instagram and choose your own cover for it.

Sharing a YouTube link in a Twitter post is pretty straightforward. Once you share the link and Twitter has some time to process it, you will often see a player appear right in the Twitter window, allowing the viewer to see the video in its entirety. To vary the level of engagement with the video, create a shorter-form video and directly upload it into a Twitter post. Ask your viewers to click a link to watch the larger video, preferably on YouTube.

Facebook takes a completely different approach to sharing YouTube videos. When you create a post with a YouTube link, you will see the link in blue in the post but it will not show the video. Clicking the link opens a new window redirecting you to the YouTube page.

Because Facebook competes with YouTube, the company prefers to have the video content uploaded directly into the post in order for you to play it in the newsfeed. Thankfully, there are no set limits for video length. The good part here is that you can usually post the same video that you created for YouTube right into a Facebook post. Once the video is ready to watch, it will play in the Facebook newsfeed.

FIGURE 12.28 If you insert your video's YouTube link in a Facebook post, clicking it will take you to YouTube.

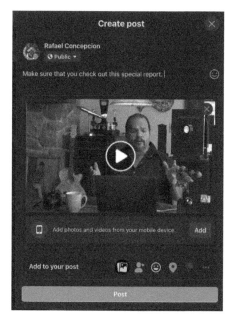

FIGURE 12.29 Facebook would rather you upload the video directly.

To test the level of engagement, use the custom graphic that you created for your YouTube or Instagram cover photo as the graphic that you post in Facebook. Use the text in the post to direct individuals to the video hosted on YouTube. You can then analyze whether viewers are more compelled to go to an external site to watch your video or watch the video directly on Facebook and make adjustments to your social posting strategy.

Comments and the $100 Bill

A closing thought that I would like to leave you with is on the topic of comments and social media. Sharing your story online requires you to have an open ear for feedback but a thicker skin for criticism. If you take a look at comments on any social channel, you will soon realize that the anonymity of social media can bring out some of the worst in human nature. Some will be supportive and encouraging of the work that you do, but it is not uncommon to see negative comments on your post, usually off-topic and designed to demotivate or infuriate you.

Sadly, this is part of the internet process. There will be individuals who make judgements about your work based on what you look like, how you speak, the type of computer you use, the typeface you design with, or the topic you decide to present on. There will be individuals who will share how much better they are or how they would have covered your topic.

When I hosted a show on photography, I often got discouraged by the volume of mean comments I saw. A friend shared something with me that I often keep in mind when making content online: "On the internet, you can go stand on a corner and hand out $100 bills, and someone will complain that you did not give them five $20 bills."

Your ideas are solid, and *you* are the person who is making a difference with the content you are choosing to produce. Listen to criticism when it's valid, focus your craft on the people who share how you are helping, and ignore the rest.

The vitriol that they share speaks more to who they are than who you are.

Don't stop creating.

CHAPTER 13

Project:
Card Game

When teaching students to shoot and edit their own videos, I've found that they sometimes find it difficult to juggle the various parts of the production process *and* learn a new piece of software. There are just too many things to focus on, which leads to frustration and disappointing results in Premiere Pro.

In this book, I've tried to help you focus on one aspect of the process at a time. First, we covered the basics of good storytelling, for example, then discussed some sound and video basics. Chapters 8 and 9 introduced the sample project, "The Spot It Surprise," and you practiced assembling the sample footage in Premiere Pro based on a shot list. Now I want to step backward to my decision-making process that led to those shots.

This chapter explains *why* I decided to make a card game story to begin with and provides an overview of the creation process from concept to completion. If you are picking up the book from this chapter, I encourage you to download the sample files and go through the online videos I created to learn the basics of Premiere Pro.

▶ FOLLOW ALONG WITH THE VIDEOS

Although reading about editing is helpful, it can't fully convey just how much of a change you can make by adjusting a couple of frames or paying attention to the timing of a clip— or how easily you can do it. For that, you need to see the editing techniques and tools in action and the difference in the resulting clips. So if you haven't watched the videos yet, I encourage you to do so before completing this project.

Once you've seen the instructional videos and gotten the hang of editing in Premiere Pro, you can use the book as an overall reference. Should you need to go back to the videos, they're just a QR code (or link) away.

To view the sample project, go to rcweb.co/storytelling-spotit.

To download the files for the sample project, go to rcweb.co/ spotit-sample.

🎬 "The Spot It Surprise" Sample Project

Use the QR code to the download files. If you're reading a print book, scan the code with your mobile device. If you're reading an ebook, tap or click the QR code.

Although the video that you make with the sample files will probably be pretty simple (we're not making *Avatar* here), the *process* of putting it together includes many learning moments and opportunities to practice techniques you'll need for more ambitious work.

Once you've finished the sample project, it's my hope that you'll find the editing process straightforward and will be inspired to try a card game video with *your* friends or family.

The Project Assignment

As you level up your production skills, you may find yourself making videos for other people. There will be times that you cannot control what the video is about and need to creatively stretch. A client might come to you with: "I absolutely love what you do. Do you think you can make me a two-minute spot about the effervescence and dynamism of fleeting joy?" It will be your job to push your creativity to get to that story. My advice? Think like a duck: calm on the surface; paddling your tail off under the water. With that in mind, here's a video prompt:

Make a 60-second video of two individuals playing with cards.

This prompt is purposely vague, allowing you to really stretch the idea of what it means to play with cards. When I assigned it in class, I got stories made with traditional playing cards, Tarot cards, and Uno cards. Once, a student made a martial arts action sequence with cards as throwing knives. Their reasoning? They were *playing* with cards. As you've seen, I went with a straightforward story of my wife and daughter competing for cookies over the matching card game Spot It.

FIGURE 13.1 The opening scene of "The Spot It Surprise," starring Jennifer and Sabine

Setting Up the Story

When you are in the story building process, it's important that your story follow a specific story formula. I recommend using Freytag's Pyramid (described in Chapter 1), like I did for "The Spot It Surprise."

After I chose my actors and the formula that I wanted to follow, I needed to map out my idea for the story. I like to use a list of questions to guide my thoughts:

- Who is the protagonist?

 Sabine.

- Who is the antagonist?

 Jennifer.

- What is the motivating feeling?

 Desire.

- What is the protagonist's goal?

 To eat the cookies.

- What is preventing the protagonist from reaching the goal?

 Jennifer is making Sabine win the game to get the cookies.

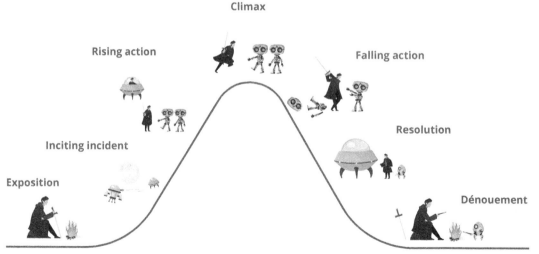

FIGURE 13.2 I used Freytag's Pyramid to outline my story's arc.

- What is the opening exposition in the story—the opening scene and setting? Think of it as the "Once upon a time" moment.

 Jennifer is reading a book with her coffee and cookies one morning.

- What is the inciting incident?

 Sabine appears, sees the cookies, and wants them.

- What is the rising action?

 Jennifer plays Spot It with Sabine and beats her card after card.

- What is the high point, the climax, of the story?

 Sabine doesn't think she's going to win.

- Is there a reversal?

 Yes.

- Is there falling action?

 Sabine goes to the refrigerator, and then sets down an apple to match a Spot It card.

- Is there a resolution?

 Jennifer laughs off the tension, and Sabine decides an apple in the morning is better.

This is the overall story that I drafted on a sheet of paper before even turning on a computer or phone. It's often a good idea to brainstorm without any technical distractions; just free write an outline. Once you map out the general direction of where your story is going, you can go deeper into the project.

Creating a Shot List

With your general idea in place, you can start breaking down each of the events in your story map into smaller components. Those components can take the form of individual video sequences. In a spreadsheet, you can start itemizing each individual shot that's required to complete the story. Set up one column to describe the shot, another to list the shot type, and a third for the filename.

The Spot It Surprise

Shot Number	Shot Description	Video File Name	Shot Type
0001	Push in shot of Jenn reading a book	video_002	ES
0002	Match action of Jenn fliping book. Reveal oreo.	video_004	MED
0003	Tight shot of cup and oreos	video_005	CU
0004	Sabine licking lips and run.	video_007	MCU
0005	Sabine runs in and gets hand slaped	video_008	WS
0006	Match action hand slap	video_009	CU
0007	Jenn saying no - no.	video_010	MCU
0008	Jenn saying no - no. and point	video_011	MCU
0009	Point to spot it	video_012	ECU
0010	Jen - you want this?	video_013	MED
0011	Sabine - bring it	video_014	MED
0012	Jenn - pick up spot it.	video_015	MED
0013	Match cut shuffle.	video_016	CU
0014	Match - Jenn shuffling	video_017	MED
0015	Sabine - looking	video_018	MED
0016	Jenn putting down card	video_019	WS
0017	Jenn - you ready	video_020	CU
0018	Sabine - yes - hair flip	video_021	MED
0019	Card game begins	video_022	ES
0020	Jenn looking at card	video_023	MCU

FIGURE 13.3 A part of the shot list included in the Spot It Surprise project

When you finish the shot list, save this file in the Documents subfolder of your project folder (assuming that you are using my Sample Project Folder template for your project). If you are using the Spot It sample project footage, you'll find the shot list I created in the sample project's Documents folder.

Shooting the Idea

Breaking down your story into a specific list of shots that you know you will need gives you a solid plan. The time you spend shooting the project goes a lot more smoothly because of it. Print your shot list, and have it handy while you're shooting. This will give you one less thing to worry about: you can cross off the shots you have in hand and can quickly see which shots you still need to finish the story.

During the shooting day, you might think of additional footage that you want to experiment with—and that's okay. As long as you capture good takes of everything on your list, you have the safety net of knowing that you have all your planned shots, along with a lot of extra footage that you can always go back to.

Once the shoot is complete, you can transfer the files from your phone into the Footage folder of your sample project. From here, you can go through each of the video clips and decide which of them are useful for the story. Once you find the keepers, note the filename of each in the shot list. For the sample project, I have already labeled the files that you need for each shot.

FIGURE 13.4 Shooting the Spot It Surprise resulted in 58 individual videos.

The shot list is your recipe card, telling you which ingredients need to be assembled in the timeline when. There is no guesswork. Follow the recipe to cook the dish.

> **TIP** If you want to make the process of finding specific footage easier, use a slate to mark the start of each shot (see "Use a Clapper/Slate" in Chapter 3). This will save you from having to view a shot in its entirety to figure out which item it is on your shot list.

Assembling the Project

The next stage of the project is to open Premiere Pro and create a project file (.PRPROJ). As explained in "Import Your Video Footage" in Chapter 7, the project file tells Premiere Pro how to assemble your clips into a sequence on your timeline. Save this file in the Premiere subfolder of your project folder so that everything is contained in one place.

To keep yourself organized, you can create separate bins for your footage, sequences, and audio. While this project is not overly complex, what you are practicing here is the workflow part of the process: making sure that every component you need is in a discrete area so that you can easily find it later. It's important to make sure that you go through this step and practice setting up the structure early. When you start working on projects that have more moving parts, you'll be glad that you spent the time learning how to make sense of all of them with a smaller project.

FIGURE 13.5 The Editing workspace in Adobe Premiere Pro

Editing Your Clips

Once all of your project is organized in the Project panel, open your shot list. Start putting the clips into a sequence in the Timeline panel using the shot list as a guide. This is a good time to practice double-clicking a clip to preview it in the Source Monitor and marking In and Out Points for each of the sections of the clip that you want to use in the sequence. Remember, the I key marks an In point, and the O key marks an Out point. The comma key places the section of video you selected in the Program Monitor onto your timeline. Once you've added that clip to the timeline, look at the next shot in the list. Find the filename for that video, and open it up in the Source Monitor to repeat the In and Out process.

While the process of adding In and Out points and moving these clips onto the sequence is simple, it's important that you work on developing the muscle memory of using two hands in Premiere Pro. Use one for clicking and dragging and the other for the keyboard shortcuts.

FIGURE 13.6 The Timeline panel with the clips in order

Here's a good workflow to keep in mind: Double-click to open each video in the Source Monitor, and use the same hand to drag the playhead through the video (a process known as *scrubbing*). Keep your other hand on your keyboard so that you can access all of the shortcuts. The goal is to keep each hand in its place, streamlining your movements to make editing faster. You can use L to move forward, J to move backward, and K to stop. Select the In and Out points with the keyboard shortcuts, and add them to the timeline with the comma, all with one hand. Again, work slowly and steadily to develop the skill. It comes in very handy when you need to process a lot of clips.

Once your clips are assembled in a timeline, practice using the Selection, Razor, and Ripple and Rolling Edit tools to make precise selections on each of the clips that you use in your sequence (Chapter 9 includes a link to a video demonstration). Often, the difference between a good edit and a great edit is the removal of several frames from one video clip and the addition of several frames to another clip. This is the art of the edit and you should spend some time trying to make your edits as polished as possible.

Adding Audio

This project is focused on developing your skills in assembling and editing video clips, so you don't have to worry about the spoken word here. The audio in each of the sample video clips is of me giving direction to the actors; it's not a part of the story. Because of this, it's important to know how to mute the audio track that accompanies each clip—your audience doesn't need to hear me coaching my wife and daughter! To mute it, Option-click/Alt-click the audio track to select it by itself and then right-click it and choose Enable to deselect it.

FIGURE 13.7 The Timeline panel in Adobe Premiere Pro

Music is a much better accompaniment to the story, so you will need to add a soundtrack to the entire edited video. As mentioned in Chapter 4, if you plan to use music created by someone other than yourself, you must take pains to acquire the proper license for your planned distribution medium and abide by the terms and conditions of that license.

In terms of workflow, when you download the audio track be sure to place it in the Audio subfolder of the project folder. You can then drag the Audio folder into the Project panel and import the audio files as well as create a bin for it. By default, your computer will place all downloaded files in your Downloads folder. If you need to edit this project on another computer, having all of the assets you need in one location will make the process easier. Getting into this habit early will pay off in the future.

Creating Titles and Credits

Once your project is laid out, you can use the Essential Graphics panel to create a title card for your video along with any associated credits (see "Adding Graphics to Your Video" in Chapter 9). Spend some time making sure that the graphics that you

add are positioned correctly in the video frame and that their typeface, color, and style suit the mood of the video.

If you used music from a website, include a credit for the piece with whatever wording and format the website specifies. Make sure you give appropriate credit for the music you use. You wouldn't want someone to use your idea without permission, so get in the habit of following copyright and permissions guidelines early.

FIGURE 13.8 The Essential Graphics panel in Adobe Premiere Pro

Exporting and Sharing Your Video

When you finish your video, you can export it from Premiere Pro or by using Adobe Media Encoder. Export the video with the Match Source - Adaptive High Bitrate preset to give you the highest quality video possible (as discussed in Chapter 11 and the companion videos). Once that's completed, move the copy of the exported video into the - Output folder of your sample project.

> **NOTE** As a measure of insurance, I like having a copy of the exported video in the export folder of my project (the - Output folder, in this case). Too many times a client has signed off on receiving a video, only to come back to me a few months later to ask for another copy.

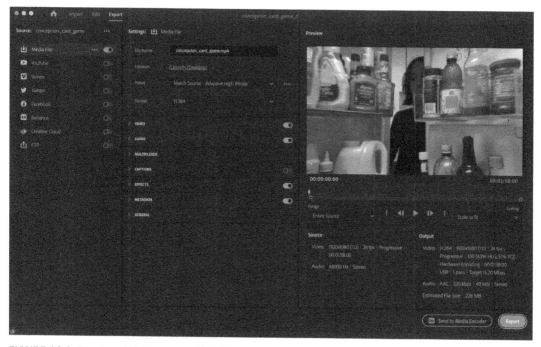

FIGURE 13.9 The Export Settings panel in Adobe Premiere Pro

From here, you should practice placing your finished video on your YouTube account, creating a short link for it using Bitly.com, and sharing it on a social media channel. See Chapter 12 for more on YouTube, why to use Bitly, and resizing your video for various social channels.

For example, if you would like to share what you have created with me, you can tweet the following:

> I made my first video using
> @aboutrc
> ##DIYStorytelling book. Check it out here:
> https://bit.ly/3xwy1hZ

In place of that link you can paste your Bitly link. I'd love to see what you do!

FIGURE 13.10 A sample tweet sharing my video

How Can You Measure Success?

The sample project was designed to teach you the process of developing a simple story from concept to completion. I developed all of the assets and shot list for you to give you a safe place for you to practice. Keeping the ideas simple makes it easy to achieve and allows you to focus on the workflow. You can replicate that process later on more complex projects of your own. To make those easier, you can download the project folder template, which contains the empty folder structure that you need to create your own project. Whenever you want to make a project, rename the main project folder, and begin to make your story. (See "A Practice Project: 'The Spot It Surprise'" in Chapter 8 for more information.)

When I assign this project to students there are a few things that I look for to measure how successful a student has been in executing their plan:

- Does the story follow the Freytag's Pyramid formula?

- Does the story have a detailed shot list?

- Do you have a good variety of shots (shots at different angles, different shot types, different types of camera movement, etc.) in your shot list prior to capturing the footage?

- Are all of the shots identified in the shot list with their filenames?

- Is the Premiere Pro project set up correctly with bins?

- Is all of the footage stored in the appropriate folders?

- Are all of the edits consistent with moving the story forward?

- Is titling and text information formatted correctly for the video?

- Is a copy of the exported file stored in the appropriate folder?

- Is the video shared on YouTube with a compelling thumbnail, title, and description?

If all of these basics are met, you can then look at the video from a creative standpoint. The goal here is to master the process. Having met that goal, your next videos are going to be great!

CREDITS

Photos and figures that are not owned by the author are credited as below:

Front Matter, Photo of Mrs. Edna Senderoff: Paul Senderoff

Front Matter, Screenshot of Vimeo: Vimeo.com, Inc

Front Matter, Photos of Vicent Laforet: Vicent Laforet

Front Matter, Photo of Norman Wechsler: Norman Wechsler

FIG01-02: colaimages/Alamy Stock Photo

FIG03-12: Cinematic Collection/Alamy Stock Photo

FIG03-01 – FIG03-03, FIG03-08 – FIG03-10, FIG07-15, FIG12-02, FIG12-03B, FIG12-04 – FIG12-06, FIG12-09, FIG12-13, FIG12-14: Google, Inc

FIG03-04 – FIG03-07, FIG05-02, FIG05-03, FIG12-03A: Apple, Inc

FIG04-08, FIG07-01 – FIG07-03, FIG07-05 – FIG07-20, FIG08-01 – FIG08-30, FIG09-01 – FIG09-13, FIG10-01 – FIG10-14, FIG11-08, FIG11-10 – FIG11-42, FIG12-07, FIG12-08, FIG12-15 – FIG12-26, FIG13-04 – FIG13-09: Adobe

FIG05-21: Moment, Inc

FIG12-01: Udemy

FIG12-10, FIG12-11: Bitly

FIG12-12, FIG13-10: Twitter, Inc

FIG12-27- FIG12-29: Meta

Index

Pearson's Commitment to Diversity, Equity, and Inclusion

Pearson is dedicated to creating bias-free content that reflects the diversity of all learners. We embrace the many dimensions of diversity, including but not limited to race, ethnicity, gender, socioeconomic status, ability, age, sexual orientation, and religious or political beliefs.

Education is a powerful force for equity and change in our world. It has the potential to deliver opportunities that improve lives and enable economic mobility. As we work with authors to create content for every product and service, we acknowledge our responsibility to demonstrate inclusivity and incorporate diverse scholarship so that everyone can achieve their potential through learning. As the world's leading learning company, we have a duty to help drive change and live up to our purpose to help more people create a better life for themselves and to create a better world.

Our ambition is to purposefully contribute to a world where:

- Everyone has an equitable and lifelong opportunity to succeed through learning.

- Our educational products and services are inclusive and represent the rich diversity of learners.

- Our educational content accurately reflects the histories and experiences of the learners we serve.

- Our educational content prompts deeper discussions with learners and motivates them to expand their own learning (and worldview).

While we work hard to present unbiased content, we want to hear from you about any concerns or needs with this Pearson product so that we can investigate and address them.

- Please contact us with concerns about any potential bias at https://www.pearson.com/report-bias.html.